ATLANTA'S
HISTORIC
Westview
CEMETERY

To one of my dearest friends — you got the very first copy, ever! Much love,

Jeff Clemmons

2015

THE
History
PRESS

Published by The History Press
Charleston, SC
www.historypress.net

First published 2018

Manufactured in the United States

ISBN 9781626199675

Library of Congress Control Number: 2017960100

For
the departed

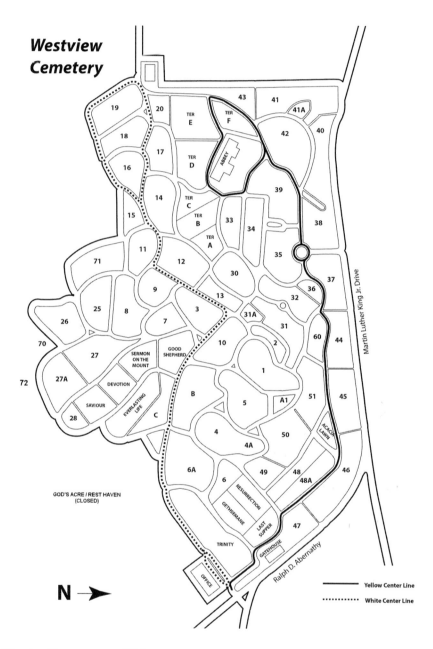

Westview Cemetery map, 2017.

CONTENTS

CONTENTS

Note: "West View" is used to denote the cemetery or its abbey prior to 1951. "Westview" is used for either entity after 1951. Depending on usage within the text, both spellings may occur in the same sentence.

ACKNOWLEDGEMENTS

I t is my pleasure to acknowledge the many people who have helped make this book a reality.

First, I want to thank my editors, Candice Lawrence and Alyssa Kate Pierce, and The History Press for allowing me the opportunity to write my second book; in particular, I'd like to thank them for their patience while I asked for multiple contract extensions. Those extensions allowed me to write a history befitting of Westview Cemetery's incredible first 130 years.

At Westview Cemetery, I am indebted to many individuals: Charles Bowen Jr., president, for allowing me access to write a true and accurate history of Westview; Martha Powers, board of trustee member—who I affectionately refer to as "Ms. Westview" because of her extraordinary seventy years of service to the institution—for sharing her knowledge and memories; Cindy Julian, director of administration, and Robert Parks, assistant director of administration, for sharing their time and access to the cemetery's archives; Gary Adams, superintendent, for the numerous private tours of Westview and for finding me a future burial spot in Section 3; Lisa Day for her efforts in tracking down information, particularly in regard to notable deaths; and Brenda Radcliff, Connie Williams, Gary Hendricks, Jimmy Sewell and the cemetery's maintenance and grounds crews for countless other favors, advice and help.

Last but certainly not least at Westview Cemetery, I owe an immense debt of gratitude to William G. Myers Jr., public relations and sales director. Without his help, advice, guidance and knowledge, this book would simply not exist as it does. For more than two and a half years

while I worked on this project, Myers was my biggest supporter, advocate and fan. For countless hours, he and I discussed anything and everything related to Westview or the business of death, as well as a plethora of other non-related topics. I am now honored to count Myers as a personal friend.

Boyd Coons, executive director of the Atlanta Preservation Center, and Paul Hammock, former director of education of the Atlanta Preservation Center, were instrumental in sparking, in part, my desire to write about Westview. Coons's question at a social event one night about the true identity of the architect of Westview's gatehouse and Hammock's quest to start regular tours at the cemetery spurred me to visit Westview for the first time. That visit—during a work lunch break—became the impetus for what you now hold in your hands.

John Soward Bayne, who I met and befriended in October 2014, deserves recognition and thanks for writing the first book on Westview, *Atlanta's Westview Cemetery*. His research was invaluable to mine, and he introduced me to the world of taphophiles.

I also owe thanks to other authors who helped me in my Westview journey: novelist and short story writer Mary Hood and novelist Ann Hite for their encouragement and support; novelist Frances Patton Statham for her information about the Irish travelers; historians Earl J. Hess and Stephen Davis for their American Civil War help; historian Sharon Foster Jones for her Atlanta knowledge; journalist Jim Auchmutey for his Atlanta stories; and two-time Pulitzer Prize nominee, biographer and mentor Virginia Spencer Carr for believing in me so many years ago. (Rest in peace, Virginia.)

Andrew P. Wood is to be praised for the incredible photographs he took of Westview Cemetery that are included in this book. It was a pleasant task to choose from the more than five hundred images he provided me for the purpose. All of those images should be bound into a coffee-table book on the necropolis.

A debt of gratitude goes out to those who were vital confederates to my mission at the following research centers, libraries or newspaper archives: the Atlanta History Center's Leah Lefkowitz, Gordon L. Jones, Helen Mathews and Don Rooney; Kennesaw State University's Horace W. Sturgis Library's Caralia Gallagher, Ashley Hoffman and Amy Thompson; Georgia Department of Natural Resources' Historic Preservation Division's Lynn Speno; the *Atlanta Journal-Constitution*'s Myra Evans and Sandi West; ProQuest's Kathy Amrose; and the United States Department of Agriculture's Kevin P. Conrad.

Special recognition needs to be given to Mark Braykovich, Kerry Gallagher, Michelle Harlow, Chris Johnson and Hilary Parrish—all editors, either by profession or skill—for reading my manuscript with a fine-toothed comb, offering much-needed edits and advice, for which I am greatly appreciative.

I offer my appreciation to my mother, Joan Schairer, who assisted me with numerous research requests and early manuscript edits; my grandmother Lois Schairer, who spent hours searching genealogy websites; my brother, Greg Clemmons, who helped with American Civil War research; Michael Dabrowa for his sketch included in this book, as well as for his and Jill Fonville's assistance with digital preparation of photographic materials; Kristen Bintliff for her French translation skills; and Chad Carlson for his knowledge of the Westview neighborhood and Georgia roadways.

Many others also helped in the development of this book in a multitude of ways, and for their services, advice and favors, I thank Adrian (the best cat ever), John Anderton, Theresa Ast, the Atlanta Preservation Center staff, Jackie Mata Barnett, Greg P. Bates, Gayle Beddingfield, Patrick Berry, Blake Blomquist, Hubert Blair Bonds Jr., Bob Caine, CIRCA, Archie Clemmons, Deborah Clemmons, Donna Coffey, Rodney M. Cook Jr., Lisa Land Cooper, Mike Davis, Debbie Castro Denson, Lee Duke, Brian Dunlap, J.D. Flora, Fanny Garvey, Deborah Gardner Gaus, Ira Genberg, Georgia Power coworkers, Tami Gerki, Robert Hall, Lee Harrop, Jacob Hawkins, D.L. Henderson, Teresa Henstridge, Rosalind Hillhouse, Tommy Jones, Mary Humann Judson, Jeremy Katz, Terry E. Kearns, Mary Clemmons Kelly, Kyle Kessler, Ginny Foster King, Maria Klouda, John Lemley, Victoria Lemos, Mary-Owen "Morgan" MacDonald, Kellie Jo Mason, Robert Lee Mays, Amy Marie Puckett McGee, Bonnie Medford, Joe Morris, James M. Ottley, Charlie Paine, Sandra Palmer, C. Clayton Powell Jr., Marcia Gay Proctor, Ana Raquel, Gordon Ray, Amy Grundhoefer Reed, Richard "Dick" Rich, Rosalind Rieser, Julie Rochman, DeWitt R. Rogers, Traci Muller Rylands, Sam Shepherd, Sharon and Howard Silvermintz, Julie Schairer Snave, Nina Stallworth, Randy Stanczyk, Stephanie Denise Irvan Steingräber, Scott Stussi, Teri Townsend, Troutman Sanders coworkers, Aniwaya Unequa, Jack Walsh, Pam Wilson and M.J. Williams.

Finally, I am grateful to my friends and family who have put up with me over the course of this project. I could not have done it without your patience and understanding. Thank you!

To others who helped in the making of this book but have been inadvertently omitted from my acknowledgements, I offer my sincerest apologies.

INTRODUCTION

THE AMERICAN CEMETERY

A Historical Perspective

C emetery" means different things to different people. For many, it is a place to remember loved ones who have passed. For some, it is an eerie place to avoid. For others still, it is an open-air museum, a repository of the community's history. Yet despite one's personal meaning, the amalgamation of what is considered a "cemetery," today, has had a long and varied past.

The English word's etymology is from the Old French word *cimetière* (graveyard) that was derived from the Late Latin word *coemētērium*. The Latin, in turn, was taken from the Greek word *koimētērion* (sleeping place or dormitory) from the word *koiman* (to put to sleep). These "sleeping chambers," if you will, with widely different burial practices and customs from different cultures over a few millennia, are, at their basic level, a place to bury the dead.

The modern cemetery in America is vastly different from its predecessors in Europe. Prior to the establishment of Père Lachaise in Paris, France, in 1804, where middle-class families were allowed to purchase perpetual burial rights for a plot of land, many in Europe, particularly the middle class, rented graves for between six and twenty years. Once the lease was up, remains were removed to an ossuary, such as the famous catacombs under Paris, or a charnel house.[1]

Even today, many Europeans—including the Germans, Dutch and Greeks—rent plots for a set number of years until their loved one's remains are removed; land is a vital resource, and cemetery space is limited. Additionally, in many of these countries when the family moves away and

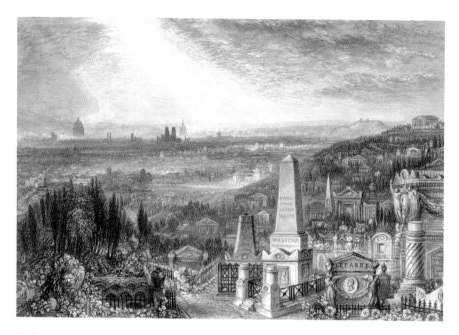

A view of Paris, France, from Père Lachaise, circa 1835. *Proof engraving by William Miller after a sketch by J.M.W. Turner, R.A.*

there is no way by which to contact them, grave plots are resold. As such, lot holders are not assured that economic pressures or overcrowding will not cause their loved one's bodies to be moved even before the allotted rental period is up.

In America, for all intents and purposes, the practice of renting burial land for a set number of years has never been a practice or issue. Since the close of the nineteenth century, families, for the most part, have not had to fear the removal of a family member's body to another place.

EARLY AMERICAN CEMETERIES

At the genesis of America, when it was still a string of colonies subject to British rule, the dead in graveyards—primarily a place for individuals to be interred around a church or town square—were often unprotected from relocation. Centrally located burial grounds were not carefully plotted, were sparsely ornamented and were used frequently as a place for markets, fairs

and meetings. In some cases, farmers were given rights to have animals eat the grass between tombstones and graves. In the 1780s and 1790s, after the American Revolution, many American city dwellers who followed the developments of European medicine and science started campaigns to close in graveyards and move them outside of town; they felt burial grounds exuded gases that aided in the spread of diseases. Therefore, as towns and cities grew and attitudes changed, graveyards were displaced; they became unwanted entities instead of being central to the community.

In response to these shifting attitudes, a group of prominent families in New Haven, Connecticut, created New Haven Burying Ground in 1796 on the outskirts of town. Adjacent to Yale University and now known as Grove Street Cemetery, it became the first cemetery to be incorporated in America, establishing a permanent and secure place for its founders to bury and protect their families' graves.

As a private corporation, New Haven Burying Ground belonged to the families who bought lots within it, rather than local ministers, sextons or government officials; the families alone would decide when and if a body could or would be removed. And while having a charter granted by the State of Connecticut allowed the cemetery owners and families to be exempt from taxes and certain liabilities imposed on other businesses or individuals, they were now solely responsible for the burial of bodies, the upkeep of the grounds and the running of the cemetery as a business. This new business model—taking care of the dead by private entity rather than by the church or state—and the opening in 1804 of Père Lachaise led to the creation of a new type of cemetery: the rural cemetery, sometimes referred to as the garden cemetery.

The Rural Cemetery

Like New Haven Burying Ground, Père Lachaise had been born out of unsavory conditions in churchyards in the core of Paris. By the 1830s, it had become a major tourist attraction due to its scenic vistas, serpentine roadways and applied English aesthetic theories. Its order—a single grave section in its core surrounded by regulated family plots that have monument (tombstone) restrictions—made it a plan that many wanted to copy in other cities. In America, one city that copied this order was Cambridge, Massachusetts.

Located just outside Cambridge, Mount Auburn Cemetery, established in 1831, would serve the Greater Boston area and become America's first "rural cemetery." The ornamental property, with its beautifully landscaped terrain that served as a botanical garden, arboretum and outdoor museum, combined the cemetery with a garden. At approximately seventy acres, it was much larger than previous cemeteries or graveyards across the United States had been. Prominent monuments were erected on family lots within the cemetery and were then touted in local papers and guidebooks as items to be visited. Like New Haven Burying Ground, Mount Auburn was organized around an association of individuals and families. Yet unlike New Haven, Mount Auburn became a top tourist destination, much like Père Lachaise.

By the middle of the nineteenth century, rural cemeteries had been established across the United States, from Massachusetts to Oregon to Georgia. In 1850, the Atlanta Cemetery, later renamed Oakland Cemetery, offered a green space for Atlanta, Georgia's populace. There, as in many other cities, residents escaping the hustle and bustle of the city core enjoyed going to the cemetery to take a stroll or have a picnic. As a forerunner to the widespread development of public parks later popularized by the work of Calvert Vaux, Frederick Law Olmsted and others, rural or garden cemeteries offered visitors picturesque landscapes that included wild scenery, rolling or sharp terrain, winding paths and water features. Many newspapers and magazines celebrated the new plantings and the erection of grand monuments. They also provided tour routes through graves, which included local histories of those buried.

Not everyone, however, was pleased with the new role and layout of rural cemeteries. Some considered them places where only middle-class or upper-class Americans could celebrate their heritage and success by erecting ostentatious monuments, which many thought cluttered the landscape. The poor and minorities were often relegated to the least desirable portions of the cemetery or were not allowed in them at all. Critics also complained that the numerous visitors streaming through the cemeteries took away from their true purpose: a place in which to mourn the dead. People became upset when funeral services were interrupted by recreationists.

Additionally, questions over the role of a cemetery as an ever-expanding business enterprise also began to change the way in which Americans viewed the rural cemetery. People had started to become more secularized, and death was gradually becoming something that specialists took care of, removing it from the family's sole domain. Therefore, cemetery organizations grappling with new laws, determining the role

of a corporate body versus lot-holders' wishes and roles, and a populace resisting the commercialization of death morphed the cemetery into a new entity toward the middle to end of the nineteenth century: the lawn-park cemetery, or landscape lawn plan cemetery.

The Lawn-Park Cemetery

In 1855, the board of directors of Cincinnati, Ohio's Spring Grove Cemetery hired Prussian-born, English-trained horticulturist and landscape artist Adolph Strauch to redesign its property, which had been chartered a decade earlier as a rural cemetery. Strauch had been an estate gardener for the wealthy in the Cincinnati suburb of Clifton and had convinced his clients to open up their properties by doing away with fences, hedges and outbuildings to provide unencumbered views of their grounds. Using that same approach, he redeveloped Spring Grove into what would become the first lawn-park cemetery.

Lawn-park cemeteries, unlike their rural counterparts, had streamlined landscapes; the pastoral would replace the picturesque topography. Within the cemetery, lawns would be expanded, trees thinned, plantings controlled, outbuildings hidden, lots simplified and monuments restricted in size and placement, being more formalized and standardized. From the latter two changes came the family lot, with one central monument, usually in the center, surrounded by multiple graves, where individual markers close to or flush with the ground would be placed.

This new type of cemetery would bring about substantial changes in the administration of death; lawn-park cemeteries were much more dependent on professionals not only to develop them but also to maintain them. By the time West View Cemetery was established as a lawn-park cemetery on the outskirts of Atlanta in 1884, cemeteries had evolved into full-fledged business enterprises.

Largely taking over what was once a sexton's role, cemetery superintendents would now manage the grounds of a cemetery. They would often act as not only a landscape designer but also a civil engineer and mechanic. Additionally, they would supervise gatehouse employees (security personnel) and work crews that planted shrubs and flowers, seeded lawns, mowed grass, dug graves and maintained lots. Cemeteries were also employing full-time surveyors, office managers, bookkeepers, cashiers and

An 1858 panoramic view of Spring Grove Cemetery in Cincinnati, Ohio. *Lithograph by Middleton Strobridge and Company.*

stenographers. Whether this office staff worked on the cemetery grounds or in downtown city offices—as was often the case—they were responsible for the selling and advertising of the cemetery. A board of directors oversaw the entire operation, which became an expensive enterprise. To offset these expenses, cemeteries offered stock, sold pre-need—selling graves prior to the death of someone—and set aside money in perpetual-care funds.

Also adding to the success of these lawn-park cemeteries were the changing attitudes of Americans toward death. By the end of the nineteenth century, science had proven that diseases were caused by microbes and not a god punishing sin, Darwin was challenging the concept of God with his theory of evolution and science and medicine were lessening the effects of religion on daily life. All of this coincided with the development of the public hospital, where more people were dying than at home, and an influx of people moving into the city, which led to the birth of funeral homes as apartments and smaller homes were without parlors for laying out the dead. Also, the rise in embalming since the American Civil War and the increasing role of the undertaker to clean bodies and handle wakes and viewings helped funerals become more ritualized. The language of death also softened to reflect the greater distance between the living and the dead—coffins became caskets, undertakers became funeral directors and the dead became the deceased.

THE MEMORIAL PARK

Two decades into the twentieth century, a new cemetery model would be born: the memorial park. In 1917 in Tropico, California, now a part of Glendale, former metallurgical engineer Hubert L. Eaton became the general manager of what had been a run-down property established eleven years earlier, Forest Lawn Cemetery. The property was losing money and failing, much like the suburb it was located in. Eaton, however, changed this by re-envisioning the place and creating Forest Lawn Memorial Park.

Within the memorial park, Eaton removed many traces of death from the landscape, eliminating the family monument and restructuring grounds to provide expansive lawns. These lawns, now called "gardens" rather than sections and often called the "Garden of the Last Supper" or the "Garden of Gethsemane," were designed to contain a central garden feature, such as a marble biblical statue, that was surrounded by graves marked only with flush-to-the ground bronze markers. As the bronze turned green, these markers blended into the scenery and were often only visible once someone approached them. It was believed that this type of grave democratized death; the rich and poor, famous or common were buried in the same manner and were indistinguishable from one another. Of course, from a maintenance perspective, it allowed for easier care since lawn mowers could move over the markers unimpeded.

From a business perspective, Eaton streamlined the process of burial by incorporating the functions of the funeral home, cemetery and monument dealer within the memorial park. He urged people to buy graves on a pre-need basis through newspaper ads, door-to-door sales and eventually radio commercials. Because of this, the memorial park was developed section by section, with pre-need sales providing much-needed capital to offset planning and construction costs.

Eaton also continued the trend of cemeteries serving as parks; in fact, he expanded on that notion, opening up his cemetery to be the setting for large Easter sunrise services and weddings. And though not credited with creating the community mausoleum, he was essential in starting the trend of opening massive community mausoleums within memorial parks, which often became repositories not just for the dead but also for art collections.

By the mid-1930s, more than six hundred memorial parks had been created across the country. Many of these cropped up next to or on the same grounds as established lawn-park cemeteries. Such was the case when Atlanta's West View Cemetery opened up its first memorial park sections in

the early 1940s under the direction of the cemetery's owner, eccentric Coca-Cola heir and real estate developer Asa G. Candler Jr.

Yet while the memorial park proved vastly popular, the overt commercialization of the mid-twentieth-century cemetery angered many who felt it should remain a sacred place. As a result, many pushed for legislative reform that would limit the actions of cemetery organizations; by 1950, there were many new state laws on the books that ensured cemetery corporations were run under government oversights.

Additionally, post–World War II America brought about changes to the family and the racial makeup of American cities. Still-segregated rural, lawn-park and memorial-park cemeteries that had once been on the outskirts of town had now been enveloped by urban cores. Many of the white families who had lived near these cemeteries moved to the suburbs and would eventually buy plots in newer cemeteries there. The mobilization of Americans also shrank the family. No longer needed were large eight- or twelve-person lots; instead, the two-person grave became common. Sons and daughters moved out of town or across the country and would no longer be buried with their parents and other family members, as had been common at the dawn of the century.[2]

THE CEMETERY TODAY

By the start of the twenty-first century, segregation had been outlawed for more than thirty years, and cemeteries were heavily regulated by state and local governments. Moreover, almost two decades into the new millennium, statistics indicate that people are moving back into the city core, which in some cases increases the demand for burial plots in older, established cemeteries. Also, the re-gentrification of older, in-town neighborhoods, where in many cases these older cemeteries currently exist underutilized, may infuse new life into them.

Today, however, the greatest threat to the cemetery is cremation. Once looked down upon for religious reasons, such as being associated with open-air pyres and pagan rituals, and for destroying the body so as to prevent resurrection, in recent years cremation has gained in acceptance and popularity. To that end, many cemeteries have added a columbarium or columbaria—niched structures to hold cremation urns—to their grounds and allowed for in-ground cremation burials to meet the growing trend. Yet

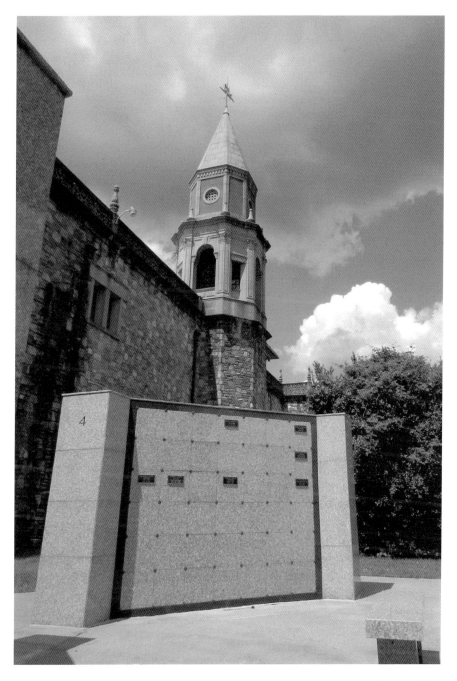

A modern columbarium at Westview Cemetery used to house cremation urns. *Courtesy of Andrew P. Wood.*

for those cremated remains that are kept by family members within their homes and subsequently passed on to successive generations, the cemetery is cut out of the death process. How will this ultimately affect cemetery operations in the future? An even greater question is what will eventually happen to those remains?

It is unclear how shifting demographics, the resettling and revitalizing of city urban cores, the blending of nontraditional families and the increasing secularization of the American public will affect the future of American cemeteries. What can be certain is that time, which brings change, waits for no man or woman. As has repeatedly happened over the last three centuries, the American cemetery will evolve and eventually resurrect itself into something new.

Part I

THE McBURNEY ERA
(1884–1930)

GRAVE CONCERNS

W est View Cemetery (now Westview Cemetery) was created out of the need of the city of Atlanta to find a suitable place to bury its dead. The city, which had been established as a railroad junction in 1837 and had two prior names—Terminus and Marthasville—before being incorporated as Atlanta in 1847, had quickly outgrown its first two burial grounds.

From the city's establishment until 1850, the majority of Atlanta's dead were buried in a city cemetery that was located south of Baker Street on the western side of Peachtree Street, near the present site of the downtown Capital City Club. At the time, city leaders realized the land would become valuable for redevelopment. Therefore, they started to look for suitable property where they could reinter the bodies and that would allow for the continued future burial of Atlanta citizens. By June 1850, they had found that property in the form of a six-acre site on the eastern edge of the city. Over the next three decades, that rural or garden-style cemetery, originally known as the city cemetery or the Atlanta Cemetery, would grow to forty-eight acres and be renamed Oakland Cemetery.[3]

Unbeknownst to the city leaders of 1850, however, was how rapidly Atlanta would expand. Just a couple years after the American Civil War had devastated the city in 1864, the city had rebounded and its population had doubled. Less than two decades later, in 1884, Oakland Cemetery had been surrounded by residential neighborhoods and no longer had any lots to sell.

To address this problem, city officials appointed a special committee to start searching in the spring of 1884 for a new burial site that would have

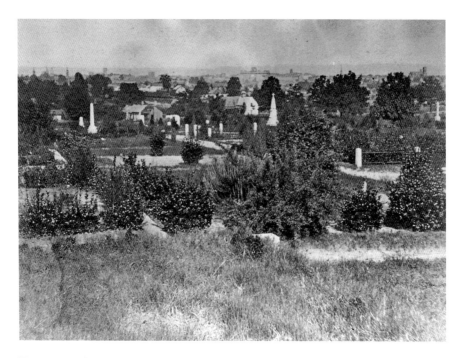

Funerary art dots the landscape of Oakland Cemetery as Atlanta's skyline looms in the distance, circa 1895. *Photo by W.J. Land,* History of Photography in Atlanta.

enough space to be used for decades to come. At the request of the city's board of health, that search focused on sites one or more miles outside the city's center; many felt that Oakland Cemetery was now too close to the city's core and posed a health risk. They wanted to ensure that didn't happen within a few years of the new property opening.

Additionally, that March, three doctors addressed the city council and impressed upon it that a new space was needed not only for Atlanta's white citizens but also for its black citizens. For years, several black citizens had petitioned the city to allow them to open their own cemetery, but the city continually denied these requests. As such, blacks were buried in the undesirable or back areas of Oakland and other surrounding community cemeteries, and they were often not allowed to use the main entrances or receive the same standard of care as their white counterparts. Over the course of negotiations, the city agreed with the doctors and consented to open separate areas in the new cemetery when it was established—one for whites and one for blacks.

After a couple of months searching for new land, the city's special committee reported to the city council in May a reversal in tactics; it felt the city should not buy any land for a new cemetery and, instead, suggested that cemeteries were best run under private ownership. Therefore, an entity that had been cobbled together by several prominent Atlanta citizens to run such a private enterprise presented to the city council that month that it would establish a new burial ground; it would be not less than four hundred acres and would contain a white section—the bulk of the property—a paupers' section, a "colored" section and a receiving vault. In return, the new cemetery association asked that the City of Atlanta not establish another cemetery for twenty years; this was later reduced to five years. Aldermen and councilmen alike agreed on the arrangement, and the new association—West View Cemetery Association—would take over the entire management of the new cemetery, with certain restrictions placed on it to prevent extortion and to protect the city.

WEST VIEW CEMETERY ASSOCIATION

On May 26, 1884, twenty-seven leading Atlanta citizens, including L.P. Grant, W.P. Inman, E.P. McBurney, Jacob Elsas, H.I. Kimball and L. DeGive, petitioned the Superior Court of Fulton County to create a body corporate and politic to be named the West View Cemetery Association.[4] A little over a month later, on June 28, the petition was granted. The association was now free to purchase land and improve it for burials.

Over the summer and for the rest of the year, members of the West View Cemetery Association, under the supervision of city officials, cobbled together properties from more than a handful of owners approximately four miles west of downtown Atlanta on Green's Ferry Road (now Martin Luther King Jr. Drive). The properties, located beyond Atlanta's then-affluent West End neighborhood and near the city's poorhouse or almshouse, consisted of approximately 577 acres of farms, homesteads and undeveloped land, which the association obtained for roughly $25,000.[5]

The assemblage of some of this land—including around 44 acres from Nathan, Boston and Henry Lamar, three black men—eventually ended bitter property disputes between previous owners, which included *writ of fieri facias*, sheriff sales and even proposed injunctions against the West View Cemetery Association.[6] Additional land would be added to the original property over several decades, bringing the acreage up to the cemetery's current 582 acres.

In addition to securing land, the West View Cemetery Association was active over the summer in gathering subscriptions to support its new

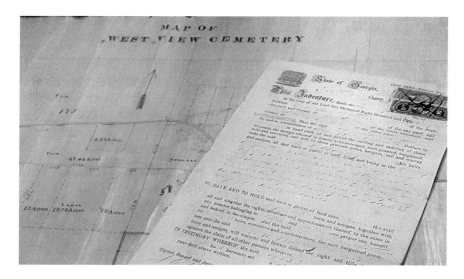

An 1884 West View map delineating lot acreage sizes and a corresponding mid-nineteenth-century land deed. *Photo by Robert Parks, courtesy of The Westview Cemetery, Inc.*

venture, organizing its governing body and issuing stock. On July 5, 1884, the association had its first meeting in the Atlanta mayor's office. At the meeting, which was chaired by L.P. Grant—an Atlanta railroad engineer, businessman and civic leader for whom Grant Park was named—attendees discussed the adoption of the June 28 petition, the issuance of capital stock in $100 shares (initially $100,000 worth, which could be increased to $500,000) and the creation of a board of directors. Each year, the board would elect a president, vice president, secretary and treasurer to look over the affairs of the association and the cemetery it was creating.

On November 18, that board met for the first time at the Atlanta Chamber of Commerce. During the meeting, two of the original twenty-seven petitioners were elected president and vice president, T.L. Langston and T.J. Hightower, respectively. On a motion, petitioner J.F. Burke was asked to act as a temporary secretary. Three days later, one of the company's directors, J.T. Orme, would be elected as treasurer and petitioner E.P. McBurney would be chosen West View's permanent secretary and general manager, beating Burke for the position in a six-to-five vote.[7] Of all these men, it would be McBurney who would be the most influential and active board member and the one who would become the public face of the cemetery, establishing it as the premier lawn-park cemetery of the South.

Though Edgar Poe McBurney was born in 1862 in Ithaca, New York, to J.C. and Lusina McBurney, he spent most of his life in Atlanta. In the city, he became a leading developer, capitalist and financier, being involved with numerous business enterprises, such as McBurney's Real Estate and Loan Exchange, which handled early subscriptions for the West View Cemetery Association; the McBurney Investment Company; the Empire Cotton Oil Company, which he helped form and eventually became executive manager, vice president and then president of; and the Trust Company of Georgia Associates, the First National Bank and the Georgia, Southern & Florida Railroad Company, where he served each as a director.

He also served as vice president of the Atlanta Chamber of Commerce, where he was instrumental in helping bring Camp Gordon to the city, served as a director of the Southeastern Fair Association and served as a member of the executive committee of the Atlanta Presidents' Club. Socially, he was a member of the prominent Atlanta Capital City Club and Piedmont Driving Club.

Along with the J.M. High family (J.M. High Company dry goods) and the J.J. Haverty family (Havertys furniture company) and many others, McBurney and his second wife, Helen Sterrett Hersey, helped build, through the Atlanta Art Association, what would become in 1926 the High Museum of Art; McBurney at one point served as an officer and director of the museum.[8]

Upon his death in 1940, McBurney left more than an estimated $1 million to establish the Edgar Poe and Helen Sterrett McBurney Memorial Fund, which would, after Helen's death in 1955, be used to fund the establishment of the McBurney Art Memorial. This new memorial, or museum, would consist of their mansion, coach house and gardens—known as Villa Nelili— and would be run by the Atlanta Art Association as a home for furniture, silver, china and other decorative arts.[9]

In the summer of 1884, however, McBurney was not making plans for his house to become a museum; he was engaged in making plans to shape West View Cemetery into Atlanta's premier burial ground.

Chapter 3

DIGGING IN

On August 6, 1884, the Atlanta public got its first glimpse—in the form of a lengthy newspaper article—of what West View Cemetery was to look like. The day before, an *Atlanta Constitution* reporter had toured the property with E.P. McBurney, who was still three months away from "officially" governing the cemetery as secretary and general manager.

McBurney told the reporter that West View was to be patterned after Woodlawn in the Bronx, New York, which was established as a lawn-park cemetery in 1863. As such, hundreds of acres of pine forest at West View would be cleared of undergrowth and, along with a few cultivated fields, would be prepared for the laying out of grave lots. On those lots, shrubs and flowers would be allowed and cared for by the cemetery association, but no fences could be constructed. Family monuments would be erected in the middle of the plots, with footstones marking each individual family member who had passed away.

To help care for the shrubs and flowers, as well as the yet-to-be-planted hardwoods and Osage-orange hedge, which was to be used as a fence for the whole of the property, the cemetery association planned to funnel some water from the property's twelve springs and numerous streams to a reservoir that would be built on a high hill on the grounds. It was from that hill that the *Constitution* reporter said he was afforded a "fine view of the city" from the west—hence the cemetery's name—as it was fifty-eight feet higher than where the city's Union Station stood downtown.[10]

The reporter also detailed in his article some ideas that McBurney had about the future of the property. For example, he wanted to create an avenue

to it, which would have been two and a half miles long, thirty-six feet wide between curbs, eleven feet on each side for streetcars and six feet outside of that for a sidewalk, all lined with trees. In addition, he wanted to preserve the American Civil War earthworks on the property that existed as a result of the Battle of Ezra Church, which occurred, in part, on the cemetery grounds on July 28, 1864, and establish drives along them for visitors to tour. He also wanted the cemetery to serve as a park.

While those three things never happened, the promise by McBurney to have guards on hand to keep order and prevent theft at the cemetery was kept; gunfights did occasionally occur among the tombstones between guards and grave robbers in the early years. McBurney's promises of a cemetery company that would "be in absolute charge and responsible for the faithful management of the cemetery"—which continues to this day—and the hiring of a landscape gardener were also kept.[11]

On August 30, a little over three weeks after the *Atlanta Constitution* article was published, landscape gardener, architect and civil engineer Thomas C. Veale arrived in Atlanta from New York. The following day, he would immediately start his employ at West View by arranging the grounds and beautifying the property, as he had done managing several cemeteries in New York, as well as a stint twenty years earlier designing Elmwood Cemetery in Columbia, South Carolina.

First up for Veale was to start laying out avenues on the cemetery grounds, which over time would be macadamized and given names, such as West View Avenue, Laurel Avenue, Valley Way and Terrace Road; decades later, these roads would be covered in asphalt and the names forgotten. But in 1884 and into the following year, Veale not only laid out avenues but also oversaw a crew of up to seventy men who graded land for burials, installed several thousand feet of sewer pipe for proper drainage and started the work necessary to plan for the construction of the cemetery's receiving tomb and entrance lodge, or gatehouse.

Surprisingly, Veale would stay at West View for only thirteen months before resigning in October 1885 for undisclosed reasons. He would go on to do architectural work in Alabama and Tennessee before heading back north to New Jersey less than a decade after coming to Atlanta, but not before leaving an indelible mark on the way West View Cemetery was designed and laid out.

Through his initial work in 1884, West View Cemetery had opened its main section for whites, which was ready for its first burial, and two other sections—Rest Haven and God's Acre—for blacks and paupers, respectively.

REST HAVEN

West View Cemetery's Rest Haven section for black burials was named as a play on words after Gilbert Haven, a white bishop in the Methodist Episcopal Church who was a racial equalitarian, social reformer and author.

Born in Malden, Massachusetts, in 1821, Haven came to Atlanta in 1872 on assignment from his church's governing body. While there, he became an early benefactor of Clark College, later Clark University, which had been founded in 1869 by the Freedmen's Aid Society of the Methodist Episcopal Church to educate freedmen or former black slaves. Haven helped the college purchase land in Atlanta and raise funds for the endowment and construction of buildings for its new campus, which would open eight years after his arrival.

Haven was not in Atlanta for long. Many white citizens thought he was too controversial and would make their race look bad; additionally, his own church was dealing with how to navigate the racial issues of the day. Therefore, because of these views and Haven's staunch and often vocal opposition to them, he was sent by the Methodist Episcopal Church to Liberia in 1876. A year later, he returned to the United States, working in the New York, Pennsylvania and Massachusetts area, before dying in the latter state in 1880 from numerous illnesses. Haven, though, would be forever linked to Atlanta's West View Cemetery when his name was chosen for its black burial section.[12]

The graves of former slaves Andrew and Lula Hill in Rest Haven, Westview's once blacks-only section. *Courtesy of Andrew P. Wood.*

Rest Haven is located in the southeastern corner of the cemetery. Its several acres were designed so that graves were clustered around three avenues—East Haven and Central Avenues forming an oval with West Haven Avenue running parallel to it. A separate entrance for the burial ground was created several hundred feet south from the main West View entrance.

Graves within Rest Haven could be purchased in the same manner that white graves were available in the main portion of the cemetery: family plots with a central stone and footstones marking individuals, or a single plot. Yet due to the lack of financial resources to do otherwise, blacks were sometimes buried two to a grave and two to a coffin, though this was an exceedingly rare practice.

One of the first burials in Rest Haven was that of Adeline Jones on October 27, 1884. She would be joined by several others over the years, perhaps the most famous being Andrew Hill in 1916 and his wife, Lula Leigh Hill, in 1949; both had been born into slavery but, once freed, became prominent citizens within Atlanta's black community and owned several properties.[13]

Another famous individual "partially" buried in Rest Haven was educator Edmond Asa Ware. A white man, Ware was one of the founders and the first president of the historically black Atlanta University, now part of Clark Atlanta University. On September 29, 1885, he was buried in West View in a thirty-foot-diameter lot that straddled Rest Haven and the bordering white section of the cemetery; the association had given this lot to his widow. Nine years later, however, he would be exhumed and reinterred on the Atlanta University campus, eventually being covered with a seventeen-thousand-pound boulder from his hometown of North Wrentham, Massachusetts.

In addition to single or family plots, certain religious or civic groups could purchase sections to bury their dead within Rest Haven, such as the 1,400-square-foot lot the Ladies Home Missionary Society, later the Women's Society of Christian Service, purchased in 1892. In the white sections of West View, many groups such as the Benevolent and Protective Order of the Elks would carry out the same practice.

Two years after Rest Haven opened, it fell out of favor with black Atlantans. After years of asking for their own burial ground, the City of Atlanta finally granted a petition in 1886 for the establishment of a black cemetery to be named South-View. Now, blacks could be buried in ground strictly theirs, instead of being relegated to a small section in the back or side of one of Atlanta's two larger cemeteries, Oakland or West View.

Needless to say, the opening of South-View seriously curtailed the sale of graves within Rest Haven. Yet despite the competition, blacks continued to

be buried—however infrequently—within the section into the later part of the twentieth century.

Unfortunately, when the West View Cemetery Association established a perpetual care system in 1907 for the upkeep of its white section, which was desegregated sixty-three years later, Rest Haven was not included in the arrangement. As such, this historic section is maintained only periodically and is closed to the general public.

God's Acre

On October 28, 1884, Dr. George W. Wilson was buried as the first pauper in West View Cemetery's potters' field known as God's Acre. He had died two days earlier in a boardinghouse on Marietta Street downtown. Sadly, no family or friends came to claim his body; therefore, he was buried at the expense of the City of Atlanta.

Less than a month later, on November 19, Atlanta officials adopted an ordinance that directed all city paupers, white or black, to henceforth be buried in God's Acre. A deal had been brokered where the City of Atlanta would pay two dollars for the burial of the deceased and the West View Cemetery Association would provide the land, as well as the labor to bury the dead and keep up the graves.

Unlike the carefully laid out family or single burial plots in West View's main cemetery section or Rest Haven, those buried in God's Acre along the southern border of the cemetery were buried in rows, one next to the other based on the date of their death; the only distinguishing difference was race. Whites were buried in certain rows and blacks in other rows.

When South-View Cemetery opened in 1886, its owners wanted to take over the burying of the city's black paupers. Atlanta's Cemetery and Relief Committee, however, was initially against this request based on the objections of West View officials and a contract that existed between the two entities. Eventually, the committee changed course and allowed for black paupers to be buried in South-View in 1888.

Unfortunately, West View and the City of Atlanta had a somewhat contentious relationship regarding pauper burials over the decades. In 1892, West View stated its contract with city officials for pauper burials was null and void since the city had reopened portions of Oakland Cemetery for burials. Sixteen years after that, West View threatened to stop burying

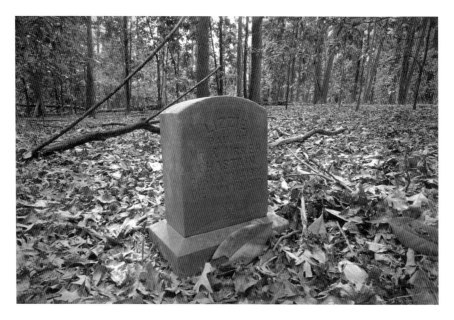

Five-year-old Lizzie Chastain's grave is one of thousands in Westview's God's Acre section, Atlanta's potters' field from 1884 to 1925. *Courtesy of Andrew P. Wood.*

paupers unless the city paid what it was paying to open and close graves in Oakland. On each occasion, the two sides reached amicable resolutions.

Most of the 5,153 graves within God's Acre are unmarked; however, there are a few marble grave monuments scattered throughout the section. A tale attached to one of those monuments is about three-year-old Robert Edmond Wood, who died on November 29, 1901, from severe burns. He and his one-year-old sister, Katherine, had been playing too close to a fireplace in a top floor of a three-story tenement home on East Hunter Street when his clothes caught on fire. By the time a neighbor got to him from a downstairs floor, the neighbor was greeted with little Robert screaming in a "heartrending and pitiful manner" with his "hands raised high above his head and his body enveloped in flames."[14]

By 1925, the City of Atlanta had stopped using God's Acre as a place to bury its paupers. The section, like Rest Haven, was not included in West View's 1907 perpetual care plan; therefore, it has been intermittently maintained and is not open to the general public due to safety concerns.

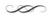

The McBurney Era (1884–1930)

With Thomas Veale on staff directing the layout and beautification of the grounds and E.P. McBurney at the helm of the association charged with running the entire operation, West View Cemetery was ready to open and receive its first burial. As the new cemetery had garnered press two months earlier when McBurney showed a reporter around its grounds, the *Atlanta Constitution* was again on hand to give details of "The First Burial in the New City of the Dead."[15]

On Thursday, October 9, 1884, fifty-year-old Helen Livingston Haskins, the wife of Charles R. Haskins, was laid to rest on a knoll not too far from the main entrance of the cemetery in what today is Section 4. She had died two days earlier of heart disease, and on the day of her burial, her body had passed in procession from her home on Jackson Street, past Peachtree and Whitehall Streets, past West End and into the newly minted necropolis. After her funeral, the *Constitution* reporter covering it walked about the cemetery, gathered details on its progress and reported them in an October 10 article.[16]

Had the reporter come out weekly to West View over the last few months of 1884 or the first few months of 1885, he could have reported on several other improvements being made, such as the readying of stone quarries on the property to be used to clad future buildings and structures, recent grading and plantings or the fact that on November 1 the association's

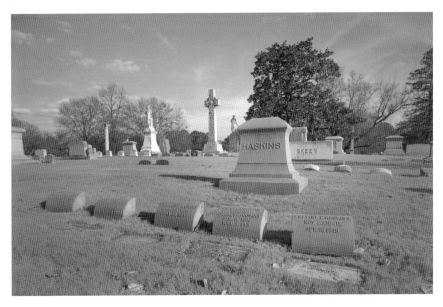

The grave of Helen Livingston Haskins, the first person buried at Westview Cemetery in October 1884. *Courtesy of Andrew P. Wood.*

West View Cemetery Company office was listed on the city's telephone exchange. That telephone would ring at a sales office on North Broad Street in downtown Atlanta.

By the end of the 1885 winter, the cemetery was being advertised as one of the largest in the country and boasting various burial sections with names such as Laurel Hill, Spring Grove, Pine Wild, Dawn Side and Terrace Hill. It also had newly drafted rules and regulations put in place: buggies could not exceed four miles per hour, horses could not leave the roadways and must be hitched at all times, flowers were not to be picked and firearms were not to be discharged on the property. A "superintendent of interments" lived on site with his family to help enforce these rules.

Toward the end of the year, Fulton County officials were improving roads in Atlanta with a concentrated effort to create a fifty-foot macadamized road leading from the West End neighborhood a mile out to West View Cemetery's gates. If the road had existed at that moment, it would have led to a cemetery that in less than one year had handled 833 interments (54 from other cemeteries) and had a seventy-five-acre lawn as a main attraction, twenty-seven flower beds to view, three night guards on duty to protect the dead and the prospect of a streetcar to soon run to it from downtown. It would be three years before both the road and streetcar became realities. Yet what would not take any time at all would be West View becoming known across the country because of J.W. Pierce's "celebrity" burial.

J.W. Pierce and Celebrity

On December 19, 1885, West View staff interred what would become the cemetery's first "celebrity": wealthy Texas ranchman and livestock dealer J.W. Pierce. Pierce had been in Atlanta buying and selling horses and cattle when he was killed near Austell, Georgia, in a Georgia Pacific train accident on his way back to Texas. His body was buried at West View but was to be exhumed and shipped to Texas once his family came to claim it.

At the beginning of February, an Indianapolis woman, Louisa E. (Sigler) Weaver, was in Atlanta claiming the dead man as her husband—J.P. Weaver and not J.W. Pierce. She stated her husband had been living in Texas with his mistress and was going by the assumed name of Pierce. Officials dug up Pierce at West View for Weaver to identify, which she did by a wound in his neck and the malformation of his toes. He was then reinterred, only to be

J.W. Pierce, a wealthy Texan, was Westview's first "celebrity." Two women claiming he was their husband garnered press across the country. *Courtesy of Andrew P. Wood.*

dug up the next day to be identified positively by some of Pierce's Atlanta associates, and then reburied.

A few days later, Pierce's wife, Allie Belle, showed up from Texas and filed suit in the city clerk's office to enjoin Weaver from having her husband's remains removed from West View; though horrified he had been exhumed twice, she had him exhumed for a third time to identify his body, which she did in the affirmative.

A complicated legal battle ensued that made headlines across the country, causing a Chicago newspaper to claim the man was neither Pierce nor Weaver but a Boston railroad builder known as "Old Man Pierce." Eventually, the court sided with Pierce's wife from Texas, Allie Belle; she told the West View Cemetery Association that Pierce's body would be moved the following winter, but it never was.

J.P. Weaver, the philandering husband, was eventually arrested in Chattanooga, Tennessee; detectives concluded that he sent his wife, Louisa, in Indiana a newspaper clipping of Pierce's death in an attempt to fool her into thinking he was dead and to rid himself of her for good.

While an accidental celebrity, Pierce is joined at Westview today by actual celebrities, such as conductor and Grammy winner Robert Shaw;

saxophonist and founding member of the S.O.S. Band Bill Ray Ellis; stage and screen actress "Gladys Hanson" Cook; Kris Kross singer James "Chris" Christopher Kelly; and circus "midget" star "Little Mabb" Adrien Esmilaire. Celebrities' family members have also been buried at Westview, such as actor and comedian Oliver Hardy's mother, Emily Norvell; and actresses Phylicia Rashad and "Debbie Allen" Nixon's grandmother, Annie Doris "A.D." Hall.

THREE YEARS AFTER PIERCE'S burial and the subsequent media hype surrounding it, West View Cemetery finally opened a permanent receiving vault in 1888. The vault, built into the side of a hill in Section 4, would serve as a temporary storage space for bodies until families could pick out a suitable burial plot or, as in the case of winter, store a body until the cemetery grounds were thawed and traversable by horse-drawn carriages.

Officials at West View had tried to build a receiving vault since the cemetery had opened; in early advertisements, officials claimed West View would be the only cemetery in the South with such a structure. Unfortunately, what is not clear in the historical record is why it took so long to complete the project. Were there temporary vaults before this one was finished, or was this one used in different states of construction?

When the first burial at West View was mentioned in an October 1884 *Atlanta Constitution* article, the receiving vault was said to be under construction. In December 1884, the public was told the vault would be ready in three months and would be capable of holding fifty-six people. Two years later, there were still mentions of the vault being built to store bodies as long as they did not have cholera or smallpox. In 1887, the West View Cemetery Association was having private conversations about finishing the vault, stating it wanted to end the practice of storing bodies temporarily at Oakland Cemetery and then having them transferred to West View.

What is certain, however, is that in 1888, the West View Cemetery Association issued bonds, of which $1,795.15 was used to complete the twenty-five-foot-long, thirty-foot-wide, eighteen-foot-high, thirty-six-body maximum, rough-hewn granite-clad receiving vault that still exists. On October 26 of that year, the vault received its first body, one-year-old Lyman Hall Jr., who was eventually moved to a grave site on the property. By January 1890, the wooden doors of the vault had been replaced by marble

Westview Cemetery's receiving vault was built in 1888 to temporarily store bodies until weather conditions allowed for proper burials. *Courtesy of Andrew P. Wood.*

ones. Fifty-five years later, in 1945, the vault was permanently sealed, as there was storage space for bodies in the then–newly constructed West View Abbey. An inscribed tablet detailing the vault's history was placed over its door in 1951.[17]

A year after the vault opened, West View Cemetery officials had discussions with a Jewish congregation about opening up a dedicated Jewish burial ground within the cemetery. The ten-acre spot at $500 an acre was to have been located at the cemetery's northwestern corner, with six hundred feet of it bordering on what is now Martin Luther King Jr. Drive. At the time, the "Hebrew congregation"—unnamed in cemetery records—owned Jewish plots within Oakland Cemetery and would use them until they were filled or a particular member specifically requested to be buried at West View.[18] For undocumented reasons, however, the plans to open this section never materialized, and discussions about it ceased by 1891. As such, while Jewish burials have occurred at Westview since it opened, it is, today, one of the few major cemeteries in Atlanta without a dedicated Jewish section.

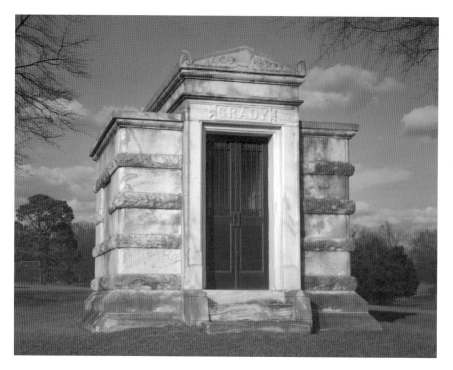

Journalist, orator and "Spokesman of the New South" Henry Grady's mausoleum. Today, his name is most associated with Atlanta's Grady Hospital. *Courtesy of Andrew P. Wood.*

Two events that did happen in 1889 and that affected West View well into the future were the reinterment of five members of Colonel L.P. Grant's family from Oakland Cemetery to a hilltop in West View and the death of journalist, orator and "Spokesman of the New South" Henry Grady. While it would take until 1892 to secure a lot and have a mausoleum built for Grady's body, these six burials, along with subsequent ones over the years—such as those of the Coca-Cola barons Candler and Woodruff families, or that of Havertys furniture titan J.J. Haverty—would solidify West View's standing as a burial ground for Atlanta's elite.

Additionally, in the fall of 1889, a monument was erected within West View to commemorate the Confederate dead of the American Civil War. Its completion ended years of failed attempts to memorialize the war, specifically the Battle of Ezra Church, which had partially taken place on the northern boundary of the cemetery.

The Battle of Ezra Church

The Battle of Ezra Church on July 28, 1864, was a major battle fought during the Atlanta Campaign of the American Civil War.[19] The battle was named after a small Methodist church that existed north of Lick Skillet Road, now Martin Luther King Jr. Drive, in what today is the southeast corner of Mozley Park just northeast of Westview Cemetery.[20] In the summer of 1864, however, this area was sparsely populated and was between downtown Atlanta, approximately three miles to the east, and the small community of Lickskillet, later Adamsville, near the Chattahoochee River to the west.

Union major general William T. Sherman and his armies had entered into Georgia two months prior to the Battle of Ezra Church in May 1864 and had steadily advanced toward Atlanta, the industrial center of the Confederacy, with the hopes of cutting its rail supply and capturing the city. The Confederacy under General Joseph E. Johnston had continually failed to stop Sherman's advancements in a series of battles, such as those in Resaca, New Hope Church, Dallas or Kennesaw Mountain, throughout May and June; therefore, Confederate president Jefferson Davis, in a controversial move, replaced Johnston with General John Bell Hood, who was deemed more aggressive and who, it was thought, might change the tide of events.

On July 20, Hood launched his first offensive maneuver toward Sherman's advancing army in a sudden assault at Peachtree Creek just north of Atlanta; yet his troops were repulsed. Two days later, on July 22, Hood—in what became known as the Battle of Atlanta—launched a second sudden attack against Sherman's armies but was once again thwarted. Sherman, slowed but undeterred, sent troops west and south of Atlanta over the following days to try to sever the last rail lines coming into the city from Macon, Georgia.

Sometime between mid-morning and noon on July 28, the Union soldiers who were sent southwest encountered Confederate troops at Ezra Church. The Confederates had been assembling in the area to stop anticipated Union movement southward and to carry out flank attacks. One of the Confederate's corps commanders who showed up to the area late that morning decided, however, to attack immediately instead of simply block Union advancement.

Over the course of five to six hours, Confederate troops were progressively repulsed back from the church and ridge line, which now lies beneath Interstate 20, to Lick Skillet Road. South of the road in what is now the northern part of Westview Cemetery is where Confederate

Union troops in waiting before the Battle of Ezra Church on July 28, 1864. *T.R. Davis sketch in* Harper's Weekly, *August 27, 1864.*

cavalry and infantry rallied and fought until eventually being pushed back from there and southeast toward a poorhouse, or almshouse, which stood near the cemetery's current gatehouse. When the fighting was done—and estimates vary—3,000 Confederate and 632 Union soldiers were killed, wounded or missing out of a combined 20,000-plus group of fighting men from both sides.

By the following day of July 29, Confederate forces had left the area and retreated farther south to join other soldiers in other skirmishes. The wounded were taken to nearby hospital units, and prisoners were rounded up and interrogated. The dead, whose blood had pooled into a stream and clogged it—later dubbed by the contemporary press as Dead Brook—were buried in mass graves on site.

Union troops, on the other hand, ensconced themselves in the area over the next several days and constructed breastworks and a redoubt to defend the ground they had obtained against future attacks. It is believed that some of these breastworks are the ones still intact in Westview Cemetery's Section 70.[21]

Eventually, Sherman's armies cut the last of the rail lines south of Atlanta and drove the Confederacy from Jonesborough, Georgia—later spelled Jonesboro—on September 1. As a result, the Confederacy, fearing another attack on Atlanta, evacuated the city; Union troops moved in and occupied it on September 2. Two and a half months later, Sherman would launch from Atlanta his infamous March to the Sea, capturing Savannah in December 1864, before turning northward to unify his armies and ultimately end the war.

Commemorating Ezra Church

In the winter of 1885, twenty-one years after the Battle of Ezra Church, a group originally referred to as the Blue and Gray teamed up with West View Cemetery Association officials to erect a monument in honor of those who died in the Atlanta Campaign. Unlike similar monuments being erected across the country, this monument was to be built to honor not only Confederate soldiers but also Union soldiers.

The Blue and Gray had its origins in a failed attempt by Colonel John E. Lane, quartermaster of the Robert E. Lee Camp #1 of Confederate Veterans in Richmond, Virginia, to raise money and build a Confederate Soldiers' home in his city for the care of disabled Civil War soldiers. Lane had asked veterans in Atlanta to form a Blue and Gray association to help him and two traveling companies raise money through a multi-city tour, which was to include a stop in Atlanta. Unfortunately, Lane's groups only toured Richmond and Norfolk, Virginia, before canceling other appearances due to the lack of interest and funds. But since the Atlanta group had formed, they wanted to do something for veterans and thus turned their attention to their own city.

At about the same time, workmen at West View unearthed two soldiers' bodies on the cemetery's grounds, which was not a common occurrence since most Confederate troops who had been buried on the Ezra Church battlefield had been reinterred at Oakland Cemetery and elsewhere years earlier. West View's management, knowing of the Blue and Gray's desire to do something in Atlanta, offered to give the group a lot to reinter the bones and add to them other remains found in the region.

With the lot accepted by the association, plans were made to erect a Union-Confederate monument made out of granite with a soldier from each

side grasping hands at the top. Under them would be the words "Unknown Fallen Braves." To raise funds for the construction of the monument, which was being billed as the first to honor both sides of the war in the United States, the Blue and Gray began planning a series of fundraising events.

On March 10, 1885, the group officially organized itself after holding preliminary meetings at the Kimball House and the West View Cemetery Association offices on Broad Street. At a meeting that day, the Blue and Gray committee stated it would be headquartered in Atlanta and had created a constitution, established fee requirements, elected officers, formed committees and officially changed its name to Battle Monument Association of the Blue and Gray, which was incorporated three months later.

As word got out to the public that the purpose of the group was to gather remains of unknown soldiers from surrounding environs, people started notifying the group of bodies buried on their properties. Those people were told that if it could not be determined which side the soldiers fought on, they should send the remains to West View for reinterment.

By April, a proposed architectural rendering had been exhibited of the monument, which was praised by members of the group.[22] It showcased a now $100,000 structure on what was being called Battle Hill, later Battle View, in West View Cemetery, as a stone fort with sculptures of soldiers on each corner, joined by two cannons. Arising from the fort was to be a 180-foot-tall granite column, containing a spiral staircase, with two soldiers, the blue and the gray, clasping hands near its apex; the whole of the piece would be capped by the goddess of liberty standing on a globe. At the base of the column, statues of significant players in the Civil War would be placed in niches. Stones with mottos inscribed on them were to be donated from various army posts, war associations and the federal government to complete the structure.

While the structure was grand and the project had attracted impressive proponents, such as President Grover Cleveland, Maine governor Frederick Robie and Georgia governor Henry D. McDaniel, it remained impressive only on paper. Three months after it was unveiled, members of the press started to decry it. Most critical of the project might have been well-known writer and politician Charles H. Smith, who wrote under the nom de plume Bill Arp. Arp wrote that Southerners had paid Northern soldiers' pensions for years and that he would rather see the money for the monument spent on pensions for Southern soldiers who had not received like compensation.

Coupled with criticism of the monument was lack of advancement in constructing it. By June 1886, forty Union and Confederate soldiers' remains

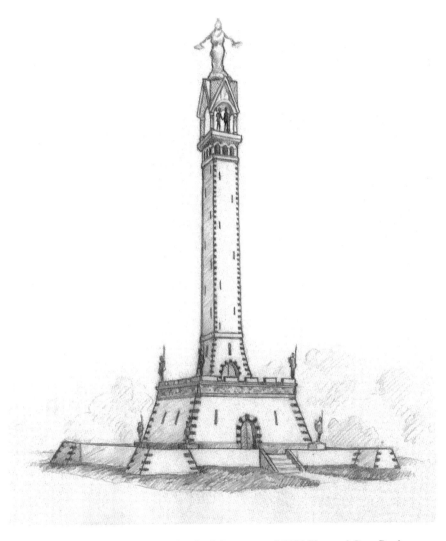

Artist Michael Dabrowa's graphite sketch of the proposed 1885 Blue and Gray Battle Monument illustrates the intended grandeur of the piece. *Courtesy of Michael Dabrowa.*

had been buried at West View but with no monument towering over them. Several other remains were in boxes awaiting burial.

On July 29, 1886, the Battle Monument association's executive committee met at the Atlanta Chamber of Commerce to discuss the matters concerning the untouched lot. West View's E.P. McBurney was in attendance and stated that the group had not had the lot surveyed, which

complicated the drafting of deeds, or given him any instruction on what to do with the property; he was not sure of the course of action to take, but he wanted work to begin.

After lengthy and sometimes contentious discussions that night, arrangements were made to have the matter addressed by the association's interment committee; those efforts eventually stalled and then ceased. In the end, Battle Monument Association leaders complained that the cemetery had not stipulated $10,000 had to be spent on the property within so many years when it was given to them and that it simply didn't have the money needed to carry out its plans. After a little more than a year of work, the project was abandoned and forgotten; the bodies at West View were reinterred elsewhere.

Unfortunately, the attempt to erect a monument commemorating fallen soldiers at West View would not be the only project to memorialize the Civil War to fail in Atlanta. From 1899 to 1910, members of the National Park Commission, Atlanta civic and business leaders and local and national politicians floated around the idea to create a national park commemorating the Civil War to be constructed on approximately one thousand acres along Peachtree Creek between Peachtree Road and the Chattahoochee River. From that park, a continuous highway system linking Peachtree Creek to where the Battle of Atlanta took place to the battlefield of Ezra Church was to have been constructed. But eventually, interest faded and money ran out.

Later in the twentieth century, however, successful plans were carried out to create Kennesaw Mountain National Battlefield Park to the north of Atlanta and to erect historical markers at various other locations around the city, including at the site of Ezra Church in Mozley Park and along the northern edge of Westview Cemetery.

In the summer of 1942, a bronze tablet commemorating the Battle of Ezra Church was unveiled between Sections 35 and 39 within West View under the auspices of the United Daughters of the Confederacy.[23] The tablet's content was written by Atlanta artist and historian Wilbur G. Kurtz, who was a co-founder of the Civil War Round Table of Atlanta and helped erect more than four hundred historical markers across northeast Georgia. He is probably best known as being a technical advisor and artistic director for the 1939 film *Gone with the Wind*.[24]

A CONFEDERATE MONUMENT

By 1888, burials in Atlanta's Oakland Cemetery had stopped unless they were for individuals who owned lots on the property. Confederate soldiers—who were advancing in age and health and seeking a proper place to be buried—were thus barred from the cemetery's Confederate section. Because of this, they began petitioning the Fulton County Confederate Veterans' Association to help them find a suitable, historic place to be interred with their compatriots. In response to the soldiers' requests, the veterans' association began negotiating a deal with the West View Cemetery Association to obtain suitable land.[25]

On October 2, 1888, Dr. Amos Fox, treasurer of the veterans' association, reported at an association meeting that a fifty-foot-square lot had been offered to the group for burials as long as a monument of at least $500 in value was erected on the site within two years. If the monument was not built, the lot would revert back to the West View Cemetery Association.[26] The land offered was on Battle Hill, the same spot on which the Battle Monument Association of the Blue and Gray had failed to build three years earlier.

Fox and fellow association member Judge W.L. Calhoun—both concurrently involved with *Atlanta Constitution* editor Henry W. Grady in building the city's Confederate Veterans' Home—were given the task of perfecting how the veterans' group would raise money for the Confederate monument. Starting that October, Fox began soliciting for contributions from people across the state, which eventually netted $360. In December, Fox came up with a raffle scheme where Atlanta citizens could buy tickets at local stores for a chance to win one of thirty-eight prizes from $5 to $100. In the spring and summer of 1889, two raffles were held, the first one alone raising approximately $1,000. By the fall, enough money had been gathered through these efforts and others to pay off the association's monument.

On November 5, 1889, Fox, Calhoun and others went out to West View Cemetery and formally accepted from hired contractors the completed, approximately twenty-foot-tall Confederate sculpture, which now stands in the cemetery's Trinity section. It consists of an infantry soldier wearing a great coat, which was carved in Carrera marble and shipped from Italy to Georgia, standing on a base of oolitic limestone, which was sculpted in Atlanta by artist J.J. Mullins over the course of six months.[27]

On the base are sculpted cannons and cannonballs upon which the soldier stands and cannons on each corner with their muzzles pointing downward. Between the corner cannons, a dedication ("Erected by the

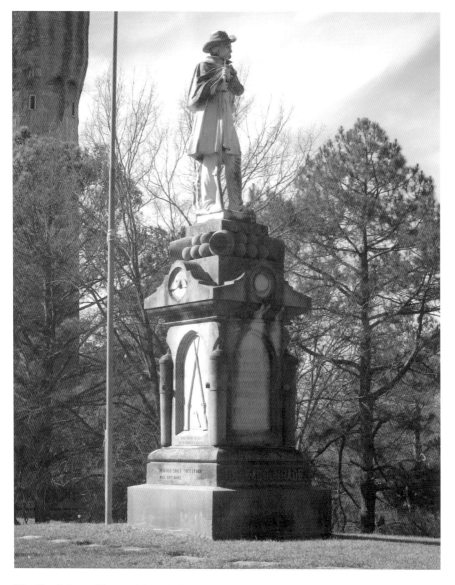

The Confederate Veterans' Association of Fulton County, Georgia, erected this monument in 1889 to honor their dead comrades. *Courtesy of Andrew P. Wood.*

Confederate Veterans' Association of Fulton Co. Ga. in Memory of Our Dead Comrades") and scripture ("they shall beat their swords into plough-shares and their spears into pruning hooks; nation shall not lift up sword against nation, neither shall they learn war any more") from

Isaiah 2:4 and Micah 4:3 are etched. Also carved on the base between the cannons is part of a stanza ("of liberty born of a patriot's dream of a storm-cradled nation that fell") from Major Sidney Alroy Jonas's poem "Lines on a Confederate Note."[28]

Accompanying those etchings are four symbols whose "meanings" were recorded in an 1890 history on the Confederate Veterans' Association of Fulton County.[29] Above the dedication is a carved serpent with his tail in his mouth, representing eternity and the "enduring devotion of the living for their dead comrades." An hourglass is above the monument's crossed swords and a plow. It represents the passage of time and "the coming of that time when the sword shall be superseded by the plow." Above the crossed muskets with bayonets and a pruning hook is a winged globe, which represents the divine, that peace will reign supreme and "that the time for their use in war will end." A butterfly symbol sits atop the Confederate battlefield grave scene. It represents immortality and suggests that "the dead shall rise from their graves in which the fortunes of war placed them."

During the last two months of 1889 and into 1890, final touches were added to the Confederate lot. Made by the American Marble Company of Marietta, twenty-five granite cannonballs resting in the mouths of granite cannons were placed in a circle around the statue, which spell out "Confederate Veterans Ground." To help partially pay for these and other improvements, Fox, through the Confederate Veterans' Association, sold white satin and gold-fringed Confederate souvenir badges at twenty-five cents apiece to the public and secured a percentage of ticket sales from the viewing of the Battle of Gettysburg cyclorama that was on exhibit in Atlanta at the time.

Other materials for the completion of the monument work were donated, such as crushed stone from the Venerable brothers of the Southern Granite Company for a circular macadam drive around the monument. In total, the entire monument cost approximately $5,000—$2,000 in actual money and $3,000 worth of donated materials and labor.[30] Over time, additional land, two mortar guns, a walkway from the edge of the grounds to the monument and a flagpole were added.[31]

Almost immediately after being erected, Confederate veterans were being laid to rest in an oval formation around the marble and limestone sculpture. In 1890, to identify those bodies, the Ladies' Memorial Society, which had also raised funds to have soldiers' remains moved from pauper graves around Atlanta to the Confederate lot, coordinated efforts to place marble markers above each individual grave. With the addition of bodies over time,

the effort to place gravestones over all 360 Confederate burials around the monument carried on into the twenty-first century; the United Confederate Veterans (UCV), the Sons of Confederate Veterans (SCV) and the United Daughters of the Confederacy (UDC) were all involved in the project.

Starting on April 26, 1939, and continuing into the 2000s, the Dorothy Blount Lamar Chapter of the UDC began hosting Confederate Memorial Day ceremonies around the monument at West View. The date, which commemorated General Joseph E. Johnston's surrender in 1865 to Union General William T. Sherman in North Carolina, had been declared a state holiday by the Georgia legislature in 1874. At these annual memorial ceremonies—where the UCV and SCV were oftentimes involved—wreaths were laid to honor fallen Confederate soldiers, new grave markers were dedicated, special guests were honored, high school and military bands would perform and gun salutes were staged.

While the Confederate monument is the only official one existing at Westview Cemetery today, it was not the last to be proposed. A month after the completed statue was accepted by Fox and Calhoun, Jefferson Davis, former president of the Confederate States of America, died in New Orleans on December 6, 1889. Immediately, the Fulton County Confederate Veterans' Association—which had met and corresponded with Davis before his death on various matters—along with West View Cemetery officials, offered a lot to Davis's family for his burial. They declined and had him interred in Hollywood Cemetery in Richmond, Virginia.

NEW VENTURES

In the first five years and three months of West View Cemetery's existence, 2,799 people had been buried and grounds had been landscaped—with a lake under construction, roads graded, a receiving vault built and a Confederate memorial erected—yet no physical office or building for the public to visit existed. To buy lots and arrange burial services, one went to the cemetery's office at 15 North Broad Street in downtown Atlanta. This, however, was to change in the summer of 1890.

On June 2, construction workers started building West View Cemetery's gatehouse, which still stands. Designed by architect Walter T. Downing of Wheeling and Downing, the approximately $3,900 Romanesque Revival structure was created to keep with the general plan of the cemetery, presenting a broad rather than high appearance.[32]

On the left side of the gatehouse is a superintendent's office, which is capped by a belfry. A twenty-three-foot-wide, twelve-foot-high, six-foot-thick arch connects it to a secretary's office and waiting room, which originally had an open-timbered roof and toilet rooms, on the right side of the structure. For years, the arch and surrounding offices became the cemetery's main entrance, where one would have to present a lot-owner card to be admitted into the cemetery.

The entire gatehouse structure is adorned in rough-hewn stone, which was quarried on site, and fitted with leaded windows, wooden doors and a 2,500-pound bell inscribed with "West View Cemetery Association 1890—McShane Bell Foundry, Baltimore, MD 1890." In addition to tolling for the

In this 1907 postcard, Westview's 1890 gatehouse is shown with ivy growing up its sides, which over time covered the structure. *Raphael Tuck & Sons' "Atlanta, Ga."*

dead, the bell would be used to summon workers on the grounds when they had a telephone call at the superintendent's office.

Over several decades, the appearance and function of the gatehouse changed. For years, ivy covered the structure. In November 1934, M.W. Newbanks & Co. was hired to construct an addition to each end of the original gatehouse. One of those additions eventually housed an office for eccentric Coca-Cola heir and one-time West View Cemetery owner Asa Griggs Candler Jr. Years after West View Cemetery owners went into the floral business, a florist shop replete with a plate-glass window operated from the structure. Eventually, the gatehouse was abandoned from everyday use in 1975.[33]

Sandwiched between the completion of West View's gatehouse and the creation of a new venture—the Westview Floral Company—were the rumblings of concerned parties asking Atlanta city officials to open a new cemetery; the five years promised by Atlanta city officials to West View organizers not to open a new burial ground when it was created had elapsed.

By 1890, the rising number of wealthy graves being erected at West View was not going unnoticed. Several Atlantans were complaining that plots there—between $16 and $400—were too expensive and that no poor person could afford them, and therefore, city officials should open a new, city-owned cemetery similar to Oakland Cemetery. As such, a two-year process to find and open a new burial ground began.

THE WESTVIEW FLORAL COMPANY

On March 17, 1891, West View Cemetery associates and others at Lowry Banking Co. in downtown Atlanta incorporated the Westview Floral Company. The new venture, with R.J. Lowry as president, J.S. Bigby as vice president, E.P. McBurney as treasurer, J. Burpitt as general manager and W.J. Burpitt as secretary, was started with $10,000 capital, with the privilege to increase to $50,000 capital.

The new company would grow flowers at greenhouses on West View Cemetery's property and sell them to lot holders and to the public from a showroom at 71 North Pryor Street downtown, as well as carry out contracted landscape gardening for wealthy residents and businesses. Its incorporators were hoping to establish the largest floral operation in the South and siphon off business that had historically been going to greenhouse owners in Washington, D.C.

Construction on Westview Floral Company's massive greenhouses at the cemetery—approximately two hundred yards southwest from the main gatehouse—and small hothouses at its Pryor Street store had started in the late summer and fall of 1890. By 1893, the company was boasting of a physical facility at the cemetery of more than 50,000 square feet of glass (roughly the size of a football field) covering a 150-foot-long rose house, a 100-foot-long fern house and another 100-foot-long greenhouse of smilax, coarser-fibered ferns, lilies, geraniums and various other flowers.

All of these plants were kept warm with an engine and boiler said to be seven times the capacity of the one used for the seven-story, three-hundred-plus-room Kimball House hotel in Atlanta. In fact, the greenhouses were so

Westview Floral Company's greenhouses were once the largest in the South. They were expanded in 1947, shown here. *Courtesy of The Westview Cemetery, Inc.*

impressive to the general public that West View Cemetery officials opened them for periodic tours, which caused streetcar companies to add additional cars and offer special routes to keep up with the demand.

In 1894, the Westview Floral Company started an advice column in the *Atlanta Constitution*, which ran for years. In it, "experts" from the company answered questions from local and out-of-state gardeners, provided growing tips and offered access to the company's flower and shrubbery catalogues and other services.

In addition to growing plants—and, later, trees—and offering advice to customers, company officials entered several floral competitions, winning numerous awards. They, along with competitors such as Edward Wachendorff and G.A. Dahl & Co., also provided flower arrangements and exhibitions for the city's Piedmont Exposition (1891) and Cotton States and International Exposition (1895).

For the Cotton States and International Exposition on October 22, the company was chosen to decorate the entire second floor of Atlanta's Hotel Aragon and a dinner table there that would seat 125 guests for U.S. president Grover Cleveland. The following day, the company provided decorations for Cleveland at a Tiffany & Co. engraved–invitation dinner at the prestigious Capital City Club; he was in town for two days to attend the exposition, meet educator Booker T. Washington and deliver an address. Though not carrying the same clout as Tiffany, the company later advertised: "The name of West View Florist on a box of flowers has the same meaning as Sterling on your silverware."[34]

Eighteen years after the Cotton States exposition in April 1913, arrangements between the Westview Floral Company (also now being styled as West View Floral Company and West View Florist) and the West View Cemetery Association changed. E.P. McBurney negotiated with the latter to lease the former's greenhouse and downtown store to R. Irving Gresham, a well-respected florist at the time connected with C.A. Dahl.

Per the lease, Gresham would manage the cemetery's greenhouse site along with its main circular entrance lot and anchor flower bed, which originally existed on a hillside in Section 4. Cemetery staff would also continue to have access and be able to use the greenhouses for their own purposes, which included everything from placing fresh flowers on graves at certain times of the year to creating and maintaining new plantings on family lots.

During Gresham's management, one of Westview Cemetery's most prominent, still-standing structures was built: a water tower. With its crenelated top, the approximately 110-foot-high, fifty-thousand-gallon tank, twenty-

Westview's water tower with its crenelated top was built in 1921. The walls around its base are from a later addition. *Courtesy of Andrew P. Wood.*

thousand-gallon settling basin reinforced concrete structure was built in 1921 at a cost of approximately $4,500; the octagonal wall currently surrounding the structure dates to a since-torn-down addition from 1947. A few years after the tower's construction, the U.S. Coast and Geodetic Survey placed a bronze, triangulation station disk (DG2675, N 33° 44.757 W 084° 26.677) on the top of the tower to be used for its national coordinate system.

In April 1922, it was announced to the public that Gresham had left Dahl's and purchased the entire holdings of "West View Florist." In this capacity, he would lead the company into the 1930s, witnessing West View Florist becoming one of the first businesses to open a shop within the newly constructed Fox Theatre complex in 1929.

After Gresham's ownership and into the 1950s, the greenhouses and property were managed by several different entities to vastly differing degrees and effects; flower shop manager T.A. Adrey, a 1916 horticulture graduate of the University of Beirut, Syria, and recognized as a leading grower in the United States, operated a floral shop from behind a plate-glass window in the cemetery's gatehouse in the early part of the decade. Eventually, however, new floral centers opening in Florida hampered West View's operational viability.

By the 1960s, Westview Cemetery officials were in complete control of the aging greenhouse structures. For a time during the decade, they ran a successful, professional planting service from the cemetery for clients such as Delta, Columbia Theological Seminary, Merchandise Mart, Macon Federal, First National Bank, Regensteins and Hilton. But by 1973, all greenhouse activities had been eliminated and the massive structures demolished.

Yet despite the greenhouses no longer existing, a plant accidentally discovered in them flourishes the world over: the Ilex cornuta "Burfordii."

THE BURFORD HOLLY

The Ilex cornuta "Burfordii," or Burford holly, once established, is an easy-to-care-for shrub or tree that grows to approximately fifteen to twenty-five feet tall with a diameter of about the same and has a symmetrical canopy. Known and prized by gardeners across the country for its glassy, dark green leaves with a single terminal spine, white flowers in the spring and long-lasting red berries (fruit) in the fall and winter, the plant was a "sport"—or mutation—discovered by the plant's namesake, West View Cemetery head gardener Thomas W. Burford.

Unlike the plant's taxonomy, which is generally agreed upon by scholars, facts about its creator are not. Depending on which historical documents are used, Burford was either born in 1851 or 1853 in England, the son of an English father and American mother from Virginia.[35] After working as a landscape gardener for Queen Victoria at Windsor Castle in the early

The Burford holly was discovered by the plant's namesake, West View Cemetery's head gardener Thomas W. Burford, around 1895. *Courtesy of Andrew P. Wood.*

1870s (his claim in numerous newspaper articles), he came stateside circa 1875 to the New York/New England area, where he found work in the floral trade. About twenty years later, he moved to Atlanta to work at West View Cemetery, following in the footsteps of the cemetery's first landscape gardener, Thomas Veale, and later gardener Professor Bellet Lawson, also an Englishman, in beautifying the grounds as well as cultivating them for wholesale nursery purposes.

Like its creator's path to Atlanta, the exact origins—date discovered, parent plant country of origin—of the Burford holly are murky. Most nurserymen agree, however, that the holly was discovered by Burford in 1895 soon after he arrived at West View. Burford received what was believed to have been Chinese holly seedlings from William R. Smith, who at the time was the superintendent of the Botanical Gardens in Washington, D.C. On one of those seedlings was a "sport," which Burford propagated.

Of the three "mother" plants that Burford created, none still exist. And if it were not for other nurserymen, the Ilex cornuta "Burfordii" might have disappeared altogether. According to G.S. Lilly, who worked with Burford

and was head gardener at Westview in the 1950s, Burford was vigilant in seeing that his plants were not sold, only gave a few cuttings away and took pleasure in refusing even a stem to requestors.

It is also through Lilly that one gets a last account of Burford before he disappears from the historical record. In a 1954 *Atlanta Journal-Constitution* magazine article, Lilly states Burford was a bachelor of medium build, with a long mustache and beard, who would only get a haircut once every three years.[36] He added that Burford was well read and a trained botanist who confined himself to one room in a ten-room home, devoted little time to making friends, often contradicted himself in conversations and liked flowers more than the holly that he created and that would eventually bear his name. Lilly also gives the last details to be found of Burford's life: that he lived to be an old man, eventually boarding with a couple that cared for him in Dallas, Georgia.

Like that of the man, the story of his holly's path to the nursery for sale to the general public is inconclusive and disputed. The most widely shared and agreed upon account is that S.R. Howell, a prominent nurseryman from Knoxville, Tennessee, who visited West View's greenhouses in 1931, saw Burford's holly, selected cuttings and propagated them back in Tennessee. Within a couple of years, he was selling them from his family's nursery's catalogues.

A lesser-known account is that of W.L. Monroe, proprietor of Monroe's Landscaping & Nursery Company in Atlanta. Monroe states in private Westview Cemetery documents that prior to going into business for himself, he had worked for the C.A. Dahl Floral Company, whose officials in 1919 pressed Burford to sell them a plant to cultivate. In respect for Burford, they would name the cloned plants in his honor.

Purportedly, Burford finally relented in 1920 and sold Dahl representatives a holly plant for thirty-five dollars. That plant was then propagated by Dahl employee "Uncle Bill" Rimpson and made for sale to the Atlanta public. Not long afterward, it was catching the eye of nurserymen from across the United States who were interested in procuring plants and cuttings of their own.[37]

What is not contested is that the U.S. National Arboretum received the holly as an accession—identified as the Burford holly (Ilex cornuta "Burfordii")—from an unknown source in 1937–38. The plant remains a popular cultivar of holly today.[38]

WITH A NEW GATEHOUSE and the successful launch of the West View Floral Company, West View officials continued to expand the cemetery's physical facilities, completing a small lake north of its receiving tomb in 1891 and building within a year after that a superintendent's home for $3,250, both of which no longer exist. Additionally, over the course of those two years, four thousand feet of temporary water lines and pipes with hydrants were installed; over subsequent decades, water pipes with faucets were laid throughout the cemetery for use by lot holders to water flowers or plants around family graves, but they were eventually removed from the grounds.

In 1892, Atlanta mayor pro tem Augustus M. Reinhardt, founder of what would become Reinhardt University, met with city council and, after debate among many parties, agreed to allow in Atlanta's Oakland Cemetery the selling of lots in previously unoccupied space. This decision by Reinhardt to "reopen" Oakland, which had not sold lots since West View's establishment, coupled with the opening of Hollywood Cemetery, created new competition for West View.

Founded by Dr. W.A. Baker, an owner of the Atlanta and Chattahoochee Railway Company, the Hollywood Cemetery Company was organized and incorporated on October 14, 1890, for $25,000 with eighty-four acres on the northwest side of Atlanta. Officially opened for business by 1892, lots were being sold for $12.50, payable $1.50 cash and $1 per month until the balance was paid in full. This payment structure was different, generally cheaper and in direct competition with West View's payment policies.

Yet while Hollywood Cemetery offered affordably priced lots located conveniently on a trolley line in pre-automobile Atlanta, its management ran into financial difficulties soon after it opened. By 1897, the Hollywood Cemetery Company was in the hands of a temporary receiver after the company had become insolvent. Thus began a more than two-decade struggle to keep it afloat.[39] Company directors eventually placed the property into a trust.[40]

Despite these setbacks, Hollywood continued for years to siphon sales away from West View. Today, it poses no threat, as it is completely abandoned and derelict. Other cemeteries, nonetheless, would be established to later challenge West View's market dominance, such as well-known Greenwood Cemetery in 1904, Atlanta Park cemetery in 1913 (later known as North

View Cemetery, Crestlawn Cemetery, Crown Hill Cemetery and Crest Lawn Memorial Park) and Arlington Cemetery in 1922.[41]

In 1892, however, to address the complaints that West View Cemetery's lots were too expensive, as well as the reopening of sections in Oakland and the opening of Hollywood, West View officials opened two new sections: 7 and 8. Section 7 was primarily made up of family plots, though it would later contain a lot for the Jennie D. Inman Orphanage. Section 8 consisted of more than two hundred single adult graves and nearly five hundred children's graves. Both were priced more reasonably than other sections had been in the past.

Four years later in 1896, West View Cemetery was being described more like a well-taken-care-of manicured park rather than a city of the dead. Approximately seven miles of roads intertwined throughout more than four thousand graves, which were surrounded by Bermuda grass; weeping beech, maple and mountain ash trees; and large flower beds. To maintain all of this was a crew of over fifty men who worked five horses whose carts, lawnmowers and wagons were housed in a "Yankee-style" barn on the property. Those animals were also used to plow fields on the grounds to raise crops, particularly grain for them to eat.

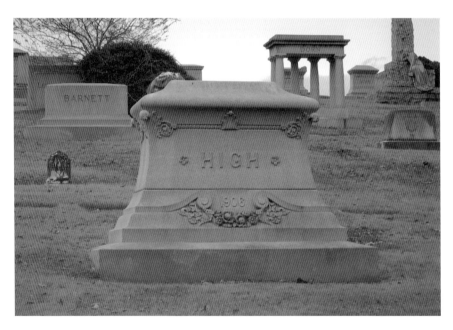

The grave of Harriet Harwell Wilson High and J.M. High in Section 4. Atlanta's High Museum was named in her honor. *Courtesy of Andrew P. Wood.*

It also was in 1896 that one of several noted sculptors' works that now reside within the cemetery was unveiled in Section 4: an Italian marble headstone carved by George G. Crouch for Mary Frances Grier. Grier, wealthy in her own right, was the mother of Harriet Harwell Wilson High, who was the wife of J.M. High of the J.M. High Company dry goods. It was Harriet High who donated her mansion in 1926 to the Atlanta Art Association, and it became the High Museum of Art.

Crouch, who had done commissions for the Vanderbilt family, ornamental work at the Georgia capitol building and numerous other projects, sculpted for Grier out of Italian marble a monument covered with ivy vines, tassels, a wreath of flowers tied with ribbons, drapery and other items. Adjoining the monument at the foot of the grave was a Crouch-sculpted vase; its cover has long been missing.

A year after Grier's death, West View workers buried Mina Von Jeweitska Zeldieka on March 18, 1897, in Section 3's single graves section. Depending on dubious accounts, she was a Russian countess.[42] Per her request, Zeldieka's heart had been punctured to prevent being buried alive before she was wrapped in a white velvet gown and placed into a white velvet-lined casket. Her remains were then carried to the cemetery in a hearse drawn by white horses, and she was laid to rest, again per her instructions, in an unmarked grave.[43]

Two years after Zeldieka's death, West View Cemetery's association ended the first full fifteen years of operations. By the end of 1899, more than 5,300 Atlantans had been buried on the expansive grounds of the property, which contained a booming floral business, a working farm and plenty of space to expand. Atlanta's premier cemetery was only in its infancy.

DYING TO GET IN

For West View Cemetery, the dawning of the twentieth century posed no new, sweeping changes to management or its physical property. A decade and a half of interments and successful operations had squarely placed the necropolis at the apex of preferred burial properties within the city of Atlanta.

The reopening of land for sale at Oakland Cemetery and the opening of Hollywood Cemetery, both in 1892, had temporarily impacted sales at West View, but its management, recognizing the need for more affordable lots, opened newer sections priced to allow a wider swath of citizens access to the sprawling acreage for the dead. Over the next several decades, burials from common to the uncommon occurred.

Most of these burials received little newspaper coverage with the exception of an obituary notice. That, however, was not the case of the burial of Sophie Kloeckler on June 1, 1904, in Section 9. Kloeckler had been found floating dead in the lake at Atlanta's Lakewood park. Some said she had been murdered—sexually assaulted, choked to death and thrown into the lake—yet others claimed she had committed suicide.

After she was buried, exhumed, examined, autopsied, reburied and the subject of numerous *Atlanta Constitution* articles to satisfy not only inquests from the public but also Georgia's governor and other leading lawmakers, the *Atlanta Constitution* hired the famed Pinkerton Detective Agency to come to Atlanta to try to find the cause of Kloeckler's death. After a two-week investigation, Pinkerton concluded she had not been murdered but could

not state definitively if she had died by accidental drowning or suicide by poisoning. Rumors were that she had been engaged to one man but was in love with another.

Between the "normal business" of death at West View, the cemetery association's secretary and general manager, E.P. McBurney, in 1906 had four small cottages built on the property for around $450 each. The new houses would join six older ones to house cemetery workers and their families.

The following year, the West View Cemetery Association established a perpetual care fund for the cemetery, excluding its Rest Haven and God's Acre sections. When the cemetery was established, plans to set aside 20 percent of lot sales for the maintenance of the property had been discussed. Those plans, however, were never carried out. In 1891, cemetery officials tried a perpetual care plan on one hundred acres set aside for such purpose; that venture proved to be successful, but it would be another sixteen years before the plan was carried out in full scale at the cemetery.

In March 1907, West View's governing association set up a committee to look into perpetual care for all future burials. Two months later, a resolution was passed to start such care, with $1,000 to be invested in an Atlanta City Bond bearing 4 percent and due in 1933. The fund was to be governed by a board of trustees, and interest from it was to be paid yearly to the secretary/treasurer for West View's needs.

Official paperwork for setting up the perpetual care fund was filed with the Fulton County Superior Court in July; the plan was approved by a judge on September 12, 1907, and filed by a clerk the next day. Though in a different form and with a diversified bond portfolio, Westview Cemetery's perpetual care plan still exists to this day.

The year after cemetery management started a perpetual care fund, it purchased a horse and wagonette for use by patrons. In 1908, Atlantans with lots at West View could now ride trolleys from town out to the cemetery and, once there, pay five cents apiece to be driven to their family's plots instead of walking the vast grounds, a difficult task for the elderly or infirm. Three years later, lot owners would be allowed to drive their own automobiles in the cemetery as long as they had a permit issued by E.P. McBurney. Within eight years of purchasing the horse and wagonette, the cemetery had replaced them with an automobile of its own and issued more than one thousand driving permits to lot owners.

On July 5, 1908, West View's greatest literary star, Joel Chandler Harris, was laid to rest in the cemetery. Having died two days earlier, the journalist, fiction writer and folklorist, who was best known for his Uncle Remus and

Brer Rabbit stories—and who was rivaled only by Mark Twain in popularity at the turn of the century—drew hundreds of people to West View Cemetery to stand in the rain for his Catholic burial service. Two years after his death, his son, Julian, selected and designed a boulder to mark his grave.[44]

Four years after Harris's death, West View officials opened Section 12 in 1912. The cemetery now had a total of more than eleven thousand interments and nearly four thousand pauper graves opened in God's Acre. Financially, the cemetery had a small fortune on hand with more than $31,000 in its coffers that January.

Also in 1912, Victor H. Kreigshaber, of the building and contracting firm V.H. Kreigshaber & Son, approached West View management as chairman of a special cemetery committee looking for between five and ten acres to buy exclusively for a local Jewish congregation. Unlike a request for similar property in 1889, West View representatives this time told Kreigshaber the cemetery was no longer selling large tracts of land to congregations and organizations, even though two decades later, under new management, a Catholic section would be opened.

As a result of West View's denial to Kreigshaber, Jewish congregations funneled their deceased to Jewish sections at Greenwood Cemetery, opened eight years earlier in 1904, and Atlanta Park cemetery, which would open in 1913. Both still exist, the latter now known as Crest Lawn, and compete directly with Westview for lot sales to this day.

The year that Atlanta Park cemetery opened, Jesse Parker Williams—a lumber and railroad magnate and president of the Florida, Georgia and Alabama Railroad—died and was buried in West View. Williams's wife, who would die eleven years later and make history in her own right when she took over as president of her husband's railroad, erected on their grave site the most famous sculpture in West View Cemetery: *Achievement* (the Williams Memorial). The monumental Tate, Georgia marble sculpture is of a woman with outstretched arms resting on pillars, one hand holding a winged globe, representing the divine, and the other grasping a laurel wreath, representing immortality. It was created in 1914 by noted sculptor Daniel Chester French, along with collaborator and architect Henry Bacon, and carved and completed in 1917 by the Piccirilli Brothers.

French, Bacon and the Piccirilli Brothers would go on to garner international acclaim for their work on the Lincoln Memorial in Washington, D.C.; specifically, French was noted for his design of Abraham Lincoln, Bacon for creating the building to house Lincoln and the Piccirilli Brothers for actually carving Lincoln in Tate, Georgia marble.[45]

Rivaled in his day only by Mark Twain, author Joel Chandler Harris's grave is marked by this granite boulder. *Courtesy of Andrew P. Wood.*

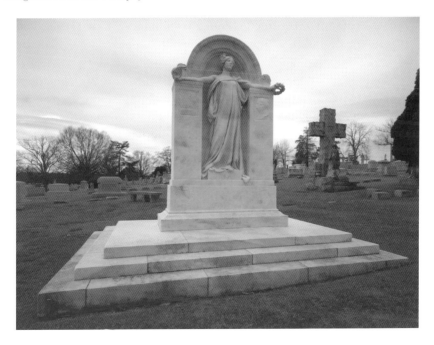

Created by Daniel Chester French, *Achievement* is Westview's most celebrated monument. French also created Abraham Lincoln for the Lincoln Memorial in Washington, D.C. *Courtesy of Andrew P. Wood.*

Three years after Williams's death, Thomas Egleston died. Involved in the insurance and banking businesses, as well as being involved with West View's secretary and general manager E.P. McBurney's Empire Cotton Oil Company and a director of the cemetery's association, Egleston is remembered most for bequeathing in his will $100,000 to create a children's hospital, which was to be named after his mother: the Henrietta Egleston Hospital for Children.[46]

At around the same time *Achievement* was completed for Jesse Parker Williams, Egleston's Tennessee pink marble cross by the Albert Weiblen Marble & Granite Co. of New Orleans was hoisted into position in Section 5 and surrounded with a matching exedra. It and *Achievement* stand today as two of the most recognizable monuments in Westview.

In complete contrast to these two monumental works is a single grave with a simple, flat monument in Section 8.[47] In it lies Adrien Esmilaire, known to the public as Little Mabb—a "midget," standing only twenty-seven inches tall.[48] In Atlanta while performing at Lakewood park with the Johnny J. Jones Exposition, Esmilaire became sick. He later died on October 18, 1918, at the Davis-Fischer Sanitarium (now Emory University Hospital Midtown) of the Spanish influenza and was buried the following day at West View.[49] For years afterward, a delegation of former friends and coworkers would make a special trek to Esmilaire's grave when they were in town, including the "Siamese Twins" and French "midgets."

Esmilaire's death is one of but a few at Westview that can be traced to the Spanish influenza outbreak of 1918. An inscription on the cemetery's 1888 receiving vault that was added in 1951 states: "Great service to the community was rendered by this vault during the winter of 1917–1918 when Atlanta's Influenza epidemic claimed hundreds of lives. Victims were brought here awaiting burial." Many have suggested these lines indicate that hundreds of victims were brought to Westview, stored in the vault and then buried on the property. Unfortunately, the dates are wrong. The Spanish influenza pandemic hit Atlanta in late 1918 and early 1919, not a year earlier, as recorded. Additionally, the number of flu victims buried at Westview during 1918 and 1919 mirrors those in the years immediately preceding and following them that died of various other flu strains.

A little over a year after Esmilaire's death, John Sherlock died on November 12, 1919; his grave would eventually house one of Westview's more ornate monuments: an angel on a pedestal flanked by porcelain plaques adhered to the monument's stone of him and his wife, Minnie.[50]

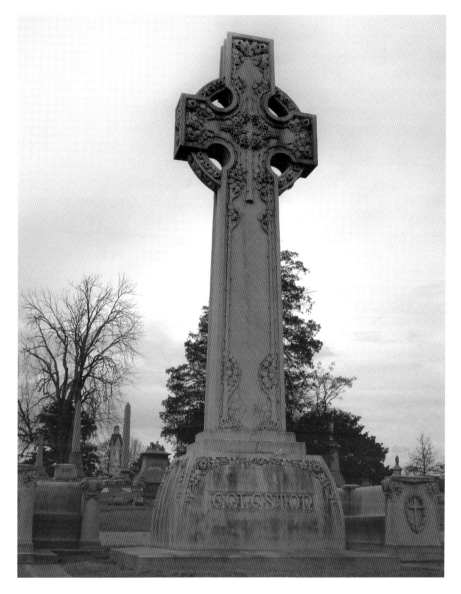

Thomas Egleston's cross and exedra reside in Section 5. The Egleston Hospital for Children was named in honor of his mother, Henrietta. *Courtesy of Andrew P. Wood.*

Of interest, however, is not so much the monument that marks his grave but the fact that he was not buried until April 28, five months after his death, because of a custom significant to a group he belonged to: the Irish horse traders.

Irish Horse Traders (Irish Travelers)

Irish horse traders, also known as Irish travelers or, pejoratively, gypsies, came to the United States from Ireland sometime between the latter half of the Irish potato famine, circa 1850, and before the outbreak of the American Civil War in 1861. As a group of about fifty individuals that consisted mainly of the O'Hara, Riley, Darty, McNamara, Gorman, Sherlock, Carroll and Costello families, they settled in Washington, D.C., where they set up a livery stable business and operated it with moderate success. City life, however, was not for the traders, and as such, under the leadership of patriarch Pat O'Hara, the group sold their business and headed south.

By the early 1880s, the families of horse traders had discovered Atlanta; Nashville, Tennessee; and Fort Worth, Texas, as places to headquarter different sects of their families. For the families such as the McNamaras, O'Haras and Sherlocks, Atlanta was chosen to be the epicenter of their activities, partly because it had Roman Catholic priests, who were not terribly common in other areas of the South at the time, but also because it had bustling rail and livestock yards.

In the fall, the traders would buy their livestock at auction and then travel into South Carolina, middle and south Georgia, Alabama and parts of Mississippi to sell horses and mules, the latter making up to 90 percent of their trade. Originally, the families traveled from town to town by horse and buggy, but once the automobile rose to prominence, the horses and buggies were replaced with expensive cars and trailers.

When the families reached a town or area where they wanted to do business for an extended period, they would set up camp, populating them with two-room tents, measuring twelve by fifteen square feet a room, which were carpeted with fresh straw and outfitted with real furniture, such as mahogany four-poster beds replete with store-bought mattresses. And while cooking stoves and "kitchens" were set up outside, the families ate on Havilland china.

These camps were almost always closed off to outsiders, except for business. The Irish men, women and children who populated them were related almost exclusively by blood or marriage, often lacked formal schooling and spoke in a southern English dialect peppered with an Irish brogue. While men tended to livestock transactions within the camp or elsewhere, women often garnered additional income for the family by bartering handmade lace with farmers' wives for eggs, chickens, hams, jellies, butter, vegetables and

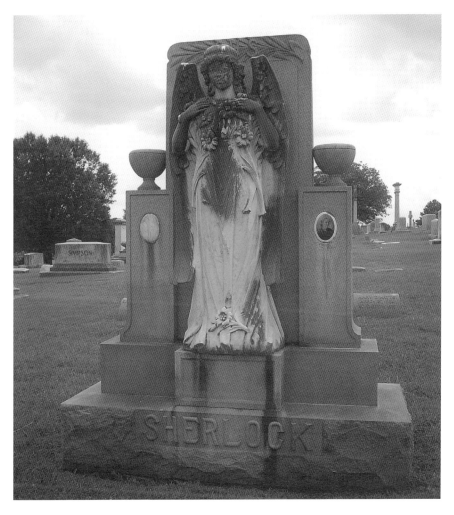

The grave of John Sherlock and his wife, Minnie; both were Irish horse traders, a group that had mass burials once a year at Westview. *Photo by the author.*

other items. Most girls within the camp were married by sixteen and the boys by eighteen or nineteen.

Every April, despite how far families had spread into the South for business, they all came back to Atlanta for once-a-year funerals, a practice that had started as early as 1881. That year, one of the Irish horse traders, John McNamara, died while in town. His family bought burial lots at Oakland Cemetery. Three years later, when Oakland Cemetery was full and no longer selling plots, the Irish traders wanting to bury their dead in Atlanta

turned to the newly opened West View Cemetery to acquire burial grounds. Over time, they would amass numerous family plots in Sections 5, 7 and 10, often erecting some of the cemetery's most elaborate monuments, primarily consisting of sculpted angels.

While the details of the traders' annual spring visits to Atlanta varied over the years—from staying at a camp with 150 to 200 tents at the intersection of Bellwood Avenue and Ashby Street (now Donald Lee Hollowell Parkway and Joseph E. Lowery Boulevard) to lodging in later years at the Cherokee Rose Court or Dogwood Tourist Court on Northside Drive—a mass funeral was always held on April 28 at the Church of the Immaculate Conception (now the Catholic Shrine of the Immaculate Conception). Following the funeral service, a procession of coffins filled with the deceased would wind its way through the streets to West View, where the deceased would all be buried on the same day.

From the 1910s to the mid-1940s, those buried were individuals who had usually died in cities scattered throughout the South and had then been shipped to Atlanta for temporary storage by mortician Edward F. Bond Sr.; he was an owner of Greenberg & Bond Funeral Home, which later became Brandon-Bond-Condon Funeral Home and was bought by the West View Cemetery Association in 1944.

By some accounts, it was Bond who kept alive the annual funeral tradition of the Irish horse traders. By his death in 1950, he had been the subject of a *Reader's Digest* article on the group and had been sought by movie companies to serve as a technical advisor for films they had planned on the nomadic traders.[51]

After the funerals and burials on April 28, the Irish did not simply mourn; they celebrated life. In the days following interment services at West View, mass engagements and weddings took place, barbecues and dances were held and business deals were done throughout Atlanta before the traders once again took to the road. Their nomadic way of life, however, was not to last.

The Depression of the 1930s and the rise in new farming technology, specifically the tractor, would put an end to horse and mule trading. By the 1950s and '60s, the Irish had begun to settle down and ply other trades, such as floor-covering salesmen, contract painters and construction laborers. By the end of the 1960s, burials at Westview had petered out. By 1970, the horse traders, now referred to as "travelers," had settled in Murphy Village, a still-active enclave of the group just outside North Augusta, South Carolina.

THE McBURNEY ERA (1884–1930)

INTO THE 1920s AND within four years of burying John Sherlock, West View personnel opened Sections 15 and 16, paved numerous roads throughout the cemetery, built a concrete dam and sluice for waterworks and adopted and reincorporated the West View Cemetery Association for another twenty-year period.

The association had incorporated in 1884 and again in 1904, amending its charter very little over the years. The biggest change over the past four decades of operation had been an amendment to the charter in 1907, when each stockholder was granted as many votes as he had shares. In 1924, the only amendments to the charter were to limit the height of foot markers to six inches and to allow for no duplicated family monuments throughout the cemetery.

By 1925, the City of Atlanta was abandoning the use of West View's God's Acre section for pauper burials and opting for other sites. In 1924, only 46 pauper graves had been sold to the city, and in 1925, only 2 were sold—the last 2 ever purchased. Over forty years, West View workers had buried 5,153 city paupers in God's Acre and more than 19,500 burials on the whole of the cemetery's grounds.

It was also in 1925 that E.P. McBurney made it known to West View's board of directors that trouble was brewing. The U.S. government was pressing cemetery management for payment of back taxes for the years between 1916 and 1921. McBurney and the cemetery board fought the matter for two years until finally hiring the Washington law firm of Williams, Meyers, Quiggle and Breeding to assist them in settling the matter with the government in October 1927.

The month prior to settling, Atlanta real estate developer Frank Adair approached the West View Cemetery Association to see if it would be interested in selling him the cemetery. It is unclear if the matter of unpaid taxes aroused Adair's interest in the prospect and prompted the cemetery board to consider his offer, but the board mulled over the proposal well into the spring of 1928. The board had also considered a buyout from the Trust Company of Georgia, but the bank declined to move forward with a purchase, indicating to the board in March that it felt no profit could be made in acquiring West View.

Eventually, Adair's offer was pulled from the table, and cemetery staff carried on with the day-to-day operations of West View—laying out Section 17, starting work on Section 18, purchasing a new automobile to drive

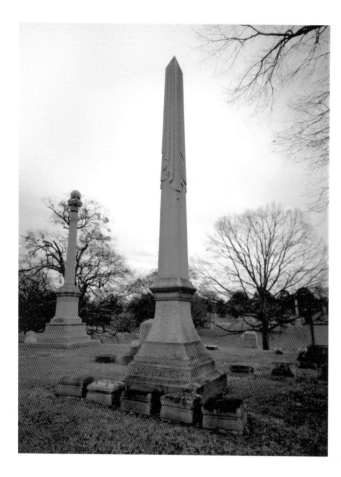

Coca-Cola founder Asa Candler Sr.'s grave is marked by a large obelisk, surrounded by "pillow" markers, Victorian-era symbols of eternal rest. *Courtesy of Andrew P. Wood.*

people to and from family plots, banning rock-face and artificial rock work from monuments and electing the first female, Pauline Sloman, to serve the cemetery's board as assistant secretary and treasurer.

Funerals, too, continued as they had. A little over a year after Adair's offer to buy West View Cemetery, business tycoon, Coca-Cola founder, former Atlanta mayor and Candler Park namesake Asa G. Candler Sr., seventy-eight, was interred in a simple service on March 15, 1929. He had died three days earlier. His second son, Asa Candler Jr., was soon to play an important and transformative role in West View Cemetery's history, forever altering Atlanta's largest necropolis.

Part II

THE CANDLER ERA
(1930–1952)

CHAPTER 6

THE ADAIR AFFAIR

On August 30, 1930, ten months after the start of the Great Depression, the West View Cemetery Association announced to the public the first significant changes in its management's history since the cemetery had been founded forty-six years earlier. No longer was E.P. McBurney, secretary and general manager, helming the institution. After trying to purchase the cemetery three years earlier, Atlanta real estate mogul Frank Adair was now in charge of the property. His ascension to the position had started several months earlier and had been backed by Coca-Cola scion Asa Candler Jr., who had buried his father a year earlier at West View and was looking for real estate investment opportunities.

Three months before Adair was announced president of West View and his brother Forrest Jr. as vice president, the West View Cemetery Association had a board of directors meeting on May 23, 1930, where the association's then-president, businessman J. Carroll Payne, discussed the board selling all of its stock through the brothers to new investors. Less than ninety days later, that happened.

On August 20, Asa Candler Jr. called to order a meeting of the new stockholders of West View. All 2,000 shares of the company had changed hands, with Candler holding 250 shares; his second wife, Florence, holding 250 shares; his Briarcliff Investment Company holding 1,300 shares; and two other individuals splitting the difference.

At the same meeting, Candler announced that all former directors of West View had sold their stock and were no longer associated with the company,

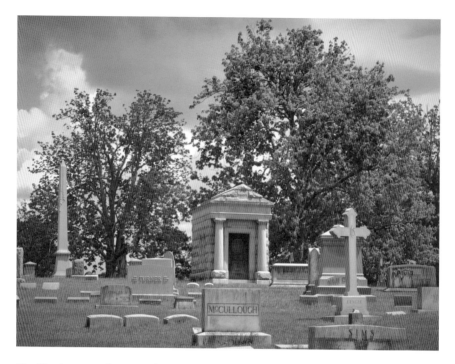

The Hawkes mausoleum stands as a sentinel over Section 1, which was well established when the Adair brothers took over West View's operations. *Courtesy of Andrew P. Wood.*

including West View founder McBurney. In their places were Candler, who was that day elected as the cemetery's new board president, his wife and other family members and associates as new directors. Other business was discussed about the future of West View, and new bank accounts were set up at Citizens and Southern National Bank.

Five days later, on August 25, West View's board of directors met again at the direction of Candler, who stated that the purpose of the meeting was for the disposition of securities held by the West View Association. At the meeting, the group decided to sell four hundred shares of Coca-Cola Class A and one hundred shares of Georgia Power Company preferred stock.

The following day at a West View stockholder meeting, two thousand shares of capital stock of West View were represented by Frank Adair, acting as an officer of the West View Holding Company. At the meeting, Candler announced that his Briarcliff Investment Company had sold its stock of West View and he, his wife and other directors of West View had resigned. Immediately, those present unanimously elected Adair, his brother and three others to act as new West View directors.

Moments after the August 26 stockholder meeting, the group held a board of directors meeting. In it, a motion was made that a dividend be declared payable to the stockholders of record on the day before of all quick assets equaling $106,958.66. Following that motion, Candler resigned as president of West View, and Frank Adair was elected to the role in his place.

As notice was made to Atlantans about the new management structure at West View, they were informed that there were no changes in cemetery policies. The new staff was simply seeking to enhance the cemetery grounds with new roadways—1.5 miles of concrete instead of asphalt installed—and general groundskeeping measures, such as the installation of new water lines and storm drains.

One of the first major additions beyond general enhancements at West View that the Adairs did came within six months of their taking over the cemetery. In February 1931, they committed to Right Reverend Michael J. Keyes, Roman Catholic bishop of the Diocese of Savannah, to set aside two sections—Sections 31 and 32—exclusively for Roman Catholic and their non-Catholic family members' burials.

One of Atlanta's leading Catholics, Havertys furniture company founder J.J. Haverty, who is buried in a private family mausoleum at the northeastern corner of Section 31, was on the church committee formed to pick out the sections and ensure they were suitable for Catholic burials.[52] Despite the original religious restrictions on both sections, cemetery deregulation over the latter half of the twentieth century resulted in them being opened to interments regardless of religious affiliation.

In 1931, while the Adairs were making improvements at West View, small indications started to appear that business might not be going as well as the duo had hoped. Over the year, advertisements showing the continual dropping of lot prices from $200 to $190 to $170 were appearing in newspapers to entice buyers.

In February 1932, Frank Adair moved the West View Cemetery Association's office from the Candler Building to the Healey Building in downtown Atlanta. This was done to reduce overhead and streamline its office operations with that of his family's Adair Realty and Loan Company as a result of the disposition of a family member's will.

By 1933, the Great Depression was in full swing and affecting business profits across the country; the Adair brothers' businesses, including West View, were not immune. While people were still dying and needed to be buried, many families could no longer pay for grand funerals or elaborate grave monuments.

A view of J.J. Haverty's mausoleum in Section 31, originally one of Westview's Catholic sections. Haverty founded the furniture giant Havertys. *Courtesy of Andrew P. Wood.*

As such, in June 1933, the Adairs were reporting net losses for West View and were seeking to borrow $565,000 in exchange for a mortgage or security deed to be given to the lender. By December, it was over for the two brothers. On the thirtieth of that month, Frank and Forrest Adair relinquished control of West View, resigning as directors and officers of the company. Asa Candler Jr. would take full control of the cemetery and usher it into its golden age.

"BUDDIE" CANDLER

Eccentric Coca-Cola heir Asa Griggs "Buddie" Candler Jr. was born on August 27, 1880, eight years before his father bought the formula for Coca-Cola from pharmacist John Pemberton and turned it into a global empire. Candler—not the businessman his father was, or even that of his older brother, Charles William, who would become president of his family's business after his father stepped down—would never helm the operations of Coca-Cola, but he would those of West View Cemetery.

After being educated at Emory College in Oxford, Georgia, which would later become Emory University, after a move to Atlanta due in part to his uncle, Bishop Warren Akin Candler, Candler was stationed in Los Angeles to help drive sales and build up Coca-Cola in California. It was rumored, however, that he spent more time drinking and visiting pool halls than running the business; he was by his own admission an alcoholic until having a religious awakening later in life.

Without success in California, Candler was brought back to Georgia by his father to run his newly purchased business venture Witham Mills in Hartwell, Georgia, approximately one hundred miles northeast of Atlanta. It was there that Candler met his first wife, Helen Magill, who was the daughter of a local newspaper editor. Ultimately, Candler was unhappy managing Witham Mills and returned to Atlanta in 1906, where he settled down for good and successfully managed various real estate enterprises for his father. With Helen, Candler had seven children, five of whom survived into adulthood, before she passed away in January 1927.

After Helen's death, Candler married his longtime secretary, Florence Adeline Stephenson of Lithonia, Georgia. Within two years of their marriage, Candler's father had died, and Candler, who had long since inherited money from him, divested himself of his father's business interests and went out on his own, acquiring real estate across Atlanta. Over the course of his life, he would own more than thirty apartment buildings and several hotel properties, including the Briarcliff, Clermont and Robert Fulton hotels. It was not, however, his hotels that brought him notoriety, but rather his varied interests and own home, Briarcliff.

Candler was an avid yachtsman, car and aviation enthusiast and big game hunter. His twenty-two-room mansion located on Briarcliff Road in Atlanta boasted a 1,700-square-foot music room, DeOvies Hall, which contained what was billed as the eighth-largest Aeolian pipe organ in the world; an animal menagerie, complete with elephants that he used at one point to clear land for a kitchen garden; and two swimming pools: one for his family and the other open to the public. He would also operate a laundry business from the mansion's property. Eventually, lawsuits involving an escaped baboon from his private zoo that stole and ate sixty dollars from a neighbor's pocketbook and a devastating fire to the laundry business ended the two ventures.

It was, however, during the time of his mansion's heyday that Candler turned his attention to West View Cemetery. For nearly eighteen years— before dying and leaving a will estimated at more than $2 million to his wife and children in 1953—Candler would take control of the cemetery's operations (his wife, Florence, running the office) and begin to reshape it, at times with the same eccentric and over-the-top embellishments he was known to carry out at Briarcliff.

Though Candler had orchestrated Frank and Forrest Adair into roles in 1930 that would allow them to run West View Cemetery for three years while he remained in the background, it was clear by December 1933 that their time had passed; he decided that he should come to the forefront and take complete control of the company.

In a January 27, 1934 stockholder meeting, Candler, acting as chairman, officially accepted the resignations of the Adair brothers. In the same meeting, Candler; his wife, Florence; another family member; and two other associates were elected as directors of the cemetery. Additionally, new bylaws were passed giving the chairman and president a yearly salary of $3,600 apiece and the president the right to remove any officer or employee of the organization at his discretion.

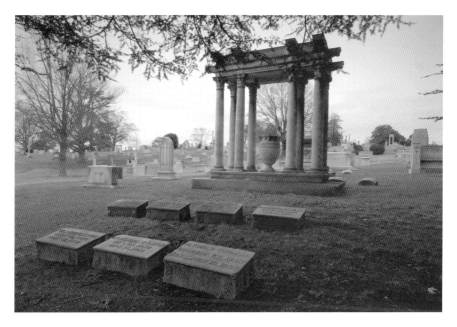

Several ornate monuments in Section 5 existed prior to Asa Candler Jr. taking full control of West View during the Great Depression. *Courtesy of Andrew P. Wood.*

Almost immediately, Candler and the new directors of West View tried to reverse the financial course of the cemetery; an immediate decision was made to sell a triangular piece of property across the street from its entrance for $2,000 to help defray outstanding costs. Candler also cut cost by getting rid of rent for the cemetery association's office by moving it back to the Candler Building from the Healey Building in Atlanta, where Frank Adair had moved it two years earlier.

By November 1934, Candler wanted to further cut costs and consolidate all of the cemetery's operations onto the physical grounds of West View, eliminating the association's downtown office. To that end, he proposed to the board of directors that M.W. Newbanks & Co. be allowed to construct office additions to West View's 1890 gatehouse. The board agreed to the plan, and in 1935, two additions, whose stones closely match the original structure's, were added—one on the south end, which would contain an office for Candler, and one on the north end.

Within a year of the additions, the cemetery was starting to turn a profit. By that point, the Salvation Army had purchased a large plot in Section 25, which would be used to bury Salvationists from across the Southeast. On September 18, 1936, a large stone engraved with the Salvation Army crest

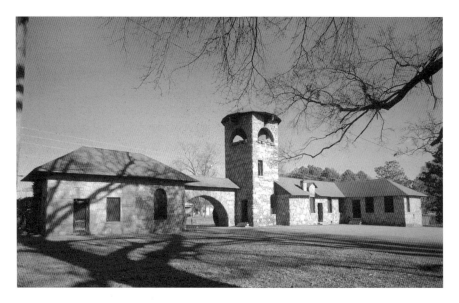

In 1935, Asa Candler Jr. added offices onto each end of Westview's 1890 gatehouse, closely matching the original stone. *Courtesy of Andrew P. Wood.*

The Salvation Army owns two large burial sections at Westview. In 1936, the organization dedicated this monument in its first lot. *Courtesy of Andrew P. Wood.*

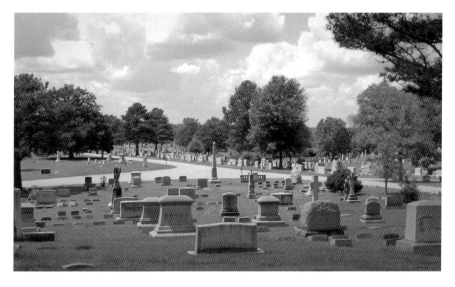

Within a decade of taking over West View, Asa Candler Jr. would switch from using upright grave markers like these in Sections 3, 10 and 13 to flat ones. *Courtesy of Andrew P. Wood.*

along with the words "The Salvation Army Soldier of Christ, Well Done!" was dedicated; later, a bench would be added upon which visitors could rest. Each soldier received an individual footstone with their name, rank and birth and death dates.

Eventually, the Salvation Army acquired another large parcel of land in what is now Section 71. Like its sister lot, one central stone, with the Salvation Army Crest and the words "Promoted to Glory, Soldier of Christ, Well Done!," and a matching flagpole were erected.

Three years after the Salvation Army dedicated its first granite stone in the southern part of West View, the cemetery was once again being touted in newspapers as one of the most beautiful places to visit in Atlanta. By the end of the decade, West View was advertising that its gates were open from 7:00 a.m. to 6:00 p.m., no walls or copings dotted the landscape, fifty acres on the grounds were being used for park purposes, an extensive nursery was maintained on the property and a Confederate monument existed to remember the South's dead from the American Civil War.

Ironically, West View's parklike atmosphere was inviting to grave robbers, who were sneaking onto the property and not only stealing fresh flowers from graves but also digging up azalea bushes and other landscape shrubbery. To combat the issue, West View officials hired six men to watch the cemetery, two outfitted with shotguns.

WEST VIEW'S GOLDEN AGE

On January 5, 1940, West View's founder and longtime secretary and general manager E.P. McBurney died after an extended illness. He was buried in his own private family lot, which houses one of the largest obelisks on the property, deeded to him years earlier by the West View Cemetery Association. His death symbolically marked a change in what West View Cemetery had been and what it would become.

Twenty-three years before his death, former metallurgical engineer Hubert L. Eaton had become the general manager of Forest Lawn Cemetery in Tropico, California, now part of Glendale. Over time, he transformed that run-down property into the model for a new type of cemetery, the memorial park, which was being emulated in cities across the country over the 1920s and 1930s. By 1940, Asa Candler Jr. planned to bring it to Atlanta, reimagining West View as a memorial park.

The memorial park plan did away with family monuments and corresponding footstones and replaced them with expansive lawns or "gardens"—often given biblical names, such as the "Garden of Gethsemane"—which would contain a central garden feature. That feature would then be surrounded by graves marked only with bronze markers placed flush to the ground. Not only was this type of marker supposed to democratize death—placing the rich and poor, famous or common in the same types of graves—but it also was easier to maintain; lawn mowers could now roll over grave markers, and the need for trimming weeds around them had been largely eliminated.

If someone did not want to be buried in the ground, many memorial parks offered large community mausoleums, which could be visited year round by families without worries of poor weather conditions. In some places, these mausoleums were built not only to be a repository for the deceased but also for art collections, such as was done at Forest Lawn.

The memorial park model also helped revolutionize the entire process of death and burial, incorporating the functions of the funeral home, cemetery and monument dealer in one place. And apart from the actual business of death, memorial parks were promoted as parks, open for tours, and places where large Easter sunrise services and weddings were held.

To sustain this new type of cemetery, memorial park owners heavily relied on pre-need sales, which they garnered through newspaper ads, radio commercials or door-to-door salesmen; the revenue generated provided capital to offset planning and construction costs.

Beginning in 1940 and stretching across the decade, Candler constructed his version of Eaton's memorial park at West View, the Garden of Memories. Originally consisting of fifty acres at its start in the summer of 1941, the "Garden of Memories" would eventually be expanded to encompass the sections that are today known as Sections 30–43 and Terraces A–F (some of these originally known as the West View Abbey Gardens) on the north and west sides of the cemetery's developed property.

In these sections—which had individual names such as the Garden of Time, the Serpentine Garden, the Rainbow Garden or the Boxwood Garden—extravagant, manicured shrubs and flowers were maintained. Interspersed between them were statuary, such as the bronze figures representing spring, summer, fall and winter that once stood in the Garden of Seasons in Sections 33 and 34.

Unfortunately, only the bronze *Childhood of Tacitus*, a scaled replica of French sculptor Eugene-Antoine Aizelin's nineteenth-century *L'Enfance De Tacite* (Childhood of Tacitus) in Section 38, exists today; the others were stolen or removed because of damage over the years. Yet the stone bases that supported these sculptures, as well as some of the low stone borders that delineated the gardens, are still intact.

Three months after opening the Garden of Memories, West View distributed its first issue of *West View Chimes* in August 1941. The newsletter—with a tagline that read: "When beauty is permanent, time only adds to its charm"—was created as a way for cemetery officials to talk to their lot owners. In the inaugural issue, it was touted that in the ninety days since the opening of the Garden of Memories, West View management had

One of the memorial sections introduced by Asa Candler Jr. was the Serpentine Garden in Section 38, seen in this 1940s photograph. *Courtesy of The Westview Cemetery, Inc.*

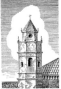

OCTOBER
1947

Published Periodically by
West View Corporation
in the Interest of West
View Property Owners.

WEST VIEW CHIMES

A Weak $30 By Itself
It Becomes Strong and Effectual In The West View Perpetual Care Plan

"WHY, THIRTY DOLLARS insures the beautiful maintenance of the cemetery in which my burial property is located — well, forever!" exclaimed the WEST VIEW property owner who was talking to the CHIMES office recently. An article in the CHIMES had revealed to him with sudden clarity the full import of the phrase "Perpetual Care." He realized that WEST VIEW takes ten percent of the lot price, thirty dollars in his case, and places it in a trust fund to keep the cemetery premises in beautiful condition — not just for many years to come, but forever.

Impossible for this relatively small sum to do such a big job? So it appeared to him at first, yet that is the essence of the guarantee given with every lot and crypt sold in WEST VIEW. How insignificant his little thirty dollars appeared to him. Single-handed, he knew it

The West View Perpetual Care Fund is held in full legal trust by the Fulton National Bank of Atlanta as trustee. The Perpetual Care Trust agreement is irrevocable, both in whole and in part, and cannot be cancelled, and no part of the principal of the Perpetual Care Fund can ever be recalled. The principal can only be invested in U. S. Bonds; State of Georgia Bonds; Cities of Georgia — namely, Atlanta, Savannah, and Macon; and Bonds underwritten by the State of Georgia.

couldn't keep the cemetery in good condition for even the part of one week.

But WEST VIEW takes the same thirty dollars and makes it do its part to care for the cemetery in general — faithfully, competently, on into the years and years to come. How? By banding together hundreds, even thousands, of ten percents into WEST VIEW'S ever-growing Perpetual Care Trust Fund — now well over $600,000. The proceeds from the judicious investment of such a large principal finances the general care of the entire cemetery. It performs duties that property owners could never perform alone — and it performs them perpetually. It keeps the roadways in smooth, rideable condition; it repairs the drainage system; it cuts the grass; and it keeps the cemetery premises in good order — always.

The caller concluded the

For a decade, *West View Chimes*, such as this October 1947 edition, informed lot holders about the happenings at West View. *Courtesy of The Westview Cemetery, Inc.*

sold $137,000 worth of lots, with an average four-lot grave going for $150. *West View Chimes*—reaching a printing of more than twenty-eight thousand copies an issue at its peak—continued to report on cemetery issues in various incarnations for a decade.

Less than a year after *West View Chimes* was first issued, a bronze tablet commemorating the American Civil War's Battle of Ezra Church, which occurred on the northern portion of the cemetery's property, was unveiled between Sections 35 and 39 on June 28, 1942. Under the auspices of the United Daughters of the Confederacy, the tablet's content was written by Atlanta artist and historian Wilbur G. Kurtz, who was a co-founder of the Civil War Round Table of Atlanta and who would help erect more than four hundred historical markers across northeast Georgia before his death twenty-five years later.[53]

Not everything that Candler envisioned for West View in the early 1940s was created. A couple years after America became involved with World War II, Asa and Florence Candler announced to the public they would be erecting a small, $50,000 Gothic chapel between the zigzag stone terraces that were constructed in what is now Section 41 of the cemetery. The chapel, which was to have been fitted with a pipe organ, was to have been deeded to the American Legion of Fulton and DeKalb Counties. Behind it in the extreme corner of the lot at Larchwood Road and Gordon Road (Martin Luther King Jr. Drive), a "Field of Honor" was to exist where servicemen killed in World War II or who were Legion members could be buried free of charge. That chapel—as well as a crematory-chapel-columbarium-cloister-crypt structure with a colonnade planned for Section 45 and an urn garden along the border of Lake Palmyra—was never built.

What was built, however, and what still stands today as Westview's crown jewel and Asa Candler Jr.'s lasting legacy to Atlanta, is Westview Abbey.

WEST VIEW (WESTVIEW) ABBEY

While never completely finished in either concept or construction, West View Abbey (officially Westview Abbey after 1951) is approximately five hundred by three hundred feet in size—equivalent to a little less than a football field and a half long by a football field across. It has five-foot-thick walls at their base, is three stories tall and contains 11,444 crypts. These dimensions make it not only one of the country's largest community

mausoleums but also a testament to Asa Candler Jr.'s vision for West View Cemetery—a premier, one-of-a-kind cemetery for Atlanta and the South. Its Spanish Plateresque architectural style—referred to by some as Renaissance, Renaissance Plateresque or Spanish Renaissance—also makes it a rarity in the southeastern United States.

Mausoleums—named after the grave built for King Mausolus by his wife and sister, Artemisia, in modern-day Turkey circa 353 BC and known as one of the Seven Wonders of the Ancient World—have been used to bury the dead in above-ground crypts rather than in-ground burials for centuries. In America, the "community mausoleum" movement started in the 1870s. Rather than just small family mausoleums for the wealthy, cemetery planners built large mausoleums to house multiple community members—wealthy or otherwise.

These large structures allowed for more people to be buried on less land than could be accomplished with in-ground burials. They also required less landscape maintenance, allowed for those not wanting to be buried in the ground to have an alternative burial option and provided family members a place to visit departed loved ones despite inclement weather.

The community mausoleum movement reached Atlanta in 1914. That year, the Georgia Mausoleum Company, based in the Candler Building downtown, was constructing Atlanta architect A. Ten Eyck Brown's Beaux Arts–style community mausoleum at North View Cemetery, now Crest Lawn Memorial Park. The structure, which was being built on a prominent hill with views of the city's skyline and would house roughly six hundred people, was touted by "experts" in an *Atlanta Constitution* article at the time as being one of the most beautiful, completely equipped and permanently built mausoleums in the United States.[54]

Twenty-eight years later, however, Asa Candler Jr. would challenge those claims by starting construction on a significantly larger mausoleum at West View Cemetery. It was to be equipped not only with modern burial equipment but also with chapels, a mortuary, a crematorium, a funeral parlor, an administration building and garden crypts—above-ground crypts with their fronts exposed to the outside that had become popular in the 1920s.

At a West View Cemetery Association stockholders' meeting on January 21, 1942, Asa Candler Jr. announced that he, his wife and family members John H. Candler and Samuel Candler wanted to purchase a 5.5-acre plot of land at West View Cemetery from the association on which to build a large community mausoleum, which Candler had in the planning stages, to be

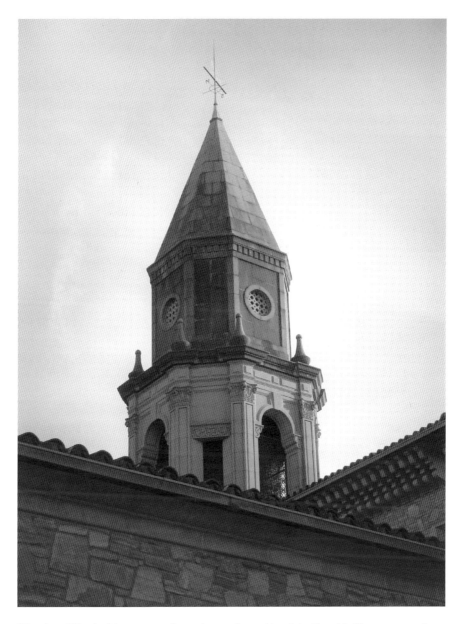

Westview Abbey's chime tower adorns the northern side of the Spanish Plateresque–style structure. *Courtesy of Andrew P. Wood.*

known as West View Abbey. The section agreed on by the stockholders was between Terraces C, D and E on the south and Sections 33, 34 and 39 to the east and north.

A month later, Candler's plans for the significant addition to West View was announced in a February 15, 1942 *Atlanta Constitution* half-page advertisement replete with an architectural rendering of the mausoleum. By March, a color pamphlet on the structure was available for those interested in receiving mailed copies.

America's involvement in World War II—which had started less than three months prior to Candler announcing his plans to the Atlanta public—delayed the start of construction on West View Abbey until October 1943. That month, crews started moving earth and quarrying the rock on site to reuse it in cladding the steel-reinforced concrete structure that was soon to rise among West View's newest memorial park sections. Within eight years, most of the abbey that stands today was built, but marble flooring and marble-faced crypt work continued on for more than two decades, with a northern wing and most of the third floor never being finished.

Westview Abbey, which includes the main mausoleum building as well as an administration building, was designed by California-based architect Clarence Lee Jay and mausoleum builder Cecil E. Bryan, who had worked together on numerous projects, including the Mountain View Mausoleum in Altadena, California, and the Sunnyside Mausoleum in Long Beach, California.[55] The style they designed Westview Abbey in was that of the Spanish Plateresque, which is noted for detailed and extensive ornamentation around doorways, windows and arcades, much like the craftsmanship of a silversmith or *platero* in Spanish.

In promotional material, it was stated that this style was chosen as a nod to Spanish explorer Hernando de Soto, who had explored Georgia circa 1540 and whom Georgians had commemorated with quadricentennial anniversary celebrations in 1940. Conveniently, however, Jay and Bryan used many of the same architectural styles and elements at West View that they had used in their California work, which was located in climates similar to those on the coasts of Spain.

The Abbey Mausoleum

The front exterior of the mausoleum on its eastern side consists of intricate cast concrete made to look like carved stone. At its apex is a "WA" symbol for

West View Abbey. Below that are four State of Georgia seals running across the top, separated by two "Pax" symbols, meaning peace. On the bottom loggia exterior, below the Georgia seals, are four City of Atlanta seals.

On the north side of the mausoleum are the carvings *Omnia mutantur nos et mutamur in illis*, which is Latin for "all things change, and we change with them"; lines from William Cullen Bryant's 1817 "Thanatopsis"; the inscription *Dominus Vobiscum*, which is Latin for "The Lord be with you"; and lines from Robert Lewis Stevenson's 1881 "Virginibus Puerisque" and John Greenleaf Whittier's 1866 "Snow-Bound: A Winter Idyl."

On the west side of the mausoleum are lines from Alfred, Lord Tennyson's 1863 "Flower in the Crannied Wall." And on the south side of it, where a parking lot is located above garden crypts, is a seal carved with "WV," for West View, and "AC," for Asa Candler Jr. Above the door entering the building under the arched bridge is the Mizpah Benediction from Genesis 31:49.

Accompanying the carved writings on the abbey mausoleum's exterior walls are tiled murals by Gladding, McBean & Co., the same company that did the tile work within the mausoleum's stairwells. The artwork these murals were based on was created by Belgian-born illustrator J. Semeyn in 1948.

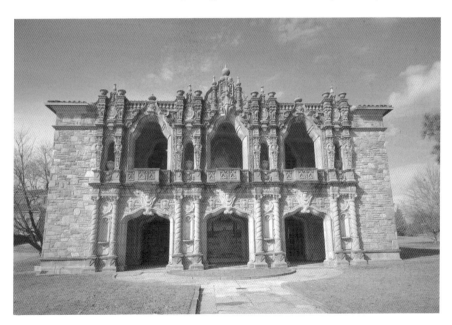

Four State of Georgia and four City of Atlanta seals decorate the intricate cast stone front exterior of Westview Abbey's mausoleum building. *Courtesy of Andrew P. Wood.*

He had been commissioned to paint mockups of the murals and to send those to West View. Once they were reviewed and approved by Candler, the paintings were then sent to Gladding and translated into tile pieces. Upon manufacture, the tile pieces were sent in crates back to West View and assembled on site, piece by piece.

Never officially named, the murals consist of the "Good Shepherd" on the bottom level and "The Graces," surrounded by tiled pieces containing lines from Albert Kennedy Rowswell's 1935 "Should You Go First," on the top level of the loggia on the front, east façade.[56] On the opposite side of the mausoleum on the west loggia is the "Sailboat" mural with lines from Alfred, Lord Tennyson's 1889 "Crossing the Bar." To the right of it on a southern wall is the "Woman on a Path" mural. Facing north, it, like the "Graces" piece, contains lines from Rowswell's "Should You Go First."

The exterior of the mausoleum was completed to its present state with the construction of a chime tower—never fitted with chimes but topped by a 3/16-inch bronze weather vane made by R.F. Knox Co. in 1947—and large garden piers and balustrades installed on the northern side of the abbey, designed in 1951 by Detroit, Michigan–based architects Harley, Ellington & Day, Inc. Between the tower, piers and balustrades was to have been a formal English garden, but it was never planted. On the eastern side of that space now is a 360-niche, polished granite, McCleskey Mausoleums–designed garden columbarium that was added in 2005.

The inside of the mausoleum consists of three floors: the Lower Chapel Floor (bottom), Chapel Floor (main) and Mezzanine (top). Within these floors are single crypts, double-depth and double-length crypts, companion crypts, couch crypts, Westminster crypts, columbaria spaces—including one for children on the Lower Chapel Floor—and private family rooms on the Chapel Floor's northwestern corridor.[57] The floors—except for the terrazzo-covered Lower Chapel Floor—as well as the crypts are covered in more than thirty-five different types of marble, such as Notre Dame, Belgian Black, Castino Rose, Alabama Cloud, White Cherokee, Etowah Pink and Vertes Issorie, from all over the world, including Africa, Belgium, Italy, Spain and the United States.

Adorning the corridors of crypts and the overall mausoleum are more than seventy stained-glass windows by several different companies. Decatur, Georgia–based Llorens Stain Glass Studios was the maker of the "Matthew," "Mark," "Luke," "John," "The Ark," "The Ten Commandments," "The Scroll," "The Star of David" and the "Ark of the Covenant" windows on the Chapel Floor, as well as other windows throughout the complex that were

The corridors of Westview Abbey's mausoleum are covered with thirty-five different types of marble. *Courtesy of Andrew P. Wood.*

installed over several years. The company also created the mausoleum's interior light well windows and the 7.4- by 6.0-foot stairwell skylight, which was installed in 1952. The Monastery of the Holy Ghost Stained Glass Studios in Conyers, Georgia, produced the mausoleum's four interior geometrically designed stained-glass windows in 1971. The most ornate windows, however, were made by the Los Angeles Art Glass Co.

Originally, Los Angeles Art Glass was going to replicate famous landscapes in a few of the mausoleum's windows, such as Yosemite Falls, or native Georgia scenes, but those plans were scrapped and replaced with religious-themed windows. On the western wall of the mausoleum is the company's "The Brook" window over the George T. Linnen sarcophagus. Based on a Tennyson poem, the window was to have been used in the mausoleum's Florence Candler Memorial Chapel narthex, but Los Angeles Art Glass Co. officials convinced Candler to use another window instead.

Los Angeles Art Glass did make windows in 1949 for the Chapel of the Garden, which included five nave windows: "Angel of Victory," "Righteousness," "Adoration," "Mercy" and the central "Christ in the Garden"; and the family room window, "The Descending Dove."

Unfortunately, this was all that was built of the small chapel located on the western side of the abbey complex. Its eight to twelve rows of pews; ribbed ceiling; wooden altar, retablo, gate and grill; vitrified tile floor; and cartouches filed with various carvings of poems were never completed due to ballooning construction costs and lawsuits that would plague Candler in the early 1950s.

Another part of the mausoleum that was never constructed because of costs was the Memorial Room, or the Court of the Transfiguration. Scrapped by 1945, this massive room would have stood where the garden columbaria now stand. The full height of the mausoleum, its northern wall would have abutted the crypt corridor that stands on the northeast side of the complex. Its southern side, faced with a seven-arched, one-story loggia, would have looked toward the chime tower and English garden.

The inside of the Court of the Transfiguration would have measured thirty-three by seventy feet wide and been done in the Italianate or Italian Renaissance style, replete with a marble floor, columns and stairs; balconies; four giant stained-glass windows; a Venetian-carved ceiling with mural paintings; and two J. Semeyn–created tiled murals. The centerpiece of the room was originally to have been West View Abbey's masterpiece: an eighteen- by twenty-six-foot-tall stained-glass reproduction of Raphael Sanzio's 1519 painting *The Transfiguration*. Candler had intended it to be a tribute to his father, Asa G. Candler Sr.

Parts of the mausoleum that were built but that went through various design changes were the Chapel Floor's stair hall; the Great Hall, intended to have been the original entrance hall; and the Florence Candler Memorial Chapel. In the stair hall area, just off the arched bridge doorway connecting the mausoleum to the administration building, a barreled ceiling was originally intended. It was scrapped because of a jog in the wall at the elevator shaft, and a flat coffer ceiling was installed instead. The hall's Colorado-quarried Colorosa Travertine staircase—made in California by Edmund B. Lohr Marble & Tile—was installed in 1948 and was part of the abbey's original plans.[58]

In the Great Hall—which is adorned with four panels inscribed with verses from Isaiah, John and Revelation and lighted by a large "rose" stained-glass window—the original bridge spanning the room and balconies were to have had wrought-iron railings. Because of war iron shortages during the 1940s, precast concrete was chosen instead. Hanging in this hall are three large chandeliers that are duplicates of chandeliers hanging in Candler's Briarcliff Road mansion's 1,700-square-foot music room, DeOvies Hall.

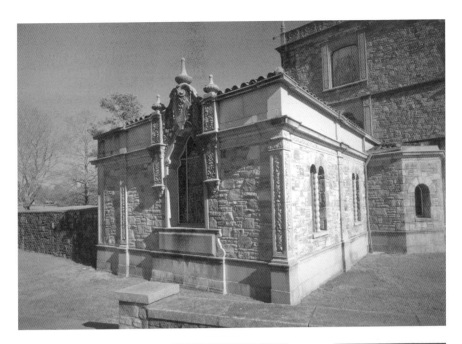

Above: The Chapel of the Garden was never completed. Its proposed interior of ornate cartouches never made it past the planning stages. *Courtesy of Andrew P. Wood.*

Right: Installed in 1948, Westview mausoleum's Colorosa Travertine staircase sits beneath a 7.4- by 6.0-foot skylight by Llorens Stain Glass Studios. *Courtesy of Andrew P. Wood.*

World War II metal shortages were the cause for switching balcony and bridge railings from wrought iron to cast stone in the Great Hall. *Courtesy of Andrew P. Wood.*

Off the Great Hall is a narthex that leads to Westview Abbey's Florence Candler Memorial Chapel. Named after Asa Candler Jr.'s second wife, Florence Adeline Stephenson, the Spanish Gothic–style chapel, which was officially dedicated on May 8, 1949, is considered by many to be Westview Cemetery's pièce de résistance. It was originally intended by Candler to be used not only for funerals but also for weddings and christenings.

With a traditional nave and side aisles, separated by concrete piers made to look like carved stone to support concrete arches and an intricately patterned fan-vaulted ceiling, the chapel was originally designed to have an undecorated dark wood ceiling divided into three great squares by massive beams. The walls were to have been plain, except for a low wainscot of richly colored tiles. Its altar was to have been decorated in a dull gold, backed by a series of reliefs and fabrics covering the organ and singers' grilles. Soon after construction started on the main mausoleum, however, plans for the chapel were changed to what currently exists.

Hanging from the fan-vaulted ceiling are four large chandeliers designed by Los Angeles–based Leo Dorner, Co. in 1947. Originally, the company

had designed one of four 11.6-foot-tall chandeliers for the chapel, but when it was shipped by train to Atlanta and installed, West View officials thought it too large. The chandelier was sent back to Leo Dorner and reconfigured. Between the end of 1948 and the first few months of 1949, West View staff installed four 6.0- by 4.5-foot-wide, silver plate and gold bronze, thirteen-light chandeliers that cost $16,660 in total. Leo Dorner also provided the three lanterns that hang in the narthex.

At the eastern end of the chapel is the apse, flanked by robing quarters for a priest to the north and a smaller "chapel" to the south for immediate family members during the time of services. Within the apse, no permanent altar was ever built, which allowed for the greater arrangement of whatever ceremonial pieces were needed for the services at hand. A large and intricate 1949 walnut pulpit and Bible stand—designed by the Krueger Manufacturing Co. and originally used in this space—has been lost.

Alongside the walnut pulpit in this area, the chapel's original pipe organ console was housed. The thirty-stop Aeolian organ, which had originally been designed and built for Candler's Briarcliff home as the "solarium

Four 6.0- by 4.5-foot chandeliers hang in the Florence Candler Memorial Chapel, which was intended to be used for funerals, weddings and christenings. *Courtesy of Andrew P. Wood.*

organ," had sixteen sets of pipes housed behind the intricate walnut reredos within the apse. That organ was replaced years later with a Hammond electric organ.[59]

The reredos was executed by Atlanta's Randall Brothers, Inc., the company responsible for the chapel's other woodwork—grilles, doors and pews. It had also been hired to do intricate carvings for the narthex, but that work was halted by Candler due to expense.

Within the upper part of the reredos are paintings by Hungarian-born artist Bartholomew (Bart) Mako, who had immigrated to the United States in 1923 and made a name for himself in California producing commercial art, sculptures and murals, including plaques for the 1932 Olympic Games and two principal murals for the 1939–40 San Francisco World's Fair. His tie to West View came from his association with its builder, Cecil Bryan; the two had worked together on various mausoleums in California.

Mako, who devoted 1948 to the planning—visiting Atlanta twice for this purpose—and the execution of the paintings for West View Abbey, was paid $9,500 for his efforts. Twenty-one of his paintings reside in the reredos. The three larger ones are known as *Faith*, *Hope* and *Charity*. Those three—one of which has four accompanying panels—are surrounded by fourteen narrower panels consisting of the twelve apostles, Moses and King Solomon.

In the narthex, seven additional Mako paintings—*The Good Shepherd*, *The Prodigal Son*, *Christ and the Rich Man*, *The Sower*, a cherub and two floral paintings—grace the walnut-paneled walls. One of the four parable paintings had to be repainted, as Candler did not like the composition of the original. Even with that setback, all of Mako's paintings were completed by November 1948 and installed before the chapel's dedication ceremony six months later.

Across the southern end of the chapel's nave are twenty-seven stained-glass panels in three large windows, each approximately 20.0 by 8.5 feet in size and created by the Los Angeles Art Glass Co. They show in panoramic view the entire life of Jesus, from nativity to resurrection, to his final appearance as "Christ the King." The company was paid $7,785 for the three windows, which were originally to have depicted angels.[60] Several smaller stained-glass windows complete the chapel, including windows in the family space on the south side of the nave. In the narthex, accompanying Mako's paintings, is the Los Angeles Art Glass Co.'s "The Good Samaritan" stained-glass window.

The mausoleum building of the abbey also contains restrooms, an elevator, workrooms, storage rooms and flower rooms—two of which are located

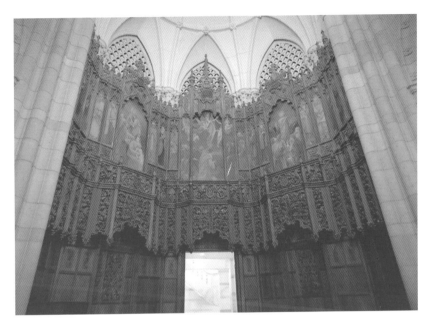

Twenty-one paintings by Hungarian-born artist Bartholomew Mako reside within the chapel's ornate walnut reredos. *Courtesy of Andrew P. Wood.*

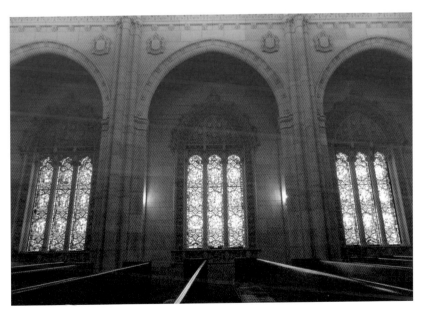

Shown here on the chapel's south wall are three stained-glass windows containing twenty-seven panels representing Jesus's life from nativity to resurrection. *Courtesy of Andrew P. Wood.*

on the second floor of the east loggia on either side of the tiled *The Graces* mural—where water could be retrieved for the flower vases affixed to the front of most crypts. During the Cold War, lower levels of the mausoleum, including the tunnel running from it to the administration building, were designated as fallout shelters.[61]

The Abbey Administration Building

Connected to Westview Abbey's three-story mausoleum by a thirty-two-foot-long, double-arched bridge containing five offices and a restroom and a tunnel containing an electrical room is an administration building. Built alongside the mausoleum, the three-story building was to have made West View Cemetery a "one-stop shop" for death, containing sales offices to sell cemetery plots, mortuary services to prepare the body of the deceased and a Family Room for wakes and viewings.[62]

On the day of the funeral, in the case of casket burials, the deceased would be wheeled from the administration building through its underground tunnel to the mausoleum building. There, the casket would be transported from the lower level via the elevator to the Florence Candler Memorial Chapel for funeral services.

Once services were over, the casket, or urn in the case of cremations, would be transported to its final resting spot on the cemetery grounds. West View's greenhouses could then provide flowers for however many days, months or years afterward one wanted, while cemetery ground crews cared for the grave in perpetuity.

In theory, Candler thought his abbey and its proposed services were great plans. In January 1951, however, the Georgia legislature started to introduce laws prohibiting cemeteries from operating mortuaries on their premises, measures that some say were directly targeted at Candler. As such, Westview Abbey's administration building was never completed as planned.

On the bottom level of the building are garages, a boiler room and work spaces. Originally, it also was to have had a receiving room where family or friends would have identified the deceased recently brought in by an ambulance or hearse, as well as a crematorium. The crematorium was to have had adjoining offices finished with marble floors, staff ceilings and cornices.

On the main level is an entrance hall and elevator lobby with an ornate coffer ceiling; several sales, administration and executive offices, the latter having walnut paneling and extensively decorated plaster ceilings; a men's

Westview Abbey's mausoleum, seen on the left, is connected by a bridge and tunnel to its administration building, seen on the right. *Courtesy of Andrew P. Wood.*

room; a women's room with a parlor; and a large Family Room for viewings, wakes and receptions. The Family Room contains a massive concrete-made-to-look-like-carved-stone fireplace and a large arched window that overlooks Terraces D and E and Lake Palmyra when it existed. Over the door in the elevator lobby heading into this room is detailed "stone" work matching that found elsewhere on the complex.

The top floor of the administration building contains a "records room" on the western side, which had originally been intended to be a "moving picture" room for Candler to screen movies, hence its having no windows; an elevator lobby; an apartment intended for the cemetery's mortician, complete with a main living space, separate kitchen and separate bathroom; an office; staff bathrooms with lockers; and a mortician work space, which contained two metal beds with drains for embalming. Even though a mortician had moved onto the property by the end of the decade, the beds were never used because the mortuary was never allowed to operate.

As had been the case with the mausoleum, World War II, financing and lawsuits curtailed much of Candler's plans for the administration building. Decorative wall tile, wood paneling, marble stairs, terrazzo floors

The administration building contained offices, a viewing room, an apartment, mortician space and more. Garden crypts, seen on the left, abutted the building. *Courtesy of Andrew P. Wood.*

and stained-glass windows that had been planned for the space were never installed. The elevator shaft in the building was never fitted with an elevator and remains empty.

Today, Westview Abbey—whose first interment was that of Elizabeth Allan in March 1946—contains more than nine thousand remains but still has spaces available in its completed sections to be filled.[63] Funerals as well as musical concerts are held in the Florence Candler Memorial Chapel, which is also used by Hollywood and various television studios as a filming location. The administration building is no longer used on a day-to-day basis, but its ornate executive offices have also been used as filming locations. Its Family Room is used for special events, such as lectures and receptions.

SEVEN MONTHS AFTER CONSTRUCTION began on West View Abbey, the cemetery association's charter for incorporation was in need of renewal. On May 30, 1944, Candler and others reincorporated the organization for another thirty-five years. In doing so, they enlarged the association's power over cemetery operations, specified they had plans to operate a mortuary and a crematory on the cemetery's grounds and indicated that they wanted to complete the construction of West View Abbey and that they had plans to continue selling flowers from the cemetery's greenhouses.

In November 1944, the association bought the Brandon-Bond-Condon Funeral Home, which at that time was the oldest undertaking establishment in the city. It had a long history with West View. Workers of the funeral home had interred the Irish horse traders in their annual burial ceremonies for decades at the cemetery.

Within months of purchase, the name of the funeral home was changed to West View Peachtree Chapel. Located at 860 Peachtree Street, the funeral home—which advertised "Where it Costs Less to Have the Best" in local papers—touted having all-inclusive prices that included embalming services, providing a casket, making available a female attendant for women and children, allowing the use of a slumber room, writing newspaper obituaries and providing a funeral coach and flower car to West View Cemetery.

At the cemetery, West View Peachtree Chapel services included providing a metal vault to place the deceased's casket in and paying for the opening and closing of the deceased's grave. When the Florence Candler Memorial

A 1947 rendering of West View's funeral home on Peachtree Street. An ambulance service was also operated from the premises. *Courtesy of The Westview Cemetery, Inc.*

Chapel was completed, one's all-inclusive funeral package included the use of the chapel, its organ and organist.

To help offset these burial prices, West View Peachtree Chapel officials also offered insurance coverage. Known as the West View Funeral Expense Protection Plan, policies provided coverage not only for funeral expenses but also for hospitalization and surgery expenses.

After World War II, the chapel also operated an ambulance facility. Through the facility, twenty-four-hour ambulance service for distress calls or transportation to and from a hospital was provided via a Cadillac ambulance equipped with the latest in then-modern furnishings.

In 1945, the year after the West View Cemetery Association bought the funeral home, the group's leader, Asa Candler Jr., purchased an airplane to serve not only his personal business endeavors but also the endeavors of the association. Between July and October 1945, Candler ran a sales promotion allowing any lot department salesman who sold $20,000, or mausoleum department salesman who sold $30,000, an all-expense-paid trip to a Southern California cemetery property on the new West View–branded airplane. If a salesperson exceeded his quota by 60 percent, he was entitled to take a spouse or guest along as well.

While many might deem this promotion extravagant for a cemetery, West View was no ordinary cemetery, and its owner was no ordinary man. More than forty men and women worked as salespeople on the cemetery grounds. In 1945, they sold more than $1.2 million in lots and crypts. The following year, they were racking up more than $250,000 a month in sales.

Their efforts over the decade allowed for several new 40s-numbered sections along the north and northeastern edges of the cemetery to be added. Numerous planners, designers, civil engineers and landscape architects, such as Carlisle Butler, L.H. Fitzpatrick, Tom F. Fleming, William B. Wise and A.J. Stooghill, seemed barely able to keep up with demand.[64]

A month before the end of Candler's 1945 sales promotion, former U.S. government worker Martha Powers started working in the cemetery's administration offices under Candler's wife, Florence. Originally diagraming burial plots and drafting deeds for the cemetery, Powers became the cemetery's front office manager in 1965. She continued to work at the cemetery in various roles for another forty-nine years.

In December 1945, three months after Powers was hired, Candler consolidated the West View Cemetery Association, the West View Peachtree Chapel and his Briarcliff Incorporated investment business into the West View Corporation. At the start of 1946, the corporation had common stock

valued at $1 million, including assets of West View Cemetery's perpetual care fund that exceeded $400,000.

The new West View Corporation continued expanding its physical presence at West View Cemetery over the following two years by adding a streamline moderne power-generating plant and service building designed by Atlanta architects Cooper, Bond and Cooper. It not only housed power equipment and other machinery needed for cemetery operations but also two apartments and a locker room for cemetery workers.

Additionally, West View's greenhouse complex was expanded to include twelve forty-two- by one-hundred-foot units. Each of these was partitioned off and contained its own electrically operated thermostat, which allowed for the year-round growing of aucuba, acalphya and more than two thousand potted begonias, twenty thousand chrysanthemums, sixty thousand pansies and twenty thousand poinsettias.

On undeveloped acreage on the western side of the cemetery that year, a stream was blocked by the erection of a new thirty- by eight-foot concrete dam to create two lakes, the larger one measuring seven acres in size. They were built to supply water via pipes to a third lake being constructed, Lake Palmyra, near West View Abbey, as well as underground sprinkler systems throughout the rest of the cemetery.[65]

A double driveway was originally planned to traverse the dam and gracefully curve around the lake. Along it and seventy-five feet from the water's edge, Candler and cemetery planners had intended to create highly sought after burial lots; those lots were never realized.

Below the dam, an ornamental bridge had been planned to span the stream made to create the lake. At it and the dam's northern end, a fieldstone pavilion and pump house was to have been erected with a lookout tower. Only the outer walls of the complex—sans a lookout tower—were built before plans were changed because of construction costs and priorities and the building was abandoned; its walls still stand but are slowly being reclaimed by the forest.

In 1947, however, Lake Palmyra, located in Terrace E, just southwest of West View Abbey, was completed. Named after Palmyra, the biblical "city of palms" in Syria that had been fortified by King Solomon, Lake Palmyra had at its western end a stone pier directly across the street from a decorative wall element in Section 43. On the other end of the lake stood a marble sculpture, the *Lady of the Lake*.

A little over two decades after Lake Palmyra was created, it would be drained because of maintenance issues and the cost of upkeep. Now, only

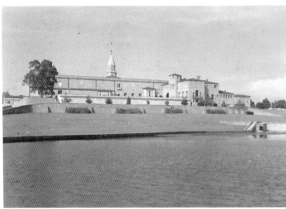

Above: These stone walls are all that was built of a pavilion and pump house Asa Candler Jr. intended to operate at West View. *Courtesy of Andrew P. Wood.*

Left: Lake Palmyra before it was drained in the 1970s. The name is now used for a different lake on the property. *Courtesy of The Westview Cemetery, Inc.*

the eastern stone edge of the lake and the decorative wall across from where the pier was still exist. The *Lady of the Lake* was put into storage.[66] Over subsequent decades, the name "Lake Palmyra" was reapplied to the seven-acre lake in the western undeveloped part of West View's property.

During the construction of these lakes, West View officials also created three fountains. The first one was erected in 1946 just inside West View's new Gordon Road (now Martin Luther King Jr. Drive) entrance, whose iron gates and stone piers were also constructed around the same time. The

A 1960s view of the Crab Orchard stone fountain Asa Candler Jr. built at West View's memorial park entrance in 1946. *Courtesy of The Westview Cemetery, Inc.*

double-tiered Crab Orchard stone fountain was filled with goldfish and pond lilies. It was surrounded by flagstone walkways, benches and flower beds. Over the years, these elements were removed, and the fountain now stands filled with dirt and grass.

Between 1947 and 1949, two more fountains were installed that featured not only water movement but also lights that changed colors. One of the Novalux 15 Projector Electric Fountains was installed in Terrace D to the south of West View Abbey; it still exists but is no longer in working order. The other one was installed in the Last Supper section across from West View's 1890 gatehouse. A sculpture titled the *Last Supper* was built behind it a few years after it was erected; in the 1970s, that fountain was removed due to maintenance issues.[67]

Between the summers of 1947 and 1948, construction crews added onto the northwestern end of West View's greenhouse complex an administration building built out of cinder blocks covered with fieldstone masonry. Part of that building wrapped around the greenhouse's 1921 water tower. Within the structure were administration offices, a reception room, a large flower display room, a public cafeteria, restrooms and perhaps its most famous space, Asa Candler Jr.'s Trophy Room.

An avid big-game hunter, Asa Candler Jr. traveled to Africa, Alaska and numerous other places to hunt for prized animal trophies. While he was on a hunting trip in Alaska, and while the new administration building was under construction at West View, Candler saw a Kenai moose and Kodiak brown bear while on an expedition. Those sightings, and the thought of adding trophies of those sizes to his ever-growing big-game collection, spurred an idea: the creation of a Trophy Room at West View. While still on his Alaskan trip, he wired the construction superintendent of the new administration building at West View and told him to raise the walls from twelve to sixteen feet in height.

Once completed, Candler's Trophy Room, at eighty by sixty feet, was billed as one of the largest private trophy rooms in North America. Over time, he added to the room's walls trophies from the Grand Tetons, the Talkeetnas and Ugashik Lake in Alaska, the Canadian Rockies, Siberia and Africa. More than seventy-four trophies of animals, in whole or in part, ranging from an Alaskan moose, goat and polar bear to an African buffalo,

At 4,800 square feet, Asa Candler Jr. built one of the largest private trophy rooms in North America at West View. *Courtesy of The Westview Cemetery, Inc.*

hippo, rhino, giraffe and elephant tusks, were placed in the room. Some of the smaller animals that were mounted in whole were placed within recesses in the room's walls that had been painted to look like the landscape from which the animals came.

True to Candler's eccentric nature, the room was a hodgepodge of items— mounted game, a large stone fireplace with an ornate French bronze clock on its mantel, stools made out of animal legs, an assortment of chairs and tables, laminate flooring, a drop-tile ceiling, fluorescent lighting and wood-paneled walls, which were also decorated with saddle mounts and guns. As he had done with his public pool and animal menagerie at his Briarcliff mansion, Candler's Trophy Room was also available for use by the public for special events, which would garner him legal trouble, as well as a place many Atlanta schoolchildren visited on field trips.

The new administration building and Trophy Room were officially occupied in June 1948. At this time, Candler moved West View Corporation's office at 549 Peachtree Street in downtown Atlanta to the cemetery. It, alongside the cemetery's office, operated out of the same building.

The completion of the building, however, capped the end of West View's golden age. Candler's ambitious plans for the cemetery would be quelled by numerous lawsuits, business dealings and legislative action.

CHAPTER 9

A GRAVE MISTAKE

On July 1, 1949, seventy-three-year-old Mamie Hill Oattis filed a $45,000 lawsuit against the West View Corporation and Asa Candler Jr. for the desecration of her eighteen-year-old grandson Jimmy Parks's grave; Parks was a Tech High School football player who had died in 1938 as a result of injuries suffered during a football scrimmage.

Since Parks's death, Oattis had visited his grave every week for more than a decade. During those visits, she had planted boxwoods and candytufts, which were transplanted from her own yard, as well as nandinas and tulips around his grave.

On May 17, as Oattis was making one of her weekly visits, she discovered her grandson's grave had been swept bare of all the plants she had planted and that the mound on it had been flattened; prior to Candler taking over the cemetery and introducing flat memorial park–style graves, graves at West View were often capped with mounds, which, over time, were covered by ivy. In shock and overcome with emotion at the state of her grandson's grave, Oattis collapsed and had to be physically carried out of West View Cemetery.

Two weeks later, through her attorneys, Oattis claimed that she had become extremely ill and had suffered mental agony and physical pain as a result of the conditions of her grandson's grave. As such, she was suing West View Corporation and Asa Candler Jr. for $25,000 in punitive damages and $20,000 for her "wounded feelings" and severe mental and physical illnesses. In the lawsuit, her lawyers also argued that the original

The removal of shrubberies similar to those in this 1940s photograph, taken in front of West View's power-generating building, resulted in numerous lawsuits. *Courtesy of The Westview Cemetery, Inc.*

10 percent of the purchase price of her grandson's grave was to keep up the lot, not remove its plantings and flatten it so that a lawn mower could move over it with ease and with little cost to cemetery management.

Twelve days after Oattis filed suit, more than two hundred West View Cemetery lot owners met at Atlanta's Georgian Terrace Hotel to protest Candler and the West View Cemetery Corporation's treatment of graves, such as Oattis's grandson's. At the meeting, a spokesperson for the group stated that more than 1,500 graves had been destroyed, upon which priceless shrubs had been removed, mounds flattened and markers broken and set flush to the ground in an attempt to reduce the expense of groundskeeping and maintenance.

Attendees joined together to become part of a legal movement to stop Candler and cemetery officials from setting aside rules and regulations in a manner that was compared to "Communism and Hitlerism."[68] The group vowed to go to trial and "put Asa Candler out of [the] city."[69] By the end of the month, three more lawsuits had been filed in which plaintiffs were seeking a combined $76,100 in compensation.

Within two months, those West View lot owners who had succeeded in getting injunctions against Candler and cemetery officials from flattening graves or removing shrubs and flowers until pending lawsuits could be settled were now claiming that graves were being completely neglected. They leveled accusations that cemetery personnel were refusing to cut the grass and trim the weeds around graves in retaliation to the lawsuits.

In response to these accusations, as well as photographs and articles about the neglect and ongoing legal battles that had started to appear in local newspapers, Candler told reporters that he was only seeking to make West View the most beautiful cemetery in the country; he claimed he had taken money from his own pockets to beautify the place. He also tried to explain that the original 10 percent from lot sales used in 1938 for perpetual care maintenance, which was of concern in Oattis's lawsuit, only provided in 1949 for about 2¼ percent, as compared with an original yield of 6 percent. He blamed this percentage difference on higher wage scales.[70]

In December 1949, in the midst of the lawsuits, the Georgia Funeral Directors Association expelled West View Cemetery from its organization. It claimed that West View officials had violated the association's code of ethics—engaging in unfair competition; the advertising of funeral and burial prices, including discounts; and the publishing of misleading information about other funeral homes.

Two months later, on February 10, 1950, a $40,300 judgment was awarded to Mamie Oattis in the first case that had been brought against Candler and the West View Corporation. The jury deliberated less than an hour, returning a verdict of $300 in actual damages and $40,000 in punitive damages. Candler's attorneys, however, immediately filed an appeal, and the case dragged on for another year.

Ultimately, Oattis received $150 in damages and $1 in punitive damages for alleged desecration of her grandson's grave at West View Cemetery. But the lawsuit and numerous others at the time changed the course of Candler's involvement with West View.

Seeking to change the public's perception of West View, in February 1950, Candler hired three new executives: Director of Public Service Harold W. Brown, who had been the editor of Atlanta's *West End Times* for the past two years, and two National Cemetery Consultants, Inc. employees from Washington, D.C., Chester J. Sparks and Grover A. Godfrey Jr. In announcing their additions to cemetery staff at a February 21 dinner, Candler promised the people of Atlanta better service and greater courtesies and cooperation with West View lot holders.

Sparks, president of National Cemetery Consultants, announced to the crowd gathered at the dinner that West View could not please all of its lot holders but that it would try to please as many as possible. He also reiterated that West View Abbey was available for anybody owning lots at

the cemetery and that the Florence Candler Memorial Chapel would be open for weddings, baptisms and concerts.

Godfrey, vice president of National Cemetery Consultants, told the assembled dinner crowd that West View had many undeveloped acres and that his, Sparks and Candler's goal was to make the cemetery the most famous in the world. He also stated that more than one thousand lot owners had signed statements requesting the removal of "obstructions" from their lots to make them more beautiful and that fifteen new people were joining this group every day; this, of course, was in direct contrast to the claims made in lawsuits at the time.

Days after Brown, Sparks and Godfrey joined Candler in running West View, a party was held at the cemetery's Trophy Room for children. The Candler Animal Party was part of Candler's effort to kick off a citywide campaign to help the *Atlanta Constitution* beat the *Atlanta Journal* in being the

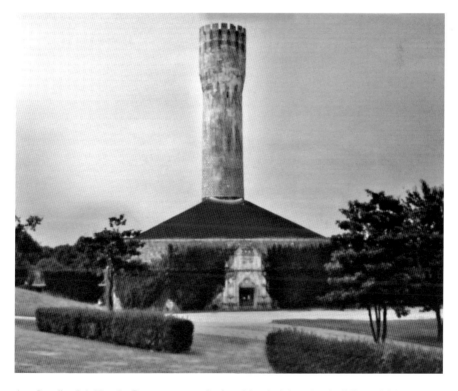

Asa Candler Jr.'s Trophy Room was attached to this administration building, which wrapped around Westview's water tower. *Courtesy of The Westview Cemetery, Inc.*

first paper in the city to buy an elephant to replace Coca, a pachyderm that had recently died. Candler had given Coca to the Grant Park Zoo, now Zoo Atlanta, years earlier from his Briarcliff estate's menagerie.

At the party on March 11, children were entertained by Sammy Sears, Sears-Roebuck's "famous" clown-magician, as well as by Candler and his son Sam, both amateur magicians. Additionally, Candler's grandson Asa Candler V narrated a film of an actual elephant hunt that was shown to the children in attendance.

Eventually, both papers secured elephants for the zoo. The *Atlanta Journal* raised money to purchase an elephant it dubbed Penny—named for the "Pennies for Pachyderms" campaign—from Biller Brothers Circus in Athens, Georgia, and got her to Atlanta first. Through a major gift from Candler and other donations made to the *Atlanta Constitution*, Coca II was purchased from Benson's Wild Animal Farm in New Hampshire.[71]

Not everyone was happy, however, that Candler, a wealthy man, was buying an elephant for the zoo. Many Atlantans, particularly *Atlanta Journal* readers, wanted the efforts of the city's children and everyday citizens to be the reason an elephant was secured for purchase. They wrote in to the paper expressing their objections to Candler's involvement.[72]

On top of those sentiments, many Atlantans and West View lot holders were upset that Candler held a magic show and children's party out at the cemetery for the purpose of raising funds to purchase an elephant. They felt the cemetery was sacred, a place for remembrance and solemnity, not for parties, fundraising and magic shows.

That sentiment and building resentment toward Candler over several pending grave desecration lawsuits—a new one seeking damages of $50,250 that had been filed just eight days before the animal party—was making Candler extremely unpopular. Yet despite growing animosity, Candler continued to build at West View.

Less than a month after Candler held his animal party in West View's Trophy Room, he unveiled West View's Fountain of Life Memorial on Palm Sunday, April 2, 1950, in front of hundreds of spectators. Conceived by Candler, the memorial in the Last Supper section consisted of a Novalux 15 Projector Electric Fountain, which had been installed a few years earlier, surrounded on its western side by a bas-relief depiction of the *Last Supper* as painted by Leonardo Da Vinci. While the bas-relief still exists, the fountain was demolished two decades after the memorial was unveiled.

At twenty-six-feet long, the main five-panel, bas-relief, 1¼-life-size *Last Supper* is flanked on its left side with a panel inscribed with verses from Luke

Fritz Paul Zimmer's twenty-six-foot-long bas-relief *Last Supper* was unveiled at West View on Palm Sunday, 1950. *Courtesy of Andrew P. Wood.*

22:14, 17–18, and on its right side with a panel inscribed with verses from Luke 22:19–20 and 1 Corinthians 11–26. Of particular interest are some German spellings and Old Testament verbiage on the panels, which can perhaps be attributed to its designer, Fritz Paul Zimmer.[73]

Born in Germany in 1884, Stuttgart native Zimmer was an internationally known architectural sculptor whose patrons included the king and queen of Wurttemberg and Graf Ferdinand von Zeppelin, inventor of the airship. He came to the United States in 1925 and within five years was teaching art at Oglethorpe University in Atlanta. Some of Zimmer's other work can be found on buildings at Agnes Scott College; on the grounds at Atlanta's Botanical Gardens; on the United States Post Office and Courthouse in Columbus, Georgia; and on the Edward Hull Crump Memorial in Overton Park, Memphis, Tennessee.[74]

After the erection of the *Last Supper* and throughout the rest of 1950, Candler continued to fight legal battles, including the ongoing desecration lawsuits, a lawsuit that sought to define the duties of West View Corporation in maintaining individual cemetery lots and a lawsuit where plaintiffs alleged that Candler and the West View Corporation were seeking to dispose of assets to avoid liability in damage suits.[75]

Eventually, the cases against Candler and the West View Corporation wound their way through the legal system. A Georgia Supreme Court case reversed lower court rulings and stated that perpetual rights to plant shrubbery were not given to plot owners, grave markers could be lowered, the cemetery was not required to add to its trust fund should it not be sufficient to cover maintenance and the cemetery must be allowed to use

discretion in regard to its operations.[76] A Georgia Court of Appeals case declared that cemetery officials had not desecrated graves at West View but only trespassed by removing lot holders' items.[77] After these rulings, all other cases were sent back to trial courts and subsequently resolved.[78]

Also during this time, members of the Georgia Senate were creating a bill that many stated was directly aimed at West View Cemetery and its legal issues over the past year and a half. Officially introduced into the Senate in January 1951, Senate Bill 78 would stipulate that all cemeteries were to now operate under the supervision of the new Georgia State Cemetery Board.

The bill would also make it illegal for a corporation or other entity operating a cemetery to engage in operating a mortuary or undertaking establishment and to sell caskets or other mortuary and undertaking supplies. Additionally, it would confine nurseries, greenhouses or flower shops on cemetery grounds to the horticultural embellishment of the cemetery or service to the cemetery's lot owners.

This bill—which would become law the following year—effectively became the death knell for Candler's active involvement with West View.[79] The cemetery could now only be operated as a burial ground; his plans for operating a mortuary, crematorium and floral business were prevented. In addition, the money intended to be used for lavish cemetery expansions had been used to fight lawsuits.

All of these factors combined with Candler's advancing age—at this point he was a septuagenarian—and the fact that he had recouped nearly $1 million from the sale of one of his hotels in the fall of 1950, helping him cut his losses to this point, prompted him to finally sell West View Cemetery. The eccentric millionaire's involvement with Atlanta's largest necropolis was at an end—almost.

WEST VIEW BECOMES WESTVIEW

On January 6, 1951, Asa Candler Jr. held a meeting with the incorporators and subscribers of West View Cemetery, including himself, Sam Candler and Florence Candler. At the meeting, the West View Corporation was incorporated as Westview Cemetery, Inc. for a thirty-five-year period, with 50 shares of common capital stock and 19,950 shares of preferred stock at $100 a share. At the time of incorporation, the cemetery's perpetual care fund stood at $595,000.

During the proceedings that day, Candler was elected chairman of the corporation and Sam was elected secretary and treasurer. Both Candler and Sam, along with Florence, were then elected directors before the three of them resigned. Taking their places were three men who were in attendance that day: Lou O. Minear, Chester J. Sparks and Grover A. Godfrey Jr. The trio was purchasing West View for approximately $2 million, ending three days of consultations with auditors and attorneys who stipulated that the new owners were not allowed to take on Candler's pending lawsuits.

At the meeting, Minear was elected Westview Cemetery, Inc.'s president, Sparks its vice president and Godfrey its secretary and treasurer. The latter two had been hired by Candler eleven months earlier, along with then–director of public service Harold W. Brown, to help reshape the public's perceptions about West View.

Lou Minear had known Candler personally for years. The two had also served together as members of the National Cemetery Association, which Candler had been director of in 1946 and which Minear was still

involved with. While Minear would lead Westview Cemetery, Inc. as president and devote as much time as he could to it, he would continue to reside in Washington, D.C. At the time, he was also the president of Fort Lincoln Cemetery, which he had spent the last fourteen years transforming from mediocrity to nationwide acclaim. Through the process, he had become known as an expert at cemetery grounds beautification and mausoleum planning.

Sparks, who had been in the cemetery business for twenty-one years, would serve out his role as vice president from Atlanta. He had worked for Minear for seven years as vice president and sales director of Fort Lincoln Cemetery before starting National Cemetery Consultants, Inc. in 1948. He would continue to run that company while also working for Westview.

Like Minear, Sparks was involved with the National Cemetery Association; at the time of purchasing Westview Cemetery, Inc., he was serving as the organization's membership chairman and had in the past been a vice president and a member of its board of directors.

Godfrey, a native Texan who had gotten his start in the cemetery business in 1938 with his father, would also serve out his role as secretary and treasurer of Westview Cemetery, Inc. from Atlanta. In 1949, he had formed a partnership with Sparks and assumed the vice presidency of National Cemetery Consultants, Inc., a position he would continue to hold while serving Westview Cemetery, Inc.

Within weeks of the three new owners taking control of Westview Cemetery, Inc.—though Candler still had a vested interest in the place, owning numerous shares of stock—new promises were made to the Atlanta public. Within the existing monumental sections, the cemetery's special care and planting services that had been discontinued under Candler's operation would be restarted; lot owners, too, would be allowed to plant their own flowers and shrubberies in those sections.

Additionally, the cemetery would open its offices on Sunday and allow for Sunday burials. The most significant change, however, was that the name "West View Cemetery" was changed to "Westview Cemetery."

Less than three months after taking over, Minear, Sparks and Godfrey held a massive Easter sunrise service at the cemetery on March 25, 1951. In front of the Fountain of Life Memorial, containing Fritz Paul Zimmer's *Last Supper*, thirty-five churches sponsored by the Southwest Atlanta Ministers' Association and the Atlanta Christian Council participated in a joint religious ceremony from 6:00 to 7:00 a.m. The principal speaker at the event, Dr. James Middleton, pastor of Atlanta's First Baptist Church, spoke to more

THE CANDLER ERA (1930–1952)

Attendees gathered to hear speakers at one of the cemetery's annual Easter sunrise services, circa 1950s. *Courtesy of The Westview Cemetery, Inc.*

than seventeen thousand people who also enjoyed musical presentations from a sixty-member choir and the Salvation Army Band.

After this service, Easter sunrise services continued at Westview for more than a decade before changing neighborhood demographics—"white flight"—siphoned off many participants who would attend sunrise services in the more predominantly white Atlanta suburbs. Ethnic population shifts within a decade and a half of the first Easter service would eventually cause the whites-only main part of Westview Cemetery to be surrounded by predominantly black neighborhoods.

During the spring of 1951, around the time of the first Easter sunrise service, Westview officials were touting a new radio program on WATL 1380, *The Abbey Hour.* The show, which featured hymns being sung by the Westview Abbey Quartet—four students from Emory University—accompanied by an organist, was broadcast live from the Florence Candler Memorial Chapel at 1:30 p.m. on Sundays.[80] Tickets were free of charge for those who wanted to attend the show in person.

The program, however, was not new. It had originated under Candler's ownership before the chapel at West View Abbey was completed. Original broadcasts were done from Candler's 1,700-square-foot music room, DeOvies Hall, at his home, Briarcliff, before they were moved to the cemetery in the spring of 1950. Once there, programs were held on Sunday afternoons at 4:00 p.m.

Minear, Sparks and Godfrey in the spring of 1951 also offered one-and-a-half-hour tours of Westview's abbey, chapel and grounds to show the public the ongoing construction efforts at the cemetery. Highlights of the tours

included showing off the new marble being placed in the abbey, as well as the installation of a $2,000 music system to play organ music throughout the structure. Tour stops also included showing the ongoing development of Westview's memorial park sections and the operations of the cemetery's greenhouses.

A few months after the tours started, it was announced in July 1951 that the cemetery had started construction on Acacia Lawn. The new development in a triangular lot between Sections 45, 46, 48, 48A, 50 and 51 would provide approximately three hundred family lots for use exclusively by Masons and their families.

Designed by Harley, Ellington & Day of Detroit, Michigan—which had also designed the large garden piers and balustrades installed at this time on the north side of Westview's abbey—Acacia Lawn was completed a year after construction had started. In the middle of the fescue and Kentucky bluegrass lot, which contained Santolina plants that spelled out "ACACIA LAWN" that have subsequently been removed, a central Masonic feature of White Cherokee marble stands. Made by the Georgia Marble Co. of Nelson, Georgia, the $4,664 feature consists of a Masonic altar surrounded by three columns, which represent strength, wisdom and beauty. On top of the altar is a broken column symbolizing death. A "Rockwood" Alabama limestone walkway surrounds the central altar and three columns.

By the end of 1951, Sparks had ordered an 8.5- by 4.0-foot-wide, faux-stone (concrete) and wrought-iron Venetian "wishing well" for $450 from Pompeian Studios in New York to be placed in Section 49. Within the first few days of the following year, the well had been set on a cement base and surrounded by two benches. A bucket and pulley were added to it, but they were subsequently stolen. Years later, the benches were removed.

But to top off the end of the first year of new cemetery ownership, Minear, Sparks and Godfrey erected a 215-foot, life-size tableau called the *Episodes of the Christmas Story* on a hillside adjacent to Westview Abbey. The tableau consisted of nine lighted scenes—"Annunciation," "Three Wise Men and Star," "Meeting of the Wise Men," "Scene in Herod's Court," "Journey to Jerusalem," "Mary and Joseph at the Inn," "Preparation of the Manger," "Heavenly Host and Shepherds" and "Nativity"—which one could view from an automobile while driving by.

In addition to this hillside display, lighted Christmas trees and fifty-three characters representing the holiday season were interspersed throughout the cemetery on land near the abbey. With no admission to come into the cemetery to view these displays from December 22 to December 31, they

Capped by a column, this Masonic altar is one of four pieces that make up the central feature of Westview's Acacia Lawn section. *Courtesy of Andrew P. Wood.*

proved to be extremely popular to families looking for Christmas activities. Cemetery staff had originally kept its gates open until 10:00 p.m. for the event but found themselves turning people away at the cemetery's gate, so they extended viewing times until 11:00 p.m.

By all outward appearances, Atlantans thought the new owners of Westview were turning things around. Plantings were once again allowed at family graves, construction of the abbey continued, new sections were

Purchased from Pompeian Studios in 1951, Westview's "wishing well" originally had a bucket and pulley and was surrounded by benches. *Courtesy of Andrew P. Wood.*

opening and Easter and Christmas activities had been held. What they didn't know, however, was that the new owners were not as invested in the cemetery as they thought.

At the end of 1951, Ray C. Wyrick of Mobile, Alabama, a nationally known cemetery landscape artist who had occasionally done work at Westview since at least 1935, was brought in to report on how cemetery officials could improve and beautify the cemetery. Welcomed by Minear, Sparks and Godfrey, Wyrick discussed with the trio numerous projects, such as adding a gate to the northwest corner of the property; platting more than 260 acres of undeveloped land on the property to yield more than 285,000 graves; creating a maintenance fund for Westview Abbey so that it did not become the property's white elephant; opening new monument sections and selling the stone monuments to put on them; and numerous other grounds and maintenance issues. He also noted that a lot of money was spent at Westview but not based economically or according to a master plan.

In a private December 11, 1951 report that he did not share with Minear, Sparks and Godfrey, Wyrick reported that he knew Sparks and Godfrey were looking to "reap a big harvest with less effort" in presumably reselling the cemetery and that Minear was willing to take another project and leave Westview altogether. He indicated that if Minear did leave, he would take the other two with him.[81]

At the time, the men did not realize how quickly this would all come to pass, nor did Asa Candler Jr. realize his reign over Westview Cemetery was soon to end, permanently.

Part III

THE BOWEN ERA
(1952–PRESENT)

NONPROFIT WESTVIEW

O n March 17, 1952, a special meeting of Westview Cemetery, Inc.'s board of directors was held in downtown Atlanta in the Haas-Howell Building. At the meeting, Lou Minear, Chester Sparks and Grover Godfrey Jr. resigned their positions as president, vice president and secretary and treasurer, respectively, as well as relinquished their roles as directors of Westview Cemetery, Inc. In their places, local Atlanta businessmen Frank C. Bowen, Charles D. Hurt and Raymond B. Nelson were appointed directors.

Bowen, along with Nelson, had purchased all of Westview Cemetery, Inc.'s outstanding common stock from Minear and members of his family, as well as Sparks and Godfrey. A native Atlantan, Bowen was a graduate of Atlanta's Boys High School and the Atlanta Division of the University of Georgia. He had been associated with his father, C.E. Bowen, for years as a building contractor and had operated the Wilbert Burial Vault Company, a maker of burial vaults, since 1937. Nelson was a native of Cedar Rapids, Iowa. He had lived in Atlanta since 1928 and was the secretary of the Family Fund Life Insurance Co. With their purchase of the cemetery, which was made public on March 22, the two took over a company that had no financial obligations except operating expenses and outstanding nonvoting preferred stock held by Asa Candler Jr.

A day later, on March 18, another meeting was held where Bowen was elected president, Hurt—an attorney with Hurt and Peek who represented the purchasers of Westview Cemetery, Inc. —was elected vice president and counsel and Nelson was elected secretary and treasurer of the corporation.

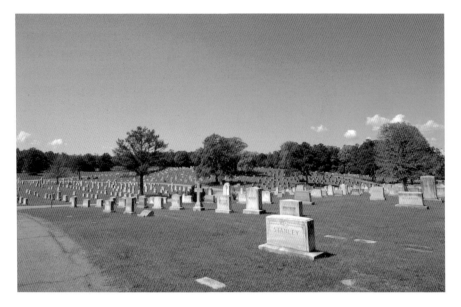

A view of the terrain in Sections 16–19 offers a glimpse of the massive cemetery Frank Bowen became president of in 1952. *Courtesy of Andrew P. Wood.*

Bowen and Hurt were to get 6 percent of the sale of lots a month until May, when that number would increase to 8 percent. At the meeting, it was also recorded that Westview Cemetery, Inc. had $30,000 of capital stock at $100 a share, with preferred stock to be had up to $2 million, divided into twenty thousand shares.

In a March 23 *Atlanta Journal* article, Bowen told the Atlanta public that plans for Westview Cemetery included the expansions of the Candler-introduced memorial park sections as well as the creation of new monument grave sections. Hired to carry out the expansions and create new sections—such as Colonial Garden, now Section 28—was Ray Wyrick, the Mobile, Alabama cemetery landscape artist who had been brought in the previous year to report on the cemetery under then-owners Minear, Sparks and Godfrey.

Bowen also stated in the article that the cemetery's perpetual care fund of almost $700,000 was not affected by the new ownership change; he and the new owners planned for 10 percent of the corporation's income from the sale of lots and mausoleum crypts to continue to go into that fund.[82]

The following month, April 1952, plans were put into place by Bowen and others to create The Westview Cemetery, Inc. by obtaining the more than nineteen thousand shares of preferred stock held by Asa Candler Jr.,

who was doing business as Candace, Inc. Candler had created the entity in April 1951, when he had sold off West View Cemetery to Minear and his associates.

Five months later, at a September 30, 1952 board of directors meeting, Westview Cemetery, Inc. executed a promissory note for twenty years for $2,430,000 with Candace, Inc., to purchase outright Westview Cemetery from Candler.[83] Security for the note was guaranteed with the actual real estate of the cemetery, and in exchange for the twenty-year first mortgage, Candler gave up all of his preferred stock. Outside of the loan, he was no longer associated with Westview Cemetery, having no say in its operations and future plans; the Candler era had officially ended.

Seven days later, on October 7, 1952, Bowen, Nelson, Hurt, Brannon B. LeSesne and Frederick W. Patterson met at what would be the first board of trustees meeting for The Westview Cemetery, Inc.—a "The" being added to create the new company's name. At the meeting, Patterson (head of the H.M. Patterson funeral firm his father had founded in the early 1880s) was elected as the cemetery's board chairman. LeSesne (an associate of Patterson's) would serve as a trustee. Bowen, Hurt and Nelson were, again, reelected to the positions they had held since March.

On October 13, a $400,000 loan from Citizens & Southern National Bank was taken out by the new company to buy back all the outstanding stock from Bowen and Nelson. Four days later, Westview Cemetery, Inc. was liquidated and all the assets from the former company were transferred to The Westview Cemetery, Inc. The new company was made a nonprofit—no stock would be issued, it would not be owned or operated for pecuniary gain or profit and a board of trustees would oversee its operations.

One of the first things the new board of trustees did was sell off the company's Westview Funeral Home on Peachtree Street. Candler had purchased it in 1944 when it was known as the Brandon-Bond-Condon Funeral Home. Over time, the venture proved to be unsuccessful. In 1952 alone, the funeral establishment had lost $8,000 in revenues.

Therefore, when Lee Borders of Cedartown, Georgia, in January 1953 offered $17,500 for the business to add to his recently formed company, Peachtree Memorial Mortuary, Inc., the board accepted it; the sale was made public on January 6. Ironically, just three years later, Patterson would purchase the business from Borders and merge it into his own—H.M. Patterson & Son.

Another matter that The Westview Cemetery, Inc. had to immediately attend to after its recent formation was the death of Asa Candler Jr. Less

than four months after he had surrendered his stock and relinquished control of Westview Cemetery, Candler died at Emory University Hospital after a long illness on January 11, 1953; he was seventy-two. His body was laid in state for an hour and a half in Westview's Florence Candler Memorial Chapel before his funeral service was held.

After the service, Candler was interred next to his first wife, Helen Magill, in Section 2. His body was originally intended to have been placed in an ornate double sarcophagus at the end of the northwest corridor in Westview Abbey. Under him, Florence's body would have been placed upon her death.

Florence, however, thought it more proper to bury Candler next to Helen. Upon Florence's death twenty-four years later, she was buried next to the two of them. She instructed Westview officials that the sarcophagus was never to be sold but to serve as a memorial to Candler.

After Candler's death, The Westview Cemetery, Inc. settled into the business of running a cemetery. Under Bowen's direction, lumber on the property was cut and sold to C.L. Stacks Lumber Co. for $25,000. Additionally, the brand-new, never-used mortuary and undertaking equipment—including an operating table and dressing table—that Candler had installed in the administration building of the abbey were sold; legislation passed in the summer of 1952 made it illegal for Westview or any other cemetery to operate a mortuary or undertaking establishment, so the equipment was of no use to Westview.

As Bowen had promised the Atlanta public when he took over the helm of Westview, he also immediately set out to expand and beautify the cemetery. By the end of 1953, an extensive map had been designed showing new roadways to be constructed on Westview's approximately three hundred acres of undeveloped land. Those roadways, which incorporated earlier plans Candler had drafted in the 1940s, particularly the construction of roads and burial plots around two lakes not open to the public, were never constructed.

Within months of the new year, Bowen had entered into a ten-year contract with the National Cemetery Service Co., which would handle lot sales for Westview. By July 1954, the new company had increased sales at the cemetery, and Bowen was being hailed for turning around Westview Cemetery after years of lawsuits and bad public relations.

Because of these increased sales, Bowen, starting in 1954 and for the next seven years, oversaw the opening of eight new memorial park–style sections: Garden of Devotion, Garden of the Savior, Garden of the Resurrection, Garden of Gethsemane, Garden of the Sermon on the Mount, Garden of

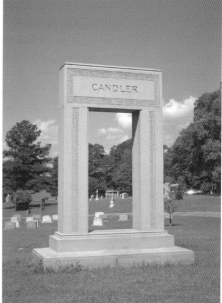

Right: Asa Candler Jr. died less than four months after he relinquished control of Westview. He was buried in Section 2. *Courtesy of Andrew P. Wood.*

Below: In Westview Abbey is this empty double sarcophagus, which was originally intended for Asa Candler Jr. and his second wife, Florence. *Courtesy of Andrew P. Wood.*

the Good Shepherd, Trinity Garden and the Garden of Everlasting Life.[84] Just like the memorial sections Candler had created in the 1940s, these new sections would contain a central garden feature surrounded by graves marked only with bronze markers placed flush to the ground.

The central garden features chosen were all designed by the McNeel Marble Co., or its successors, of Marietta, Georgia. Made of Carrara marble statues from the Lavagnini Studios in Carrara, Italy, which were placed on top of Tennessee pink split-face marble, the features, which ranged in price from $1,000 to $2,300 apiece, are: a Bible with the Lord's Prayer (Garden of Devotion), Jesus standing with his hands open (Garden of Our Savior), an angel in front of an open tomb (Garden of Resurrection), Jesus praying (Garden of Gethsemane), Jesus sitting with bent knee (Garden of the Sermon on the Mount), Christ as a shepherd (Garden of the Good Shepherd), an altar (Garden of Trinity) and Jesus and a woman at a well (Garden of Everlasting Life).

In January 1955, a year after these new sections started to open, Bowen and other cemetery personnel looked into the advisability of painting

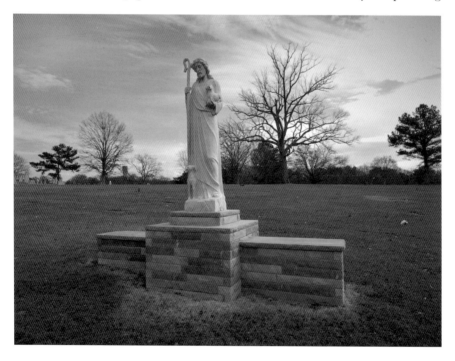

This statue in the Garden of the Good Shepherd is typical of ones found in mid-century memorial parks. Flat grave markers surround it. *Courtesy of Andrew P. Wood.*

certain parts of Fritz Paul Zimmer's 1950 *Last Supper* sculpture, which was part of the cemetery's Fountain of Life Memorial. By August of that year, however, any plans to carry that out had been deferred. And within twenty-two years, the fountain had been destroyed and the land it sat on became part of the burial space of the Garden of the Last Supper, one of the last memorial sections Westview management opened.

By the end of the 1950s, under Frank Bowen's management, Westview was thriving, averaging 1,200 interments a year. In total, the cemetery contained 120 acres of monument sections, 100 acres of memorial park sections and 362 acres of undeveloped land. Traversing all of this were 19.8 miles of paved roads.

Yet despite the improvements of the cemetery under Bowen and The Westview Cemetery, Inc., change within the neighborhoods surrounding it, as well as the broader world, would impact the future of the cemetery.

CHAPTER 12

A CHANGING WORLD

In the early 1950s against the backdrop of the Cold War and the Korean War, American city demographics were changing, and Atlanta's were no exception. The influx of white Atlantans leaving the city core after World War II to settle in newly created suburbs and blacks moving into the neighborhoods they left behind was in full swing. Some whites, however, fought to keep the neighborhoods they had established.

Just eight days before Frank Bowen and others at a September 30, 1952 board of directors meeting executed a promissory note with Candace, Inc. to purchase Westview Cemetery from Asa Candler Jr., the Southwest Citizens Association, Inc. was established to thwart blacks from moving into white residential areas southwest of Atlanta's downtown core near Westview Cemetery. The newly minted organization requested by resolution that Atlanta mayor William B. Hartsfield and Atlanta's city council ascertain the cost of building a six-lane highway from Peters Street downtown to West View Drive and Gordon Road at the entrance of Westview Cemetery. They also requested that land south of this road and along the cemetery's eastern and northern borders be zoned for businesses.

At the time, the Southwest Citizens Association's board touted it had brokered deals with black real estate firms to not sell property south of Westview Drive. The board also stated it had been making arrangements with blacks living south of the road to sell their homes to white interests. In essence, the board wanted to create a buffer zone between whites to the south and blacks to the north of Westview Drive, with Westview

Cemetery on its western end being an unofficial dividing line between the two populations.

This was not the first time the white citizens of Atlanta had tried to create these types of "buffer zones" and prevent "blockbusting."[85] Since the 1920s, they had tried to keep blacks from expanding west out of the city. Some of their first efforts failed in the 1920s, when Booker T. Washington, Atlanta's first black high school, opened west of Atlanta's historically black university now known as Clark Atlanta.

Two and a half decades later, whites failed again; despite efforts to keep them out, black families moved into Atlanta's Mozley Park neighborhood west of Booker T. Washington High School and just north of Westview Cemetery, where the Battle of Ezra Church had taken place in 1864.

At about the same time to the west and north, the middle-class black residential area of Collier Heights opened; it would eventually become home to numerous civil rights icons, such as Martin Luther King Jr. and Ralph David Abernathy, both of whose names would eventually replace the Gordon Road name around the north and east sides of Westview Cemetery.

From the start of the Southwest Citizens Association's efforts and throughout the 1950s—while Bowen was making his improvements at Westview, selling off a non-profitable funeral home, increasing sales and installing new garden sections with Italian marble statues—the association and other white Atlantans continually tried to prevent blacks from moving into homes in neighborhoods bordering the cemetery, particularly to the south and west. By the 1960s, those efforts were failing. As was happening across the South where whites were losing the fight to keep segregation, many gravitated to and had a renewed interest in the "Lost Cause"—a romanticization of the "Old South" and the Confederacy.

On April 26, 1961, the Dorothy Blount Chapter of the Daughters of the Confederacy, along with members of the Sons of Confederate Veterans, participated in the Ninety-Fifth Confederate Memorial Day celebration at Westview Cemetery—an event held there yearly since 1939—with renewed vigor. Among the graves of Confederate soldiers buried around the base of a memorial statue erected in the cemetery in 1889, Charles A. Moran, a Sons of Confederate Veterans inspector-in-chief, presented a Confederate flag in memory of his grandfather Cornelius Sheehan and other dead. Weeks later, the veterans group erected a flagpole at the site to fly the flag.[86]

Three months after the Confederate Memorial Day celebration, on July 30, 1961, the Sons of Confederate Veterans reinterred Edward Peter Clingman, a first lieutenant in the Confederate army, in Section 70 against

the base of some Civil War–era breastworks. Clingman had been killed in Cambellton, Georgia, trying to keep Sherman's troops from severing rail lines headed into Atlanta. His removal from a lone grave near Cambellton to Westview was done to coincide with the centennial start of the American Civil War; it was also done with great fanfare, including speeches, rifle salutes and the playing of musical anthems.[87]

Originally, the Sons of Confederacy had planned to bury a Union solider next to Clingman on the property; they indicated they wanted to create a Blue and Gray Memorial Park to bury soldiers from both sides. If the plans had been carried out, which they were not, they would have mirrored efforts proposed for Westview in 1885.

Less than a year after Clingman was reburied, Westview workers began the grim task of burying 48 of the 106 Atlantans killed in a June 3, 1962 plane crash that occurred at Orly Field in Paris, France. Most of the passengers from the crash—many of them the city's leading art patrons— were returning to Atlanta after three weeks abroad on a trip sponsored by the Atlanta Art Association.

The first victim of the crash interred at Westview Cemetery was Mary Louise Humphreys, who was buried in Section 28 on June 17. Forty-seven more burials would take place over the following two months. These victims, along with the others buried elsewhere throughout the city, would

The rise behind Confederate soldier Edward Peter Clingman's grave in Section 70 is believed to be remnants of American Civil War breastworks. *Courtesy of Andrew P. Wood.*

be the impetus for civic and business leaders to build what today is known as the Woodruff Arts Center in Atlanta; when the center opened four years after the crash, it did so with a casting of Auguste Rodin's *The Shade* (*L'Ombre*), which was given to the City of Atlanta by the French government in memory of those who had been killed at Orly.

In the weeks following the crash, it became fodder for the ongoing civil rights struggles in the city and nation. While Martin Luther King Jr. and actor Harry Belafonte canceled sit-ins scheduled in downtown Atlanta to allow the city to grieve, Malcolm X, speaking in Los Angeles, gained widespread national attention by expressing thanks for the death of the more than 120 white people killed on the plane.

Two months after the Orly disaster, Westview found itself, again, in the center of debates over the segregation of Atlanta neighborhoods. In August, a proposal had been put before the city's board of aldermen, and passed, to establish an approximately eighty-acre black cemetery off Willis Mill Road next to Westview on its western side. Atlanta mayor Ivan Allen Jr., however, vetoed the controversial zoning ordinance. He objected placing a black cemetery in a predominantly white neighborhood as a "buffer zone" to what he deemed as black "encroachment and penetration." In fact, he felt the cemetery would only aggravate "both penetration and encroachment."[88]

Over the course of the following months, Allen set about to try and implement his own plan of "stabiliz[ing] the white segment[s]" of populations on the western side of Westview Cemetery by proposing numerous street changes in the Peyton Forest and Audobon Forest neighborhoods; he actually went so far as to erect barricades in December 1962—dubbed "Atlanta's Berlin Wall"—along Peyton and Harlan Roads in the area to stop the encroachment of black home seekers into Cascade Heights to the south.[89] Three months later, the barricades were deemed unconstitutional by a judge and removed. Allen's efforts to prevent blacks from moving into the white neighborhoods south and west of Westview Cemetery were to no avail; change had come. By the end of the 1960s, Westview was a predominantly white cemetery in the middle of predominantly black neighborhoods.

This changed, however, on April 2, 1970, when Westview's board of trustees under Bowen's guidance declared it no longer the policy of the cemetery to restrict burial within its main grounds to whites. Blacks, now no longer limited to interment only in Westview's Rest Haven section, had an all-inclusive cemetery in their own backyard.[90]

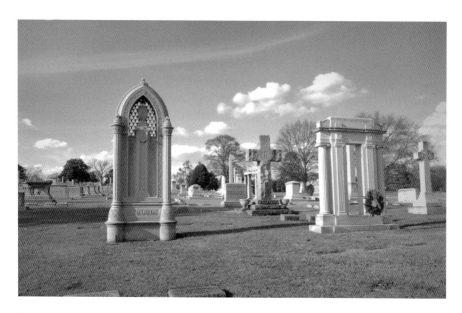

Section 5, seen here, and all of Westview's whites-only sections were desegregated in 1970. Blacks were no longer restricted to Rest Haven. *Courtesy of Andrew P. Wood.*

For the whites who had moved away from the cemetery to suburbs predominantly on the northern side of Atlanta, a new interstate roadway system provided them easy access to Westview. Interstate 20, which bisects Atlanta, runs parallel to the cemetery along its northern and northeastern sides and has exits that begin or end only a few hundred feet from the cemetery's entrances.

A FAMILY AFFAIR

Moving into a new decade, Frank Bowen, along with recently hired general manager Clarence E. Boner from Atlanta's Crestlawn Cemetery and director of sales William G. Myers Sr. from Sandy Spring's Arlington Cemetery, charted Westview into new territory. For the first time, the cemetery was truly integrated—a milestone many other cemeteries in Atlanta had yet to do, either on their own or by law.

Yet despite—or because of—the possible increase in business by allowing another segment of the population into the main cemetery grounds to buy lots, Westview officials decided to suspend Sunday interments, a practice that continues to this day. Bowen and others felt it was too much to ask employees to work seven days a week. Consequently, this move reversed cemetery policy that had been set in place nineteen years earlier when Lou Minear, Chester Sparks and Grover Godfrey Jr. had bought the cemetery from Asa Candler Jr. But it also guaranteed a day of relative peace for mourning, as there would be no tractors working on the grounds.

Additionally, during this time, there was talk of completing the third floor of the abbey—unfinished at this point for more than a quarter of a century—and carrying out necessary maintenance on several other buildings and the expansive grounds that had been developed over the past eighty-six years. To increase sales, cemetery staff advertised in local newspapers that it had plenty of room to expand—more than three hundred acres—and that it offered not only memorial park–style lots but also new monument sections, such as Section 70 and eventually Section 71.

Bowen and others also had another plan for raising capital: starting a new business venture, Westview Landfill, Inc.

WESTVIEW LANDFILL, INC.

Westview Landfill, Inc., with Frank Bowen's son, Charles E. Bowen, listed as its registered agent, was incorporated in November 1970 by Fulton County Superior Court judge Jeptha C. Tanksley.[91] The special-use landfill, mainly for commercial refuse, consisted of approximately eighty acres of unused land at the back of Westview Cemetery's property.

To reach the landfill, Westview's owners built a road off what is now Ralph David Abernathy Boulevard south of the cemetery's main entrance. The road, whose entrance was closed to the public by a forty-foot gate surrounded by eighty feet of ornamental fencing by South Cobb Iron Works of Mableton, Georgia, wound between the cemetery's main section and its Rest Haven and God's Acre sections before reaching the landfill. Along it, a brick check-in station was built to monitor the city, independent and commercial haulers bringing refuse in and out of the property.

By 1971, the landfill was in business as one of three private landfills in the city, and it very quickly proved to be a profitable enterprise. Because of its success, there were even rumblings within Atlanta's governmental channels in 1972 of possibly buying the landfill from Westview's owners for city purposes, but nothing materialized. Two years later, however, the operation's success spurred the Bowen family to create yet another business: United

A landfill operated for twenty years on unused cemetery property. Seen here is a portion that has reforested itself since its closure. *Courtesy of Andrew P. Wood.*

Waste. That new company, a waste removal business that became a success in its own right, eventually took over the landfill operations at Westview.

At one point during its zenith, Westview Landfill, Inc. operated two caterpillar compactors, two bulldozers, four earth movers, one motor grader and a five-hundred-gallon water-fire truck. All of these were used to cover items brought into the landfill so that it could be used in the future for cemetery purposes.

Despite successfully operating for fifteen years, complaints and periodic protests from people in the neighborhoods bordering the landfill, specifically members of Southwest Atlanta's Neighborhood Planning Unit I (NPU-1), finally convinced the Bowen family to cease its operations. In February 1986, the Georgia Department of Natural Resources' Environmental Protection Division (EPD) approved a closure plan for the landfill, which gave it an estimated life of four more years.

By the end of 1989, plans were in place to permanently close the site; the landfill that had helped Westview Cemetery personnel maintain their expansive burial grounds during times of stiff competition with suburban cemeteries ceased operations the following year. In the nearly three decades since its closure, the property containing the landfill has reforested itself. This has created dense forested buffers between the cemetery and the neighborhoods to its south and southwest.

IN SEPTEMBER 1972, WITH the death of The Westview Cemetery, Inc.'s chairman of the board, Frederick Patterson, Frank Bowen was elected to the role. He would also continue as Westview's president. In these roles, and with the success of the landfill as well as the paying off of the twenty-year promissory note to Candace, Inc. for Westview Cemetery, Bowen and other cemetery management looked into creating a modern office complex to serve the cemetery well into the future.

In the early months of 1973, Westview staff moved the cemetery's administration offices from the building they had occupied since 1948 around the water tower to Westview Abbey's administration building. In March, Bowen, his son Charles Sr. and others asked Henry Howard Smith, an AIA architect who was the son of famed Atlanta architect Francis Palmer Smith, to come up with preliminary plans for a new administration building.

Their intentions were to put the new building close to the water tower where the old one was; however, after a trip that summer to Fort Lincoln Cemetery in Washington, D.C., Charles Sr. changed his mind. Instead, he wanted to create a new entrance and drive just down from Westview's 1890 gatehouse and old entrance. The new administration building would sit just inside the cemetery's property off the drive.

With this change of plans, the Bowens still wanted to pull down the old, abandoned water tower building and greenhouses. Asa Candler's big game trophies, which until this point had hung in the Trophy Room of the now abandoned building, were sold in June to the Fernbank Science Center, now the Fernbank Museum, to do with as it wished. Three months later, Bowen hired the Chester Wrecking Company of Atlanta to dismantle the old complex. All that remains of the building are the octagonal walls, which were originally internal ones and that housed a safe, around the base of the still-standing water tower.

In November 1973, Smith's plans for a new seventeen-thousand-square-foot administration building were approved by Westview Cemetery's board. In April 1974, the building and contracting firm of Marthame Sanders & Co. was chosen to erect the new building, and by that summer, construction had started.

On September 24, 1974, just weeks after construction had begun, Frank Bowen and the other members of the cemetery's board elected Charles E. Bowen Sr. as president of The Westview Cemetery, Inc. Brannon Lesesne, who had been with Bowen since 1952, would assume the role of secretary, while businessmen Charles Hurt and Frank Bowen would be elected secretary and treasurer of the company, respectively.

Charles Bowen Sr. had been intrinsically enmeshed with his father, Frank, at Westview Cemetery since his father had purchased the property; over that time, he had risen through the ranks as the cemetery's general manager and vice president. A native Atlantan and graduate of the University of Georgia, he had also been affiliated with his family's other businesses: the Wilbert Burial Vault Company; historic Greenwood Cemetery, which the family had purchased in 1955; and Westview Landfill, Inc.

Bowen Sr. took over as president of an organization that was burying approximately 1,500 people a year—a number that would average out to 4 people a day if the cemetery operated seven days a week. At the time, Saturdays and Mondays were the busiest days for burials.

In September 1975, a year after Bowen Sr. took over as president, cemetery staff moved into its new two-story, approximately $738,000 modern-style,

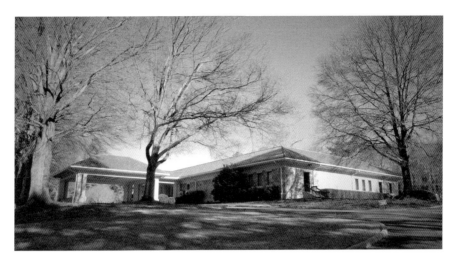

Cemetery staff moved into a new administration building in 1975 that had been designed by architect Henry Howard Smith. *Courtesy of Andrew P. Wood.*

fieldstone-clad building fronted by a large porte-cochère. What greeted them inside was a nearly finished building that contained a waiting room, sales offices, a kitchen and employee lounge, conference rooms, a drafting room, a microfilm room, a switchboard, a pneumatic tube system, bathrooms, garages and a courtyard. Decorative elements—such as the cast-iron grills from the Lorio Iron Works of New Orleans near the front door—and other items were not in place until the first half of 1976. A fountain originally planned for the front of the building was never built, nor an elaborate gate designed by landscape architect W.L. Monroe Jr. ever realized. Westview officials did, however, construct a new entrance gate and flower island designed by the building's architect, Henry Howard Smith. The entire new complex was officially dedicated on June 6, 1976.

During the same year the building opened, the section of Gordon Road running along the cemetery's northern border was renamed Martin Luther King Jr. Drive. Gordon and two other roads—Hunter Street and Mozley Drive—that made up a ten-mile stretch through predominantly black neighborhoods in Atlanta were all collectively given the new road name. Now, the new name reflected a black leader from the community and not a Confederate general, slave owner and lemon elixir patent–holding segregationist.[92]

Three months into the following year, another substantial change came to Westview Cemetery: the death on March 3, 1977, of the chairman of the

board and former president, Frank Bowen. Two days after his death, he was laid to rest in Section C. An active member of various civic organizations, including the Masons and Yaarab Temple, and religious institutions, such as Atlanta's First Baptist Church and Northside Drive Baptist Church, Bowen had ushered Westview through twenty-five years of steady growth and tremendous societal change.

THE BUSINESS OF DEATH

With the death of Frank Bowen in 1977, Charles Bowen Sr. and other family members, along with Westview staff, moved into four decades of relative calm; with the exception of a few small building projects and routine maintenance items, everyone went about the everyday business of death.

The end of the 1970s brought some changes to Westview Cemetery with the removal of Lake Palmyra in Terrace E and the demolition of the Novalux 15 Projector Electric Fountain in front of Fritz Paul Zimmer's *Last Supper* in the Garden of the Last Supper. Both, which had been installed in the late 1940s, had ongoing maintenance issues over the years; therefore, for cost-saving measures, they were eliminated from the landscape. Stone walls that once formed the eastern and partial southern ends of the lake still remain as silent sentinels to its existence.

Seven years after Frank Bowen's death, cold weather damaged many of the mature, century-old trees on Westview's property in the winter of 1984–85. In particular, the cemetery lost more than thirty deodar cedars, an evergreen species native to the western Himalayas that can grow to 164 feet tall with a trunk 10 feet wide in diameter. With their conical tops and drooping branches, these trees were extremely popular in cemeteries during the late nineteenth and early twentieth centuries.

Continuing into the 1980s since the takeover of the cemetery from Candler, lot plantings had been phased out. No longer were families allowed to put shrubberies around individual graves or plant flowers.

In fact, most of the shrubberies that had been planted over the past one hundred years had been removed. Families that had once cared for them had moved away and abandoned them, creating grounds maintenance issues. In addition, root systems would often dislodge, upend or crack family monuments.

A handful of graves with shrubbery around them still exist; the most well-preserved—and probably one of the most elaborate that existed—is the grave of prominent pharmacist James Glenwell Dodson and his wife at the corner of Section B facing Sections 4 and 6A. This grave, with its massive double Ionic column monument, has shrubbery around it, and it also is the only grave in the cemetery that still has individual grave coverings similar to the ones Asa Candler Jr. was accused of ripping off of lots when his legal troubles started four decades earlier.

In 1987, two years after storms had decimated trees and landscaping at Westview, Bowen and other cemetery staff commissioned lauded Atlanta historian Franklin M. Garrett for $1,000 to write a brief history on Westview. Within the year, Garrett, noted for his massive two-volume, two-thousand-plus-page *Atlanta and Environs: A Chronicle of Its People*, published a brief essay titled "WEST VIEW: An Atlanta Beauty Spot of Peaceful Repose." Garrett's work was the first piece outside of newspaper articles that had been written about Westview. It also included the names of 570 people buried at the cemetery, names he had gathered over decades of researching and writing necrologies.

The following year, Westview management opened a 264-niche columbarium inside Westview Abbey on the Lower Chapel Floor. Designed by McCleskey Mausoleum Builders, this would be the second columbarium to be opened on the property.

Also in 1988, Westview's maintenance building on the western end of the property was expanded with an addition designed by then–Westview vice president of the board Charles Bowen Jr., who had a degree in civil engineering. The metal building contained an office, mechanical shop, break room and lockers for cemetery maintenance crew.

In 1990, Westview management resurfaced several roads throughout the cemetery and added a new roof to the 1890 gatehouse. A year later, the name of the road running in front of the gatehouse was changed from Gordon Road to Ralph David Abernathy Boulevard. Abernathy was a minister, close friend of Martin Luther King Jr. and co-founder of the Southern Christian Leadership Conference (SCLC). His name replacing former Civil War general John B. Gordon's on street signs near the cemetery cemented the

The Dodson plot is the only one in Westview with extant plant coverings and shrubberies that give a sense of what many graves used to look like. *Courtesy of Andrew P. Wood.*

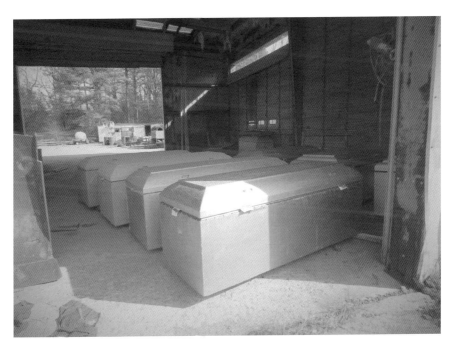

Cement burial vaults, in which caskets are placed at the time of burial, sit in storage at Westview's maintenance complex. *Courtesy of Andrew P. Wood.*

change in neighborhood demographics that had been occurring over the last forty years.

Outside of a few unusual incidents (such as Atlanta police officer S.F. Patterson crash-landing a police helicopter into the cemetery on the night of January 15, 1994, after experiencing mechanical trouble with its new engine) or the burials of individuals whose deaths had been highly publicized in the press (such as the tragic death of Centennial Olympic Park bombing victim Alice Stubbs Hawthorne in 1996 or Buckhead office shooting victim All-Tech Investment Group day trader Joseph Dessert in 1999), the 1990s were an uneventful decade for Westview leaders.[93]

At the start of the new millennium, Westview Cemetery received an Award of Appreciation from Trees Atlanta for the efforts its grounds crews put into making Atlanta greener. Not only were the crews responsible for burying the dead and maintaining graves and monuments, but they were also responsible for the upkeep of the cemetery's many prize-winning trees, which include the massive, century-old Red Oak in the Trinity Section, the smaller fifty-five-foot-tall gingko tree in Section 4 and the forty-seven-foot-tall catalpa (or catawba) tree in Section 12. In 2000, the gingko tree was named winner of the Trees Atlanta Big Tree Contest.

Three years into the new millennium, a new roof costing management more than $100,000 to complete was put on Westview Abbey in June. A year and a half later, on December 8, 2004, Bowen Sr. executed a contract with Associated Tribute Sys., Inc. for a new garden niche columbarium to be built and placed next to the abbey's mausoleum; Associated was a division of McClesky Co., which had sixteen years earlier executed a columbarium for the cemetery inside the mausoleum. Officially named the Garden Niches at the Abbey, the $100,000-plus 360-niche columbarium of polished stone opened in November 2005. It was placed on the north side of Westview Abbey within a courtyard where Asa Candler Jr. had originally intended to build the abbey's Memorial Room or the Court of the Transfiguration.

At the time Westview Cemetery was having its new garden columbarium built, the City of Atlanta was buying up tracks of green space along the Chattahoochee River, as well as acquiring two parcels of land nearly two hundred acres in size along North Utoy Creek. Those two parcels, which border Westview Cemetery to the west and southwest, were eventually named Lionel Hampton Park, after former landowner and jazz musician Lionel Hampton, and Lionel Hampton–Beecher Hills Park, after Hampton and nearby Beecher Hills Elementary School. Now a nature preserve, the two properties contain multi-use trails that, along with other trails built over

Westview is the home of many prize-winning trees, including the red oak shown in this photograph that lives in the cemetery's Trinity section. *Courtesy of Andrew P. Wood.*

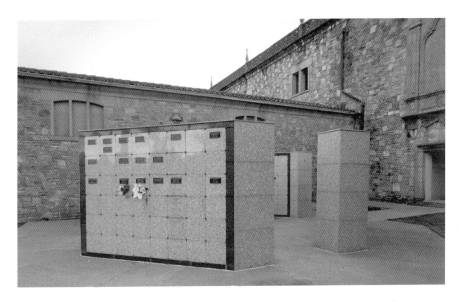

The Garden Niches at the Abbey were added in 2005 to house cremation urns. Two other columbaria exist within Westview Abbey. *Courtesy of Andrew P. Wood.*

the following eleven years in front of Westview Cemetery and elsewhere in the surrounding neighborhoods, connect to the Atlanta Beltline.

After nearly forty years of service as The Westview Cemetery, Inc.'s president, Bowen Sr. relinquished control of the cemetery to his son, Charles E. Bowen Jr., on January 1, 2014. Bowen Jr., a graduate of the Georgia Institute of Technology, had been involved with his family's cemetery since he started helping his grandfather and father in 1976 working part time on the grounds. Over subsequent years, he had taken on various leadership roles not only at Westview Cemetery but also at the family-owned United Waste Service Company, where he had served in the roles as owner and vice president, and the family-owned Piedmont Precast/Wilbert Burial Vault Co., where he had served as owner and secretary. He was vice president at Westview from 1988 until being named president. Over the years, Bowen Jr. also had been involved in waste management legislative reform and, like his grandfather, cemetery legislative reform.

Additionally, in 2014, longtime employee Martha Powers retired from her day-to-day operations of running Westview Cemetery's front offices. On December 31, the courtyard behind Westview Cemetery's current administration building was dedicated in her honor. A bronze plaque was placed in the space recognizing her astonishing seventy years of service to Westview. Powers continues to serve as a member of Westview's board of trustees.

Two months prior to Powers's retirement, Bowen Jr. and other cemetery employees held events to celebrate Westview Cemetery's 130th anniversary. On October 25, several speakers, including Bowen Jr.; Rodney Mims Cook Jr., founder and president of the National Monuments Foundation; Boyd Coons, executive director of the Atlanta Preservation Center; and author John Soward Bayne spoke to crowds assembled at Westview Abbey about the role the cemetery had played over the last century and three decades and the historical significance of preserving necropolises in general; they also discussed the role Westview Cemetery was still to play in Atlanta—as an outdoor museum and repository of historical information.

In the weeks prior to this event, Bayne's book *Atlanta's Westview Cemetery* was self-published. In addition to brief histories on the cemetery under different owners, it also contains the short bios of more than 150 people buried in the cemetery. Those bios are accompanied by photographs of the deceased's graves and, in some instances, other relevant photographs. At the end of the book, Franklin Garrett's 1987 essay "WEST VIEW: An Atlanta Beauty Spot of Peaceful Repose" is included.

Two days later and for the three days following, Westview Cemetery staff gave guided bus tours of the property. On October 30 from 5:00 to 9:00 p.m., Westview Cemetery's Bowen Jr. welcomed more than four hundred guests to Westview's abbey complex to participate in "Party with the Past," an ongoing free program the Atlanta History Center hosted at different sites throughout the city to connect Atlantans to the historic locations around them.

Bowen Jr. remarked in an *Atlanta Journal-Constitution* article during the time of the events that he was trying to find a way to mix the solemn business of running a cemetery with celebrating its historical significance.[94] With more than 100,000 graves already in existence, Westview Cemetery has room for plenty more. After 130 years of operations, the cemetery still has more than three hundred acres upon which to make history.

EPILOGUE

In the few years since Westview Cemetery turned 130 years old, Charles Bowen Jr. has continued in his efforts to celebrate Westview Cemetery's historical relevance while at the same time running an active cemetery with hundreds of burials a year.

In February 2015, the cemetery board renewed its efforts to explore the historical and cultural aspects Westview Cemetery had to offer to Atlanta citizens. To that end, Bowen and the board opened up the cemetery's grounds for tours to be led by the Atlanta Preservation Center.

During the Atlanta Preservation Center's annual 2015 Phoenix Flies Celebration of Historic Sites, regularly scheduled walking tours of Westview Cemetery began. Because of the size of the cemetery, two tours were developed—the Nineteenth-Century Tour and the Candler-Era Tour—both of which are led by trained volunteer guides on alternating schedules between March and November. The Nineteenth-Century Tour starts at the 1890 gatehouse and winds through the earlier established sections of the cemetery. The Candler-Era Tour starts at the double-tiered Crab Orchard stone fountain in Westview's memorial park sections and traverses the areas Candler added in the 1940s. Westview Abbey is also explored during both of these tours.

Also discussed during the February 2015 board meeting was getting the cemetery into the National Register of Historic Places. That process is still being looked into; however, one item suggested during the meeting and that has come to fruition is the development of the Friends of Historic Westview

Cemetery. Formalized in 2016, one of the first projects the new organization wants to occur is the rehabilitation of Westview's 1890 gatehouse. They plan to not only restore the structure to its original grandeur but also install in it a gift shop, a small museum on the cemetery and public bathrooms. The group is currently formalizing its plans.

On December 6, 2015, "Christmas at the Abbey," a sold-out ticketed event, was held in the Florence Candler Memorial Chapel. Harmonix and the Flute Choir from the private Walker School in Marietta, Georgia, performed a selection of musical arrangements from Bach to traditional Christmas carols. The concert was held in honor of the Bowen family's sixty-three years of leadership at Westview. Sadly, Charles Bowen Sr. did not live to see the moment; he had passed away on June 18 at age eighty-four and was laid to rest alongside his father in Section C.

Three months later, on March 12 during the Atlanta Preservation Center's 2016 Phoenix Flies Celebration of Historic Sites, Westview Cemetery officials, as part of their offering for the citywide event, hosted at the abbey's Family Room the Atlanta Audubon Society. A representative from the society presented a lecture to attendees about the types of birds found on the cemetery's expansive grounds, such as geese, hawks, doves, woodpeckers, chickadees, sparrows, blackbirds, meadowlarks, grackles, wild turkeys and numerous other species. Afterward, participants walked the cemetery property with binoculars to spot as many of these birds as they could find.

Because of the interest generated at this event, Westview Cemetery personnel applied to the Atlanta Audubon Society for the cemetery to become a certified bird sanctuary; official certification was granted to Westview in June 2016. Within months, brown-headed nuthatch nest boxes were added to the property and a "wildlife sanctuary" sign was placed near the cemetery's 1890 gatehouse.[95]

On March 19, seven days after the Audubon event in the Family Room, a "Robert Shaw Centennial Celebration" was held in the abbey's Florence Candler Memorial Chapel, with musical performances by the Atlanta Symphony Orchestra. The event was held in honor of what would have been fourteen-time Grammy award–winning conductor Robert Shaw's 100th birthday. He died in 1999 and is buried in Section C at Westview. His stepson, celebrity chef Alex Hitz, was the guest speaker at the event.

Also since its 130th anniversary, Westview Cemetery has become quite popular with Hollywood. Numerous films and television shows have been filmed on the cemetery's grounds, as well as in its abbey, such as one of the

Movie and television studios often film at Westview. Shown here is lighting equipment sitting in Terrace C prior to use. *Courtesy of Andrew P. Wood.*

Fast and the Furious film installments, the film *Triple 9* and the television shows *Constantine* and *Sleepy Hollow*.

Westview officials, of course, still serving the cemetery's main purpose as a place to bury loved ones, opened Section 72 in August 2015. That section is capable of holding more than eight hundred individuals. When it has been filled, plenty of land exists for expansions that could take Westview well into the next century.

NOTABLE BURIALS

Last Name	First Name	Born	Died	Accomplishment(s)	Location
Abbott	Benjamin F.	1839	1911	lawyer, Cotton States Exposition director	Section 1
Adair	Forrest, Sr.	1864	1936	real estate developer, Yaarab Temple potentate	Section 1
Adair	George W., Jr.	1873	1921	real estate developer	Section 1
Adair	George W., Sr.	1823	1899	real estate developer; Adair Park namesake	Section 1
Adams	Louis	1934	1997	chief justice of gypsies (Roma)	Section 31
Alexander	Dorothy M.	1904	1986	Atlanta Ballet founder	Section 1
Allan	Elizabeth	1876	1946	first entombment at Westview Abbey	Abbey
Allen	Ivan, Jr.	1911	2003	Atlanta mayor, reinterred in Oakland Cemetery	Section 5
Allen	Ivan E., Sr.	1876	1968	Ivan Allen Company co-founder	Section 5

Last Name	First Name	Born	Died	Accomplishment(s)	Location
Almand	Bond	1894	1985	Georgia Supreme Court chief justice	Section 50
Alston	Robert C.	1873	1938	Alston & Bird founder	Section 5
Andrews	Walter P.	1865	1935	Georgia General Assembly member, President Woodrow Wilson commissioner general appointee, Benevolent and Protective Order of Elks grand exalted ruler	Section 4
Arkwright	Preston S.	1871	1946	Georgia Power president	Section 5
Asher	Joseph F.	1901	1992	Rich's vice president, Rich's Credit Union president	Section B
Atkinson	Henry M.	1862	1939	Georgia Electric Light Company (now Georgia Power) majority stockholder	Section A1
Bagby	James C., Sr.	1889	1954	Major League Baseball (MLB) pitcher	Section 35
Bain	Donald M.	1847	1931	Burns Club founder	Section 1
Barili	Alfredo	1854	1935	Barili Music School founder, nephew of soprano Adelina Patti	Section 7
Bell	Emma E.	1843	1914	Bell House proprietor, residents known as Bell House Boys	Section 5
Benteen	Frederick W.	1834	1898	United States Army brevet brigadier general, Custer's Last Stand participant, (cenotaph) reinterred in Arlington National Cemetery	Section 7

Last Name	First Name	Born	Died	Accomplishment(s)	Location
Beutell	Russell L.	1891	1943	architect	Section 1
Bigham	Madge A.	1874	1957	children's book author	Section 16
Blackwell	Samuel E.	1909	1995	actor, Theater Hall of Fame founding member, novelist	Section 19
Bond	Edmund F., Sr.	1875	1950	Brandon-Bond-Condon Funeral Home founder and president, Irish horse traders burial organizer	Section 30
Bowen	Charles E., Sr.	1930	2015	Westview Cemetery president	Section C
Bowen	Frank C.	1905	1977	Westview Cemetery president	Section C
Boyd	George D.	1826	1918	contractor, Union army captain	Section 7
Britt	Ralph M.	1895	1958	artist	Resurrection Section
Brittain	Marion L.	1865	1953	Georgia Institute of Technology president	Section 3
Bronner	Nathaniel H.	1914	2003	Bronner Bros. founder and president	Section 6A
Bronte	Patricia	1918	1954	author	Section 34
Brown	Charles M.	1903	1995	politician, Charlie Brown Airport namesake	Section B
Brown	James Epps	1867	1925	Southern Bell Telephone Company president	Section 10
Brumby	Thomas M.	1855	1899	naval officer	Section 6
Burton	Roderick A., II	1987	2009	rapper, known as "Dolla"	Section 46
Butt	William Moore	1805	1888	Atlanta mayor	Section 2
Cambell	Lecresia M.	1962	2016	gospel singer	Terrace C

Last Name	First Name	Born	Died	Accomplishment(s)	Location
Candler	Asa Griggs, Jr.	1880	1953	Coca-Cola Company founder's son, West View Cemetery owner, real estate developer	Section 2
Candler	Asa Griggs, Sr.	1851	1929	Coca-Cola Company founder, Atlanta mayor	Section 4
Candler	Charles H.	1878	1957	Coca-Cola Company president	Section 4
Candler	Florence S.	1895	1977	West View manager, Florence Candler Chapel in Westview Abbey namesake	Section 2
Candler	John S.	1861	1941	Georgia Supreme Court judge	Section 4
Carr	Anne C.	1917	2005	Cherokee Garden Library at the Atlanta History Center founder	Section A1
Cefalu	Pete R.	1889	1946	blind champion gardener	Section 17
Cefalu	Vincent	1850	1935	Cefalu & Company founder	Section 31
Clingman	Edward P.	1842	1864	Confederate States of America lieutenant, grave moved to Westview Cemetery in 1961	Section 70
Cohen	John S.	1870	1935	U.S. senator	Section 4
Collier	George W.	1813	1903	Collier Road and Collier Hills neighborhood namesake	Section 4
Conklin	Charles M.	1848	1929	Conklin Tin Plate & Metal Company founder	Section 5

Last Name	First Name	Born	Died	Accomplishment(s)	Location
Cook	Gladys Hanson	1883	1973	actress, known professionally as Gladys Hanson	Section 4
Cook	Josephine H.	1947	1996	Fulton County Superior Court judge murdered by her son	Section 70
Cook	Rodney M., Sr.	1924	2013	Atlanta alderman, Georgia politician	Abbey
Cox	Sallie T.H.	1855	1929	Atlanta Woman's Club founder	Section 5
Creecy	Howard W., Jr.	1954	2011	pastor, Southern Christian Leadership Conference (SCLC) president	Abbey
Dahlbender	Eugene V.	1923	1990	Georgia Golf Hall of Fame member	Everlasting Life
Darden	Erin F.	1900	1992	female pilot, Georgia chapter of the Ninety-Nines member	Good Shepherd
Davis	Stanley R.	1916	1996	restaurateur, the Big Chicken (Marietta, GA) visionary	Section A1
Davison	Beaumont	1864	1932	Davison's department store founder	Section 1
DeGive	Laurent	1828	1901	DeGive's Grand Opera House proprietor, DeGive's became Loewe's Grand Theatre and premiered *Gone with the Wind*	Section 1
DeLoach	Alonzo A.	1857	1921	inventor	Section 1
Denny	Willis F.	1874	1905	architect	Section 1
Dessert	Joseph J.	1939	1999	All-Tech Investment Group day trader, Mark O. Barton murder victim	Section 32

Last Name	First Name	Born	Died	Accomplishment(s)	Location
Dickey	James E.	1864	1928	Emory College, Emory University presidents	Section 4
Dickey	John R.	1857	1939	Atlanta Stove Works founder, novelist James Dickey's great-uncle	Section 5
Dickey	Thomas S., Sr.	1925	1987	Civil War historian, novelist James Dickey's brother	Section B
Dinkler	Carling, Sr.	1894	1961	hotelier, Dinkler Plaza Hotel owner	Section 31
Doak	Cornelia H.	1885	1940	golfer, Georgia State Woman's Golf Association organizer	Section 14
Dobbs	H. Talmage, Jr.	1915	1989	Life of Georgia chairman of the board	Section B
Dobbs	H. Talmage, Sr.	1888	1946	Georgia governor Ellis Arnall's chief of staff, Industrial Life and Health Insurance Company executive vice president	Section B
Dobbs	Samuel Candler	1868	1950	Coca-Cola Company president, Reinhardt University benefactor	Section B
Donehoo	Paul	1885	1940	blind Atlanta coroner	Section 11
Dorsey	Hugh M.	1871	1948	Georgia governor	Section 5
Dougherty	Edward Emmett	1876	1943	architect	Section 1
Downing	Walter T.	1865	1918	architect, designed Westview Cemetery's 1890 gatehouse	Section 3
DuBose	Beverly M., Jr.	1918	1986	Atlanta History Society, now Atlanta History Center president	Section A1

NOTABLE BURIALS

Last Name	First Name	Born	Died	Accomplishment(s)	Location
Dull	Henrietta C.S.	1863	1964	cookbook author	Section 14
Edgar	James D.	1885	1921	professional golfer	Section 14
Egleston	Thomas	1856	1916	Trust Company of Georgia director and vice president, Henrietta Egleston Hospital for Children founder	Section 5
Ellis	Bill R. (Billy Ray)	1938	1988	S.O.S. Band founding member	Garden Crypt
Ellison	Michael E.	1952	2001	artist, educator	Abbey
Emerson	William A., Jr.	1923	2009	journalist, *Saturday Evening Post* editor-in-chief	Section A1
Esmilaire	Adrien "Little Mabb"	1882	1918	French midget circus star	Section 8
Ferst	Monie A.	1891	1965	Scripto, Inc. founder	Abbey
Fleet	William A.	1883	1918	(cenotaph) Rhodes Scholar, first from Virginia	Section 14
Forrest	Vernon	1971	2009	U.S. Olympic and professional boxer	Abbey
Freeman	Y. Frank	1890	1969	Paramount Pictures executive	Section 10
Gaines	Frank H.	1852	1923	Agnes Scott College founder and president	Section 10
Garlington	Frances King	1906	1973	King Plow Co. president	Section B
Garrett	William J.	1825	1896	West View Cemetery founding member	Section 4
Gentry	William T.	1854	1925	Southern Bell president	Section 1
Gilbert	S. Price	1862	1951	Georgia Supreme Court justice	Section 3

Last Name	First Name	Born	Died	Accomplishment(s)	Location
Glenn	Wilbur F.	1839	1922	minister, Glenn Memorial United Methodist Church namesake	Section 1
Gordy	Frank W., Sr.	1904	1983	The Varsity founder, Reinhardt University benefactor	Abbey
Gordy-Rankin	Evelyn J.	1907	2006	The Varsity founder's wife, businesswoman, Reinhardt University benefactor	Abbey
Gorman	Ossian D.	1841	1924	poet	Section 3
Grady	Henry W.	1850	1889	*Atlanta Constitution* editor, orator	Section 50
Grant	Bryan M. "Bitsy," Jr.	1910	1986	champion tennis player	Section 1
Grant	Lemuel Pratt	1817	1893	railroad engineer, businessman and civil leader, Atlanta Grant Park namesake	Section 1
Graves	John T.	1856	1925	U.S. vice president candidate, newspaper editor	Section 5
Green	Samuel	1889	1949	obstetrician, Imperial Wizard of the Ku Klux Klan	Section 10
Gress	George V.	1846	1934	lumber baron, "The Battle of Atlanta" Cyclorama donator	Section 6
Grier	Mary F.	1840	1896	mother of Harriet High (High Museum), monument by acclaimed sculptor George G. Crouch	Section 4
Gunn	John R.	1887	1956	minister, author	Section 39

Last Name	First Name	Born	Died	Accomplishment(s)	Location
Hall	Annie D. "A.D."	1906	2008	actresses Phylicia Rashad and "Debbie Allen" Nixon's grandmother, union organizer	Abbey
Hall	Lyman	1859	1905	Georgia Institute of Technology president	Section 1
Hamilton	Alice M.	1888	1978	author	Section 34
Hammock	Cicero C.	1823	1890	Atlanta mayor	Section 4
Harbin	Oliver W.	1834	1910	locomotive engineer involved in "Great Locomotive Chase"	Section 12
Hardon	Virgil Orvin	1851	1904	Grady Memorial Hospital founding physician member	Section 1
Hardy	Emily N.	1860	1948	legendary comedic actor Oliver Hardy's (Laurel and Hardy) mother	Abbey
Harman	Henry E.	1866	1926	poet	Section 5
Harris	Joel Chandler	1848	1908	author	Section 1
Harrison	Emily S.	1874	1973	Fernbank Forest champion, creator	Section 4
Hartsfield	William B.	1890	1971	Atlanta mayor, airport namesake (Hartsfield-Jackson)	Section 13
Hartsock	Ernest	1903	1930	poet	Section 14
Haskins	Helen L.	unk.	1884	Westview Cemetery's first burial on October 9, 1884	Section 4
Haverty	Clarence	1881	1960	Havertys president, son of the founder	Section 1
Haverty	James J.	1858	1939	Haverty Furniture Companies Inc. (Havertys) founder	Section 31

Last Name	First Name	Born	Died	Accomplishment(s)	Location
Haverty	James R.	1920	2007	Havertys president, grandson of founder	Section 31
Hawkes	Albert K.	1848	1916	optician, inventor, philanthropist	Section 1
Hawthorne	Alice J.	1952	1996	Centennial Olympic Games bombing victim	Section 38
Hentz	Hal F.	1883	1972	architect	Section 5
Herreshoff	J.B. Francis	1850	1932	first American to receive Perkin Medal, (cenotaph) interred in Bristol, Rhode Island	Section 5
Hicky	Daniel W. "Jack"	1900	1976	poet, columnist	Terrace D
High	Harriet H.W.	1862	1932	Joseph M. High's wife; donated mansion to become the High Museum of Art	Section 4
High	Joseph M.	1855	1906	J.M. High Company founder	Section 4
Hightower	Thomas J.	1829	1916	West View Cemetery vice president	Section 4
Hill	Andrew, Sr.	1854	1916	ex-slave, Peters Land Company employee, landowner	Rest Haven
Hill	Lula L.	1855	1949	ex-slave, dress maker, known as "Polly Peachtree"	Rest Haven
Hirsch	Harold D.	1881	1939	Coca-Cola lawyer, helped determine kosher status of drink	Section 4
Hollowell	Donald Lee	1917	2004	civil rights attorney	Section 6A
Howell	Clark, Sr.	1863	1936	Pulitzer Prize–winning journalist	Section 5
Howell	Evan P.	1839	1905	Atlanta mayor, Howell Mill Road namesake	Section 5

Last Name	First Name	Born	Died	Accomplishment(s)	Location
Howell	Isoline Campbell	1895	1978	Atlanta Junior League founder, Aunt Fanny's Cabin creator	Section 5
Howell	Major Clark	1894	1966	newspaper editor	Section 5
Humphreys	Mary Louise	1925	1962	first Orly Field Air France plane crash victim buried at Westview Cemetery	Section 28
Humphries	Charner	1795	1855	Whitehall Tavern operator	Section 5
Humphries	George P.	1837	1885	architect	Section 1
Idlett	Arthur Leroy	1902	1991	Atlanta Black Crackers player, school principal	Section 46
Inman	Samuel Cooper	1927	2010	businessman, road builder	Section B
Johnson	Joseph, Jr.	1870	1942	newspaper editor, Order of Acorns founder	Section 10
Jones	Joseph W.	1912	2005	Coca-Cola executive, Jones Ecological Research Center namesake	Section A1
Jones	Vivian M.	1942	2005	one of the first two African American students at the University of Alabama and its first African American graduate	Section 70
Kelly	James C. "Chris"	1978	2013	half of the rap duo Kris Kross	Section 6A
Key	James L.	1867	1939	Atlanta mayor	Section 16
King	Clyde L., Jr.	1902	1961	King Plow Co. president	Section B
King	George E.	1851	1934	King Hardware Company founder	Section 5

Last Name	First Name	Born	Died	Accomplishment(s)	Location
Kloeckler	Sophia T.	1880	1904	mysterious death at Lakewood Park prompted investigation by famous Pinkerton Detective Agency	Section 9
Kurtz	Wilbur G.	1882	1967	artist, historian	Terrace E
Langston	Thomas L.	1834	1911	West View Cemetery president	Section 4
Latham	Thomas Warrner	1843	1898	Confederate States of America colonel, attorney, businessman	Section 1
Leide	Enrico	1887	1970	cellist, conductor	Section 60
Lowery	Evelyn Gibson	1925	2013	civil rights activist, SCLC/WOMEN founder	Section C
Lucas	William D.	1936	1979	Atlanta Braves general manager, first African American to hold executive position in MLB	Sermon on the Mount
Lycett	William	1855	1909	porcelain artist	Section 3
Madden	John S.	1880	1937	World War I captain, prison guard, poet	Section 19
Maier	Frank H., Sr.	1908	1991	Maier & Berkele chairman of the board, jewelry company founded by his father	Section 1
Marks	Dinah	1944	1999	"Madam Bell," psychic, businesswoman	Section 31
Mayer	David	1815	1890	dry goods merchant, Hebrew Benevolent Society president	Section 1
Mayer	Elisa A.	1829	1902	Grandmothers' Club founder and president	Section 1

Last Name	First Name	Born	Died	Accomplishment(s)	Location
McBurney	Edgar P.	1862	1940	West View Cemetery founding member, secretary and general manager	McBurney Lot
McGill	Ralph E.	1898	1969	Pulitzer Prize winner, *Atlanta Constitution* editor	Section 48
Means	James C.	1904	1979	architect	Section 17
Mims	Livingston	1833	1906	Atlanta mayor	Section 4
Mims	Sue Harper	1842	1913	instrumental in establishment of the First Church of Christ Scientist in Ansley Park	Section 4
Mitchell	James R. "Jim"	1947	2007	Atlanta Falcons player	Section 47
Montgomery	Arthur L.	1854	1940	Coca-Cola Bottling Company founding member	Section 5
Moore	Arthur J.	1888	1974	Methodist bishop	Abbey
Moraht	Kurt	1886	1918	SMS Cormoran oberleutnant (German senior lieutenant)	Section 8
Munford	Dillard	1918	1993	Munford Inc. (Majik Markets) chairman, columnist	Section C
Murphy	George E.	1850	1926	architect	Section 4
Muse	George	1854	1917	George Muse Clothing Company (Muse's) founder	Section 5
Negri	Guido	1886	1942	Herren's restaurant owner	Section 26
Nelson	Cleland K.	1852	1917	Episcopal Church bishop	Section 5
Newman	Frances	1883	1928	novelist	Section 4

Last Name	First Name	Born	Died	Accomplishment(s)	Location
Nunnally	Charles Talbot	1869	1932	work clothing manufacturer	Section 4
Orr	Angus Elgin	1867	1938	poet, author, often known as "Uncle Billy"	Section 2
Orr	Joseph K., III	1920	2009	investor, Pot O' Gold board of director member	Section 5
Padgett	Benjamin Robert	1850	1920	builder, developer	Section 9
Padgett	Benjamin Robert, Jr.	1882	1951	builder	Section 4
Page	Eddie Brown, III	1954	1998	historian, Sons of the Confederate Veterans African American member	Section 6A
Palmer	Charles F.	1892	1973	Techwood Homes developer, U.S. president Franklin D. Roosevelt advisor, author	Section A1
Paschal	James V.	1920	2008	Paschal's Motor Hotel and Restaurant co-founder	Abbey
Paschal	Robert H.	1908	1997	Paschal's Motor Hotel and Restaurant co-founder	Abbey
Paschal	William A.	1921	2003	National Football League (NFL) player	Abbey
Patterson	Frederick W.	1882	1972	President Franklin D. Roosevelt's mortician	Section 5
Patterson	Hyatt M.	1851	1923	undertaker, H.M. Patterson & Son Funeral Directors founder	Section 5

Last Name	First Name	Born	Died	Accomplishment(s)	Location
Peck	William Henry	1830	1892	poet and author	Section 4
Pell	Arianna "Ria" R.	1968	2013	restaurateur, Food Network contestant	Section 70
Perkerson	Medora F.	1892	1960	author	Section B
Peters	Edward C.	1855	1937	Peters Land Company president	Section 5
Pierce	J.W.	1833	1885	Texas livestock dealer, Westview Cemetery's first "celebrity" burial	Section A1
Powell	Romae T.	1926	1990	first African American Georgia state court judge	Section 28
Preacher	G. Lloyd	1882	1972	architect	Section 31
Pringle	Robert S.	1883	1937	architect	Section 30
Ragsdale	Isaac N.	1859	1937	Atlanta mayor	Section 5
Reeves	Ollie F.	1889	1963	Georgia poet laureate	Section B
Refoule	Margaret A.	1916	1947	murdered socialite	Section 4
Regenstein	Joseph	1874	1946	Regenstein's founder's son	Section 10
Rhodes	Amos G.	1850	1928	Rhodes Furniture Company founder	Section 1
Rich	Richard H. "Dick"	1901	1975	Rich's president	Section 5
Rich	Walter H.	1880	1947	Rich's president, Atlanta Dogwood Festival founder	Section 5
Richardson	Harry V.B.	1901	1990	Interdenominational Theological Center at Atlanta University founder and first president	Abbey

Last Name	First Name	Born	Died	Accomplishment(s)	Location
Ripley	Thomas A.	1895	1959	author of *They Died with Their Boots On*, which inspired the movie by the same name	Section 17
Robinson	Frank M.	1845	1923	Coca-Cola name and Spencerian script logo creator	Section 5
Robinson	Louise P.C.	1916	1962	Peachtree Garden Club founder	Section 5
Robinson	Roby, Jr.	1908	1962	Robinson-Humphrey director, company started by his father	Section 5
Rogers	Nicolas Q.	1979	2010	NFL player	Section 71
Rosser	Luther Z.	1859	1923	Leo Frank's (the National Pencil Company) attorney	Section 5
Scruggs	William L.	1836	1912	diplomat, author	Section 1
Seiz	Emil C.	1873	1940	architect	Section 13
Sharpe	L. Guy, Jr.	1929	2004	radio and television weatherman	Terrace D
Shaw	Robert L.	1916	1999	conductor, multiple Grammy Award winner	Section C
Shepherd	John B.	1904	1983	first registered African American State of Georgia professional engineer	Section 42
Sheppard	Eugenia	1899	1984	renowned New York–based fashion columnist, novelist, Eugenia Sheppard Award namesake	Section 19
Sherlock	John	1871	1919	Irish horse traders member	Section 5

Last Name	First Name	Born	Died	Accomplishment(s)	Location
Smith	David N.	1937	1982	International Horizons, Inc. and International Suzuki Center founder	Section 70
Smith	Francis P.	1880	1971	architect	Section 13
Smith	Henry H., II	1927	2017	architect, designed Westview Cemetery's 1974 administration building	Section 13
Smith	Lucile K.T.	1877	1951	Atlanta Woman's Club president, Lucile King Thomas Auditorium (now Opera) namesake	Section 5
Smith	Rankin M.	1925	1997	Life Insurance Company of Georgia (Life of Georgia) CEO, Atlanta Falcons owner	Section B
Smith	Robert E.	1895	1987	Boston Braves pitcher, Atlanta Cracker coach	Section 38
Smith	Tullie V.	1885	1967	last Tullie Smith House occupant, now at the Atlanta History Center	Abbey
Spalding	Jack J.	1856	1938	King & Spalding founder	Section 5
Speer	Daniel N.	1836	1893	State of Georgia treasurer	Section 1
Springs	H. Hammond	1902	1922	champion motorcycle racer	Section 10
Stanton	Frank L.	1857	1927	first poet laureate of Georgia	Section 4
Steinhauer	Frank C.	1871	1971	automobile distributor	Section 9
Stephens	Nan Bagby	unk.	1946	Broadway playwright, composer and librettist	Section 4

Last Name	First Name	Born	Died	Accomplishment(s)	Location
Stevens	Josiah P.	1852	1929	J.P. Stevens Engraving Company founder	Section 5
Stockdell	Harry C.	1854	1912	first Capital City Club president	Section 12
Sullivan	Lillian Bennett	1888	1977	contralto soloist	Terrace A
Suggs	John "Johnny" B.	1896	1977	Atlanta Cracker baseballer, father of LPGA founding member Louise Suggs	Section 42
Suggs	M. Louise	1923	2015	Ladies Professional Golf Association (LPGA) founding member	Section 42
Thacker	Floyd O.	1934	1987	Thacker Construction Co. founder	Abbey
Thompson	Ida E.	1875	1906	white "fatality" of 1906 Atlanta race riot	Section 3
Tichenor	Issac T.	1825	1902	A&M College of Alabama (now Auburn University) president	Section 10
Tillman	Charles D.	1861	1943	musician, "Old Time Religion"	Section 4
Tilly	Dorothy R.	1883	1970	civil rights activist, U.S. president Harry S. Truman appointee to the President's Committee on Civil Rights	Trinity Section
Troutman	Henry B.	1886	1978	Troutman Sanders founding member	Section 12
Tucker	Henry Holcombe	1818	1889	Mercer University president, University of Georgia chancellor	Section 1

Last Name	First Name	Born	Died	Accomplishment(s)	Location
Turner	Fred J.	1893	1967	Southern Bell Telephone and Telegraph Co. president	Section 4
Tyre	Nedra	1912	1990	author	Section 27, ashes spread on mother's grave
Ward	Horace T.	1927	2016	first African American federal court judge in Georgia	Section 6A
Ware	Edmond A.	1837	1885	Atlanta University president, reinterred Clark Atlanta University	Ware Lot (no longer exists)
Ware	J. Lowell	1928	1991	*Atlanta Voice* editor	Abbey
Whalum	Wendell Phillips, Sr.	1931	1987	musician, conductor, educator, minister	Abbey
Whelchel	Benjamin F.	1895	1954	U.S. House of Representatives member	Abbey
Williams	Cora Best Taylor	1860	1924	Florida, Georgia and Alabama Railroad president, bequeath establishes Jesse Parker Williams Foundation, monument by renowned sculptor Daniel Chester French (Lincoln Memorial)	Section 5
Williams	Jesse Parker	1842	1913	Florida, Georgia and Alabama Railroad president, monument by renowned sculptor Daniel Chester French (Lincoln Memorial)	Section 5

Last Name	First Name	Born	Died	Accomplishment(s)	Location
Winecoff	William F.	1870	1946	Winecoff Hotel owner; killed along with 118 others in 1946 Winecoff Hotel fire, including his wife, Grace	Section 35
Wood	Robert E.	1898	1901	three-year-old burned to death, see "God's Acre"	God's Acre
Woodruff	Ernest	1863	1944	bought Coca-Cola from Candler family in 1919	Section A1
Woodruff	Robert W.	1889	1985	Coca-Cola Company president, philanthropist	Section A1
Woodward	John C.	1866	1939	Georgia Military Academy, later Woodward Academy founder	Section 17
Zeldieka	Mina Von Jeweitska	1817	1897	countess (Russian or Prussian depending on dubious accounts), sometimes spelled Zeldeika, buried in unmarked grave per her request	Section 3

Every reasonable effort was made by the author to present accurate information in this list. To report inaccuracies or discrepancies, please contact or visit Westview Cemetery.

NOTES

Introduction

1. Over the course of Père Lachaise's existence, the cemetery has garnered a reputation as the preeminent place to be buried in Paris. Writers Colette, Molière and Oscar Wilde; composer Chopin; musician Jim Morrison; and numerous other famous individuals are interred on the grounds. As a result, space has become scarce, and in recent years, the cemetery has operated by offering thirty-year leases, which, if not renewed, results in those buried there being dug up and the land reused.
2. David Charles Sloane's *The Last Great Necessity: Cemeteries in American History* was referenced heavily to compile this brief history of the American cemetery.

Chapter 1

3. In 1872, the Atlanta Cemetery, founded in 1850, became Oakland Cemetery. The cemetery is forty-eight acres, not eighty-eight acres, as is often cited in books over the past several years because of a typographical error.

Chapter 2

4. Those twenty-seven petitioners were L.P. Grant, Walker P. Inman, George W. Parrott, James R. Wylie, John Stephens, James F. Burke, Edgar P. McBurney, Benjamin J. Wilson, Thomas J. Hightower, A.P. Woodward, James W. English, Thomas N. Chase, Jacob Elsas, Rufus B. Bullock, Jacob Haas, H.I. Kimball, J.C. Bridges, C.J. Simmons, C.W. Francis, L. De Give, Willis E. Ragan, W.D. Luckie, L. Gholstin, Jack W. Johnson, Benjamin E. Crane, Thomas L. Langston and Henry H. Cabaniss.

5. 1884 Stockholders Report: proposed land to be purchased (allowing for slight variations): J.H. Jackson, 64 acres @ $80 = $5,120; J.P. Watson, 5 acres @ $100 = $500; R.C. Fain, 56 acres @ $45 = $2,520; R.C. Fain, $8\frac{1}{4}$ acres @ $100 = $825; A.A. Wilson, 25 acres @ $50 = $1,250; A.A. Wilson, 40 acres @ $45 = $1,800; Jos. Flieshell, 110 acres @ $30 = $3,300; B.J. Wilson, 150 acres @ $30 = $4,500; R. Fain, 75 acres @ $40 = $3,000; Lamar, 44 acres @ $50 = $2,200 for a total of $577\frac{1}{4}$ acres at $25,015.

6. It would not be until 1877 that all land titles were finally secured for the original 577 acres.

7. Over the years, multiple company officers and directors would be elected. E.P. McBurney's father, J.C., was involved with West View at its inception but would later relocate to Macon and own multiple real estate properties.

8. McBurney's first wife, Maggie Berry, who was the daughter of prominent Atlanta pioneer citizen Maxwell R. Berry, was heavily involved with the Home for the Friendless, now Hillside Cottages, which provides residential and community mental health services for children and their families. She worked for the organization for more than twenty-five years, leaving, upon her death in 1912, $5,000 for the group. McBurney would eventually become chairman of the board of trustees of Hillside Cottages, handling its finances. A cottage would be erected, which still stands, in the couple's honor on the Hillside campus off Courtenay Drive in what is now Midtown Atlanta. A year after Maggie's death, McBurney would marry Helen Sterrett Hersey of Paterson, New Jersey, whose father, Charles N. Sterrett, headed the international silk manufacturer and Paterson-based Lambert Silk Co. McBurney had met Helen when she was in Atlanta visiting the wife of Georgia governor John W. Slaton. After the marriage, the two became ensconced within business, social and Presbyterian religious circles in Atlanta; McBurney was involved for many years in the affairs of North

Avenue Presbyterian Church and donated church bells to the First Presbyterian Church of Atlanta in honor of his parents. They also were active in the city's art scene.

9. Villa Nelili, a two-story, cream-colored brick home with stately columns that was two doors over from the High Museum, which was located in the former mansion of the High family, was demolished in the mid-1960s. In its place arose structures that are now part of the Woodruff Arts Center complex, including the Alliance Theatre, the Atlanta Symphony Orchestra and the High Museum of Art.

Chapter 3

10. *Atlanta Constitution*, August 6, 1884, 7.

11. Ibid. In 1885, John Smith was listed as not only the guard superintendent but also the "foreman of the hounds" in cemetery paperwork.

12. In addition to Rest Haven at Westview, a library was named in 1889 in Bishop Haven's honor at the Gammon Theological Seminary next door to Clark University.

13. After emancipation and as a young man, Andrew Hill organized and was captain of the black Fulton Guards and served as a lieutenant in the Governor's Volunteers. For the last twenty-five years of his life, he worked as a janitor for Peters Land Company and accumulated a considerable amount of personal property. Lula Hill, after being freed, taught school, helped found Central Church and established a student loan fund at Clark University. She was known among the whites in Atlanta as Polly Peachtree, serving as a leading dressmaker to Governor John Slaton, the Inman family and others. The couple's children would go on to become physicians, pharmacists and a school principal.

14. *Atlanta Constitution*, November 30, 1901, 7.

15. Ibid., October 10, 1884, 5.

16. Today, when one visits Haskins's grave, one will notice her son Milton B. Weed buried next to her. He died a year before her on June 3, 1884, of consumption and had been buried at Oakland Cemetery. In February 1885, his body was reinterred at Westview.

17. Despite the inscription on the sealed door of the 1888 Receiving Vault, there are no historical records at Westview to indicate an influx of dead stored in the vault as a result of the 1918 influenza epidemic. Perhaps serving as only temporary storage and not just for future burials at West

View, the dead were not permanently recorded on Westview's rolls. In 1918, only twenty-eight people are listed as being placed in the vault.

18. West View Cemetery's January 15, 1890 Stockholders Report. The congregation is believed to be the Hebrew Benevolent Congregation, now known as the Temple.

19. The battle is also known as the Battle of Lick Skillet Road or the Battle of the Poor House by the Confederacy.

20. Ezra Church was also known as Mount Ezra Church or Ezra Chapel.

21. For more than one hundred years, people have claimed the earthworks at Westview Cemetery were Confederate ones. Most likely, however, they are the Union earthworks of the Morgan & Ward Line, July 31, 1864, or possibly the 15 AC Line, August 2, 1864. Confederates did build earthworks south of Atlanta but not in the area of Westview Cemetery.

22. It is believed the sketch of the monument was done by architect George P. Humphreys of Norrman and Humphreys; in newspaper articles at the time, only "Architect Humphrey" is referenced.

23. Newspaper articles in the *Atlanta Constitution*'s database claim the installation of the tablet was on June 28, 1942; however, the dates for the articles were manually added and not scanned from the actual paper. It seems odd that they would have unveiled this tablet a month prior to the actual anniversary date of the battle. Perhaps "June" should have been entered in the database as "July." Therefore, a specific date was not listed in the text of this chapter.

24. Wilbur G. Kurtz died in 1967 and is buried in Terrace E at Westview Cemetery.

25. The Fulton County Veterans' Association had actually started talking to West View Cemetery officials in October 1886 about securing a lot for Confederate burials. It is unknown why these efforts stalled until October 1888.

26. Per the West View Cemetery Association's January 16, 1889 fourth annual stock holders meeting, the Battle Monument Association of the Blue and Gray land deed for a spot tendered to the group on May 19, 1886, was rescinded; the land was given to the Fulton County Confederate Veterans Association instead. The deed on the property would revert to West View on January 1, 1890, if a monument of $2,500 was not erected. This amount is larger than that reported in newspaper accounts of the time.

27. In the *History, Confederate Veterans' Association, of Fulton County, Georgia*, compiled by Robert L. Rodgers, historian, CVA, which was published

by V.P. Sission in 1890, it states on page 18 that work on the monument "was executed by John Walton, of Atlanta, Ga." However, Walton was in the granite business (Atlanta Stone & Granite Co.), and it's assumed he supervised the overall project but was not responsible for the actual sculptural work. Walton is well known for constructing the Dr. Robert Battey mausoleum in Rome, Georgia.

28. Slight variations of the originals exist on the statue. Isaiah 2:4 (and Micah 4:3) King James Version of the Bible: "And he shall judge among the nations, and shall rebuke many people: and they shall beat their swords into plowshares, and their spears into pruninghooks: nation shall not lift up sword against nation, neither shall they learn war any more." The complete stanza of Jonas's poem reads: "Show it to those who will lend an ear to the tale that this paper can tell of liberty born of the patriot's dream, of a storm-cradled nation that fell."

29. *History, Confederate Veterans' Association, of Fulton County, Georgia*, compiled by Robert L. Rodgers, historian, CVA, published by V.P. Sission in 1890.

30. The Confederate Monument was touted as being unveiled to the public "soon" in an April 26, 1890 *Atlanta Constitution* article. Confederate colonel Albert Cox was to deliver an ovation at the event. No record, however, was found of when the event took place or if it did. There were many other Confederate projects happening around the city at this time, in addition to the death of Jefferson Davis and the death of Confederate Veterans Association member Henry W. Grady on December 23, 1889.

31. The flagpole was erected in 1961.

Chapter 4

32. *Atlanta Constitution*, June 1, 1890, 20. For years, the gatehouse has been inaccurately credited as the work of architect George P. Humphreys.

33. Current plans are to rehabilitate the structure as a visitor center and event space to be operated by the Friends of Historic Westview Cemetery.

34. *Atlanta Constitution*, December 5, 1914, 4.

35. The 1910 United States Census states Thomas W. Burford was born "about" 1853. Other biographies on the Internet state 1851.

36. *Atlanta Journal and Constitution Magazine*, December 19, 1954.

37. "The Real Story of Ilex Cornuta Burfordii" by W.L. Monroe, October 17, 1955.

38. According to the U.S. National Plant Germplasm System (NPGS), the Burford holly is listed as NA 30576 and was received on February 1, 1937. The National Arboretum is a part of the National Plant Germplasm System within the Agricultural Research Service (ARS) of the United States Department of Agriculture (USDA).

39. In October of that year, Hollywood Cemetery was sold on Fulton County's courthouse steps to J.W. Smith of Gainesville, Georgia, for $41,000. He, however, backed out of the deal when not all of the property he wanted was included in the transaction.

40. The trust created was to have built a cemetery gate, chapel and complete other improvements; the gate and chapel were never built, and only minor improvements were made overall.

41. Modern-day Crest Lawn Memorial Park's history is confusing and was difficult to ascertain. Started by the Atlanta Cemetery Association in 1913 for a $50,000 investment, it was near the Marietta and Inman rail yard lines and was to have eight thousand lots and be known as the Atlanta Park cemetery. By 1914, the property was known as North View Cemetery when construction of architect A. Ten Eyck Brown's mausoleum was started. Later, the property's name would change from Crestlawn to Crown Hill Cemetery and then to its current name.

42. Some historical documents list her as a Prussian countess.

43. Countess Mina Von Jeweitska Zeldieka (sometimes Zeldeika) is buried in Section 3, row Q, grave 11, between Fred "Roger" (Rodgers), 1896, on her right and Fannie Baker, 1897, on her left, both of whom have headstones. According to contemporary newspaper articles, Zeldieka had an eventful life. Born in 1817 in St. Petersburg into a German ducal family with ties to the Russian court, she married Count Zeldieka, a Russian nobleman, when she was sixteen. He supposedly served on Tsar Nicholas's imperial staff until Nicholas's death. After offending Nicholas's successor, Tsar Alexander II, and associating with the person who tried to assassinate him, Dmitry Karakozov, Zeldieka lost his place on the Russian court and fled the country with Mina and their son. Eventually, they settled in New York City after being refused refuge in England and Germany. There, Count Zeldieka developed a drinking problem, which eventually drove him to suicide. Years later, the couple's son married a "dancing girl" against Mina Zeldieka's wishes and fled to New York. Zeldieka spent several years traveling and living around the country—in Philadelphia, Chicago, Cincinnati, St. Louis and San Francisco—trying to find her son before she gave up the search around

1885 and settled in Atlanta. In the city, she rented a few rooms and quietly lived out her life, having few friends, until her death at Grady Hospital the day before her burial.

Chapter 5

44. At more than six feet in length and more than five feet high, Harris's rusticated Georgia granite piece from the McNeel Marble Company has a bronze tablet on one side inscribed with his name and part of a preface Harris had written for the A.B. Frost edition of *Uncle Remus*; Frost was the illustrator of the work. Sometime later, a bronze medallion of Harris was added to the stone.

45. *Achievement* is credited to Daniel Chester French in 1914; completed Piccirilli-sculpted piece based on French's design is 1917. These dates could be challenged. Pinpointing the exact date of completion was challenging and reported in different sources as anywhere from 1913 to 1917.

46. Egleston also left money to create an education wing at All Saints Episcopal Church in Atlanta and to erect a $7,500 monument on his family's plot in Westview.

47. Esmilaire's original, small monument inscribed with French has long been missing. In 2017, at the suggestion of the author, the current marker to indicate the location of Esmilaire's grave was installed.

48. Esmilaire came to America in 1916 along with other circus sideshow stars, including seven-and-a-half-foot-tall Battista Hugo, with whom he was often photographed in Europe. He was often billed as a member of the Johnny J. Jones Midget Troupe or the Marechal Midgets.

49. An alternative narrative is that Esmilaire died of a broken heart and not influenza. Shortly before he came to Atlanta with the Johnny J. Jones Exposition, Alma, the "Jolly Fat Girl," an eight-hundred-pound costar who he was supposedly in love with, had died in Birmingham, Alabama.

50. The porcelain plaque of John Sherlock has been missing for years. Its whereabouts are unknown.

51. *Reader's Digest* 39, no. 23 (July 1, 1941).

Chapter 6

52. J.J. Haverty, along with Westview's E.P. McBurney, was a major contributor to Atlanta's art scene. He died on October 18, 1939, and was originally buried in the community mausoleum at Crown Hill Cemetery, now Crest Lawn Memorial Park. He was later interred at Westview once his Francis P. Smith–designed Gothic family chapel and mausoleum was built. Many of the paintings he collected in the twilight years of his life were posthumously donated to Atlanta's High Museum of Art.

Chapter 8

53. Wilbur Kurtz, who is buried in Westview's Terrace E, died in 1967. He is probably best known as being a technical advisor and artist director for the 1939 film *Gone with the Wind*.
54. *Atlanta Constitution*, March 15, 1914, 5.
55. Cecil E. Bryan had worked with Frank Lloyd Wright for one year, followed by a stint with Ralph Modjeski, a pioneer in the use of reinforced concrete and builder of the Bay Bridge between San Francisco and Oakland, California. West View Abbey was one of Cecil's largest projects.
56. The line on the main *Graces* mural—"earthbound, enslaved by toil and strife at last eternal peace and life"—is from an unknown source, perhaps made up to be reminiscent of other quotes on the building.
57. Originally touted was that every crypt in the building was connected to a ventilation system that allowed gas drainage to occur through formaldehyde tanks installed on a lower floor and that, in turn, brought sterilizing vapor into each crypt.
58. "Colorosa Travertine" was the market name for a limestone quarried by Colonna & Co. of Colorado, Inc., from mines near Cañon City, Fremont County, Colorado, where the author's brother, Greg, and nephews, Kenny and Deven, lived at the time of the writing of this book.
59. Per John Soward Bayne's book, *Atlanta's Westview Cemetery*, the organ had fallen into disrepair and was traded for a Hammond electronic organ to Reverend Roy O. McClain, who served as pastor of Atlanta's First Baptist Church from 1953 to 1970. McClain, like Bayne, was an organ enthusiast. It is believed that when McClain retired to South Carolina, he donated Westview's organ to Charleston Southern University. Later

Westview owners, the Bowen family, were heavily involved with Atlanta's First Baptist Church, including its building committee.

60. Asa Candler Jr. changed his mind in 1948 about the three large windows in the chapel depicting angels. He opted, instead, for Christ's life.

61. During the height of the Cold War, the Atlanta Metropolitan Area of Civil Defense indicated to Westview Cemetery management that the U.S. Corps of Engineers was scouting for buildings that would be suitable as fallout shelters for the Atlanta public in the event of nuclear attacks. The Corps of Engineers would stock the buildings chosen with food, water, medical supplies and radiological instruments, as well as provide fallout shelter signage. On July 25, 1962, Westview officials received license and privilege agreement forms authorizing the use of the cemetery's abbey tunnel and mausoleum's lower level as shelters. Paperwork was officially signed on December 17, 1962, two months after the Cuban missile crisis, designating the structures as such. Barrels of food and supplies still exist on the property.

62. The main arch of the bridge is eighteen feet wide; the smaller arch is seven feet wide.

63. Elizabeth Allan's crypt is on the Chapel Floor level, around the corner from the mausoleum's travertine staircase.

64. In mid-February 1947, new section markers were installed; designed to look like residential street number signs used in some Atlanta neighborhoods at the time, the approximately six-foot-tall iron markers still exist and are used to delineate sections of the cemetery.

65. This seven-acre lake is now named Lake Palmyra; the original lake alongside the southern end of the abbey was drained in the 1970s.

66. The *Lady of the Lake* is now stored in the basement of the abbey. Its head has long been removed, and its whereabouts are unknown.

67. The fountain was blown up with dynamite.

Chapter 9

68. *Atlanta Constitution*, July 14, 1949, 1.

69. Ibid.

70. Ibid., November 24, 1949, 12B.

71. Six essay winners from a contest Candler held for the purpose of picking out Coca II were flown on West View Corporation's plane to New Hampshire, making a quick stop in Washington, D.C., to pick up

Candler's friend U.S. vice president Alben Barkley. The elephant chosen from those at the Wild Animal Farm was then brought south to Atlanta by train.

72. Ironically, it was during this pachyderm rivalry that the two papers announced they were merging. *Atlanta Constitution* political editor M.L. St. John declared at the time, "We are putting all our elephants in one basket." Grimes, *The Last Linotype*, 80.

73. The actual *Last Supper* bas-relief, while designed by Zimmer, was executed by an Atlanta modeler in marble dust and cement.

74. In addition to teaching at Oglethorpe, Zimmer, along with artists Athos Menaboni and Ralph M. Britt, operated a private art school in Atlanta for many years.

75. In the latter, a judge in October 1950 dismissed a petition brought by West View lot owners to prevent Candler from selling three hotels that he owned: the Robert Fulton, Briarcliff and Clermont. Weeks after the dismissal, Candler sold the Robert Fulton Hotel for $850,000 to Fred B. Wilson, an Atlanta capitalist.

76. *West View Corporation v. Alston, et al.*

77. *West View Corporation, et al. v. Alexander.*

78. Unfortunately, Candler's legal troubles did not involve only West View lot holders but also his own attorneys. In January 1951, James A. Branch and Thomas B. Branch Jr., Candler's lawyers, sued him and West View Corporation for back fees amounting to a little more than $8,000. Since 1941, they had represented him in some twenty lawsuits, including eleven regarding West View Cemetery and one regarding the Robert Fulton Hotel. Like other lawsuits, these were eventually settled.

79. Senate Bill 78 was enacted on July 1, 1952.

Chapter 10

80. The quartet consisted of Jimmy Callahan (bass), later Jack Bozeman; Charles DeJarnette (baritone); Winter Griffith (second tenor); and Harrison Reeves (first tenor); the organist was Viola Aiken.

81. Ray F. Wyrick report dated December 11, 1951, which is located in files within Westview Abbey's archives.

Chapter 11

82. *Atlanta Journal*, March 23, 1952, 16-C.
83. On July 31, 1972, The Westview Cemetery, Inc. paid the promissory note from Candace, Inc. off in full; said note, or loan, was paid to Florence Candler, Trust Co. for trustee of Mrs. Samuel Candler, Mrs. Pauline S. Wilkerson, Mrs. Pauline S. Wilkerson as guardian for Sandra Candler and Samuel Candler, deceased.
84. These gardens are listed in the order in which they were opened; however, there is some discrepancy among cemetery records, so the order could vary slightly.

Chapter 12

85. From Dictionary.com: "Blockbusting—the profiteering real-estate practice of buying homes from white majority homeowners below market value, based on the implied threat of future devaluation during minority integration of previously segregated neighborhoods."
86. On August 10, 2011, Ulysses Crawford and John Mattox, led by Atlanta civil rights activist and local talk show host Reverend Benford Stellmacher, gathered at Westview Cemetery to protest the flying of a Confederate flag in its Confederate memorial section. Stellmacher stated that both the flag and the sculpture over which it flew were symbols of racism and endorsements of slavery. As such, he wanted the flag taken down. Stellmacher had noticed the flag four days earlier during the burial of Reverend Howard Creecy Jr., leader of the Southern Christian Leadership Conference (SCLC). Westview officials at the protest stated it was against state rules and regulations to disturb the Confederate memorial where the flag was being displayed, and the protest subsided. Four years later, in part because of new and ever-increasing protests over the displays of Confederate flags across the South, the flag was quietly removed.
87. A native of North Carolina, Clingman joined the Confederacy in Arkansas in April 1861. Through successive engagements over the years, his regiment had found itself southwest of Atlanta near the small village of Campbellton in the summer of 1864 trying to prevent Sherman's troops from cutting the rail lines coming into Atlanta. It was at this time that he was mortally wounded and buried nearby on Dr. Hornsby's land. The death date of April 23, 1864, on Clingman's monument has been

the subject of debate; there were no Federal troops in or south of Atlanta at that point. It is believed the monument, which had been moved to Westview along with Clingman's remains from its original location, had been carved incorrectly years earlier. Some historians think he died in August, while others think it was a month earlier in July. The engravings on top of the stone were added at the time of re-interment.

88. *Atlanta Constitution*, August 25, 1962, 26.

89. Ibid., September 5, 1962, 7.

90. In addition to changing racial policies at Westview, Frank Bowen had been instrumental in other cemetery reform. In 1969, he helped craft and get passed through the Georgia legislature statutory provisions that regulated the operation of cemetery companies in regard to the establishment and use of perpetual care funds. Prior to that, Bowen had maintained a successful fund at Westview.

Chapter 13

91. Talk about adding a landfill to Westview's property had started in 1966; cemetery management had noted in meeting minutes that other cemeteries had had successful ventures such as they were proposing with a landfill.

92. Atlanta road name history is difficult, as the city changes street names often. Gordon Road was named after Confederate general and former Georgia governor John B. Gordon. Hunter Street had been named after slave owner Alston Hunter Green. Mozley Drive had been named after Hiram Mozley, a patent holder of a popular lemon elixir who reportedly donated the land that became Mozley Park on the condition it was for white residents only.

Chapter 14

93. Joseph Dessert was killed, along with eight others, by Mark O. Barton on July 29, 1999, in a shooting spree incident at two Buckhead Atlanta companies. Barton had killed his wife and two children prior to the office killings.

94. *Atlanta Journal-Constitution*, October 21, 2014, B4.

Epilogue

95. The author of this book was in attendance at the March 12 Atlanta Audubon Society event. After he saw a brochure with a section calling out for "wildlife sanctuary" applicants, which had been handed out during the event, he suggested to the society's lecturer and bird tour guide, Joy Carter, that Westview Cemetery should become a sanctuary. After discussions with Westview president Charles Bowen Jr. and director of administration Cindy Julian over subsequent days, an application was submitted by Julian. Upon receipt of the application, the Atlanta Audubon Society made site visits to the cemetery to ensure it met certain requirements before accepting its application in June 2016.

BIBLIOGRAPHY

Periodicals

Alexandria Gazette
American Bar Association Annual Reports
American Cemetery
Atlanta Business Chronicle
Atlanta Constitution
Atlanta Daily World
Atlanta Journal
Atlanta Journal-Constitution
Atlanta Magazine
Cato Citizen
Cemetery Legal Compass
Confederate Veteran
Florist Review
Gen. Gordon Dispatch
Independent
Masonic Messenger
Modern Cemetery
New York Times
Northside Neighbor
Patch
Reader's Digest

Southern Cultivator and Dixie Farmer
West End Times
West View Chimes
Westview Chimes

Other Sources

Abrams, Ann Uhry. *Explosion at Orly: The Disaster That Transformed Atlanta.* Atlanta: Avion Press, 2002.

———. *Formula for Fortune: How Asa Candler Discovered Coca-Cola and Turned It into the Wealth His Children Enjoyed.* Atlanta: iUniverse, 2012.

Adams, Gary. "Various Subjects: Grave locations, Westview history, tours." Multiple in-person discussions and tours with author, 2014–17. It was Gary who found a grave site for the author in Section 3.

Atlanta Urban Design Commission. *Atlanta Historic Resources Workbook.* Atlanta, 1981.

Bacote, Clarence Albert. *The Story of Atlanta University: A Century of Service, 1865–1965.* Atlanta: Atlanta University, 1969.

Bayne, John Soward. *Atlanta's Westview Cemetery.* Atlanta: Vanity Press, 2014.

———. "Various Subjects: Atlanta history, Westview history, discussions about South-View and Greenwood cemeteries." E-mails to and in-person interviews with author, 2014–17.

Berry, Patrick. *The History of the Westview Neighborhood.* Patrick Berry, Steffi Langer-Berry and Chad Carlson, contributors. Stockbridge: Georgia DNR Historic Preservation Division National Register of Historic Places, 2015.

Bintliff, Kristen. "Little Adrien. Translation of French biography." E-mails to author, 2015.

Bowen, Charles, Jr. "Various Subjects: Bowen family history, Westview Cemetery history, tours of Westview, archives usage, use of photographs for book and the business of cemeteries." E-mails and phone calls to and in-person interviews and discussions with author, 2014–17.

Branch, Taylor. *Parting the Waters: America in the King Years 1954–63.* New York: Simon & Schuster, Inc., 1989.

Butler, S.H. "Asa Candler Jr.: The Man, the Myth, the Mansion." Background Radiation, February 21, 2017. shbutlerwrites.wordpress.com/2017/02/21/asa-candler-jr-the-man-the-myth-the-mansion.

"Candler, Asa Griggs, Jr." Personality file, Kenan Research Center, Atlanta History Center.

Candler, Asa Griggs, Jr. "Self-Surrender." In *These Found the Way: Thirteen Converts to Protestant Christianity*, edited by David Wesley Soper. Philadelphia: Westminister, 1951, 53–62.

Carlson, Chad. "Various Subjects: Westview Cemetery, Westview neighborhood, Belt Line, Atlanta history." E-mails to and multiple in-person discussions with author, 2014–17.

The Cemetery Hand-Book: A Manual of Useful Information on Cemetery Development and Management. 2nd ed. Madison, WI: Park and Cemetery Publishing Co., 1931.

Clemmons, Greg. "The Battle of Ezra Church and various American Civil War subjects." E-mails and phone calls to author, 2014–17.

Clemmons, Jeff. *Rich's: A Southern Institution.* Charleston, SC: The History Press, 2012.

"Clingman, Edward Peter." Personality file, Kenan Research Center, Atlanta History Center.

Conrad, Kevin. "Burford Holly." E-mails to author, 2017.

Coons, Boyd. "Various Subjects: L.P. Grant family, Gresham's Florist, Westview gatehouse, Atlanta Preservation Center, Friends of Historic Westview Cemetery." E-mails to and in-person discussions with author, 2014–17.

Cooper, Lisa Land. "Westview Cemetery—The Story behind One Confederate's Grave." The Story Behind the History. lisalandcooper. com/westview-cemetery-store-behind-one-confederates-grave.

Crimmins, Timothy, Anne Farrisee and Diane Kirland. *Democracy Restored: A History of the Georgia State Capitol.* Athens: University of Georgia Press, 2007.

Danylchak, Erica. "Westview Cemetery: A Cultural Landscape Worthy of Preservation." *Garden Citings.* Atlanta: Cherokee Garden Library Newsletter, 2009.

Davis, Ren, and Helen Davis. *Atlanta's Oakland Cemetery: An Illustrated History and Guide.* Athens: University of Georgia Press, 2012.

Davis, Stephen. "Battle of Ezra Church." E-mails to author, 2016.

———. "The Grave of Lieutenant Edward Peter Clingman, C.S.A.: The Story Behind a Tombstone." Atlanta: private printing, 1994.

Day, Lisa. "Various Subjects: Notable Westview graves, interment locations." E-mails and phone calls to and in-person discussions with author, 2014–17.

Ecelbarger, Gary. *Slaughter at the Chapel: The Battle of Ezra Church 1864.* Norman: University of Oklahoma Press, 2016.

Farris, Jen. "Film and television at Westview Cemetery." E-mails to author, 2015.

Fonseca, Isabel. *Bury Me Standing: The Gypsies and Their Journey*. New York: Vintage Books, 1996.

Forrest's Escort Camp Sons of the Confederate Veterans. "Gallery of Distinguished Confederate Georgians." car0lesc0tt.tripod.com/forrest3.html.

Garrett, Franklin M. *Atlanta and Environs: A Chronicle of Its People and Events*. New York: Lewis Historical Publishing Company, Inc., 1954.

"Georgia Historic Landscape Survey Form." Atlanta: Cherokee Garden Library, Atlanta History Center, 2008.

Gravely, William B. *Gilbert Haven: Methodist Abolitionist: A Study in Race, Religion, and Reform, 1850–1880*. Nashville, TN: Abingdon Press, 1973.

Grimes, Millard B. *The Last Linotype: The Story of Georgia and Its Newspapers Since World War II*. Macon, GA: Mercer University Press, 1985.

Hammock, Paul. "Various Subjects: Writing book on Westview Cemetery, Westview history, Westview tours, Atlanta Preservation Center, Friends of Historic Westview Cemetery." E-mails to and in-person conversations with author, 2014–16.

Hatch, Laurence C. *Biographies in Ornamental Horticulture*. N.p.: private web printing, 2011.

Haverty, Rawson. *Ain't the Roses Sweet*. Atlanta: private printing, 1989.

Henderson, D.L. "Various Subjects: Rest Haven and South-View Cemetery." E-mails to author, 2016.

Hess, Earl J. "Battle of Ezra Church and American Civil War earthworks." E-mails to author, 2015–17.

———. *The Battle of Ezra Church and the Struggle for Atlanta*. Chapel Hill: University of North Carolina Press, 2015.

Hillside. hside.org.

Influenza Encyclopedia: The American Influenza Epidemic of 1918–1919: A Digital Encyclopedia. "Atlanta, Georgia." www.influenzaarchive.org/cities/city-atlanta.html.

Jones, Gordon. "American Civil War earthworks." E-mails to author, 2016.

Jones, Sharon Foster. *The Atlanta Exposition*. Charleston, SC: Arcadia Publishing, 2010.

———. "Various Subjects: Atlanta history and burials at Westview Cemetery." E-mails to author, 2014–17.

Jones, Tommy H. "G.W. Collier House (c. 1868)." Tomitronics. tomitronics.com/old_buildings/collier/index.html.

Julian, Cindy. "Various Subjects: Westview Cemetery history, Rest Haven, God's Acre, Atlanta Audubon Society and bird sanctuary, cemetery maps." E-mails and phone calls to and in-person discussions with author, 2014–17.

Kaemmerlen, Cathy J. *The Historic Oakland Cemetery of Atlanta: Speaking Stones.* Charleston, SC: The History Press, 2007.

Keister, Douglas. *Stories in Stone: A Field Guide to Cemetery Symbolism and Iconography.* Salt Lake City, UT: Gibbs Smith, 2004.

Kelly, Dennis. *Kennesaw Mountain and the Atlanta Campaign: A Tour Guide.* Marietta, GA: Kennesaw Mountain Historical Association, Inc., 1990.

Kemp, Kathryn W. *God's Capitalist: Asa Candler of Coca-Cola.* Macon, GA: Mercer University Press, 2002.

Kruse, Kevin M. *White Flight: Atlanta and the Making of Modern Conservatism.* Princeton, NJ: Princeton University Press, 2005.

Maréchal, O. *Biographie de The Little Adriens: Le Plus Petit Diminutif Humain.* Paris: private printing, 1910.

Myers, William "Grant," Jr. "Various Subjects: Westview Cemetery history, Westview burials, Westview archives, cemetery practices." E-mails and phone calls to and numerous personal interviews and visits with author, 2014–17. During the writing of this book, Myers was author's main point of contact and became a personal friend.

Olsen, Susan. "Thomas C. Veale." E-mails to author, 2015.

Olson, Harriett Jane, ed. *The Book of Discipline of the United Methodist Church.* Nashville, TN: United Methodist Publishing House, 2000.

Parks, Robert. "Various Subjects: Friends of Historic Westview Cemetery, Westview tours and history." E-mails and in-person discussions with author, 2014–17.

Powers, Martha. Personal interviews, May 2 and May 30, 2015; and January 9, 2016.

———. "Various Subjects: Westview history, leaders, employment and interments." E-mails to author, 2015–17.

Prentice, George. *The Life of Gilbert Haven, Bishop of the Methodist Episcopal Church.* Cincinnati, OH: Walden & Stowe, 1883.

Reed, Wallace P., ed. *History of Atlanta, Georgia.* Syracuse, NY: D. Mason & Co., 1889.

Rodgers, Robert L. *History, Confederate Veterans' Association, of Fulton County, Georgia.* Atlanta: V.P. Sission, 1890.

Rutherford, Sarah. *The Victorian Cemetery.* Oxford, UK: Shire Publications, Ltd., 2008.

Rylands, Traci Muller. "Welcome to Westview Cemetery, Part I." "Welcome to Westview Cemetery, Part II." Adventures in Cemetery Hopping. adventuresincemeteryhopping.wordpress.com.

Schairer, Joan. "Various Subjects: Thomas Burford, necrologies, cemetery searches, initial read of manuscript, edits." E-mails and phone calls to author, 2014–17.

Schairer, Lois. "Various Subjects: Thomas Burford, genealogy, Westview Cemetery history." E-mails and phone to author, 2014–17.

Sloane, David Charles. *The Last Great Necessity: Cemeteries in American History.* Baltimore, MD: Johns Hopkins University Press, 1991.

Statham, Frances. "Irish horse traders." E-mails to author, 2015.

Steinhoff, Kathryn Terese. "An Exploratory Research Study of Collection Management Tools for the Knoxville Botanical Gardens and Arboreta's Living Plant Collection." Master of science thesis, University of Tennessee–Knoxville, 2003. trace.tennessee.edu/utk_gradthes/2208.

St. Johns, Adela Rogers. *First Step Up Toward Heaven: Hubert Eaton and Forest Lawn.* Englewood Cliffs, NJ: Prentice-Hall, 1959.

Taliaferro, Tevi. *Historic Oakland Cemetery.* Charleston, SC: Arcadia Publishing, 2001.

Thomas, Bettye Collier. "Race Relations in Atlanta, from 1877 through 1890, as Seen in a Critical Analysis of the Atlanta City Council Proceedings and Other Related Works." Master of arts thesis, Atlanta University, 1966. digitalcommons.auctr.edu/cgi/viewcontent.cgi?article=2694&context=dissertations.

Unequa, Aniwaya. "Little Adrien." E-mails to author, 2015.

Warren, Charles. "Thomas C. Veale." E-mails to author, 2015.

West View Cemetery & Abbey, subject file, Kenan Research Center, Atlanta History Center.

Westview Cemetery archives, 1884–present.

Westview Cemetery, subject file, Historic Preservation Division, Department of Natural Resources, Stockbridge, GA, 2016.

Williams, M.J. "Burford Holly." E-mails to author, 2017.

Williford, William Bailey. *Peachtree Street, Atlanta.* Athens: University of Georgia Press, 1962.

Wood, Andrew. "Tour and photographic sessions at Westview." In-person tours, 2017.

Works Progress Administration. *Georgia: A Guide to Its Towns and Countryside.* Athens: University of Georgia Press, 1940.

INDEX

ABOUT THE AUTHOR

Although born in Mobile, Alabama, Jeff Clemmons considers himself an Atlantan, having lived in the metropolitan area for more than thirty years. His family has an even older connection to the city with his great-great-grandfather Archibald Clemmons fighting in the Atlanta Campaign, including the Battle of Atlanta, during the American Civil War.

Clemmons has a degree in business administration from Reinhardt University and a degree in creative writing from Georgia State University. His current full-time employer is a large electric utility, where he works in the corporate communication department.

Outside of his day-to-day job, he gives walking tours that he created of Atlanta's Midtown and SoNo districts and Westview Cemetery for the Atlanta Preservation Center. He also serves on the board of the Atlanta Preservation Center's auxiliary group, CIRCA, which offers its members private tours of some of metropolitan Atlanta's most interesting historic structures.

Atlanta's Historic Westview Cemetery is Clemmons's second book. All of his research for it is housed at the Atlanta History Center.

∽∞∾

Also by Jeff Clemmons

Rich's: A Southern Institution

Visit us at
www.historypress.net
···